VEGETABLES

Text
DELPHINE HIRASUNA

Design
KIT HINRICHS

Photography
TOM TRACY

Recipes
DIANE J. HIRASUNA

CHRONICLE BOOKS

Text:
Delphine Hirasuna
Design:
Kit Hinrichs
Photography:
Tom Tracy
Recipes:
Diane J. Hirasuna

Design Associates:
D.J. Hyde
Lenore Bartz
Production Manager:
Tanya Stringham
Project Coordinators:
Diana Dreyer
Laurie Goddard

Chronicle Production Director:
David Barich
Chronicle Staff:
Fearn Cutler
Bill LeBlond

Illustration:
Regan Dunnick
John Hyatt
Tim Lewis
John Mattos
Will Nelson
Tadashi Ohashi
Hank Osuna
Daniel Pelavin
Colleen Quinn
Susie Reed
Alan Sanders
Ward Schumaker
Dugald Stermer
David Stevenson
Bud Thon
Carolyn Vibbert
Sarah Waldron
Phillipe Weisbecker

Library of Congress Cata-
loging in Publication Data:
Main entry under title:
VEGETABLES.
Bibliography: p.
Includes index.
1. Vegetables.
2. Cookery (Vegetables)
I. Hirasuna, Delphine 1946–
TX401.V44 1985
641.3′5 85-9620
ISBN 0-87701-361-6 (pbk.)
Printed in Japan
by Toppan Printing Co., Ltd.

Chronicle Books
One Hallidie Plaza
San Francisco
California 94102

VEGETABLES

CONTENTS

THE EARLY YEARS
VEGETABLES

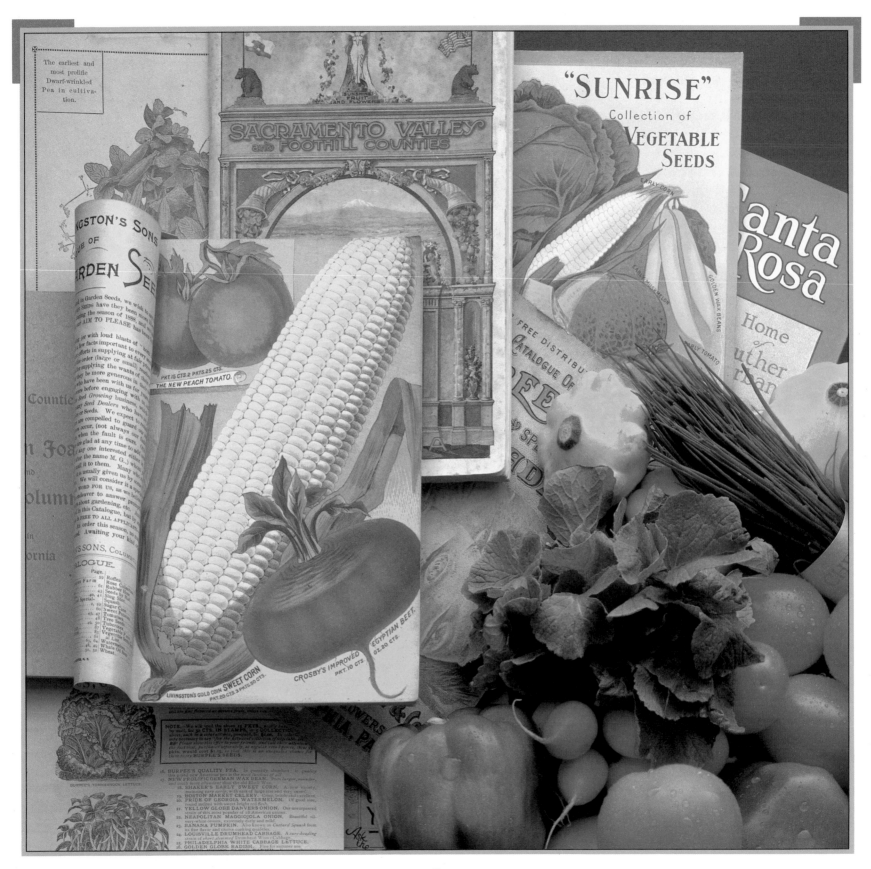

There was a glorious time a half century ago when many people needed to consume more than seven thousand calories a day just to maintain their strength. Fatty meats, heavy sauces, sweet jams, and loads of butter could be enjoyed without a twinge of guilt. A twelve-hour day on the farm milking cows and bailing hay or scrubbing floors and washing clothes by hand expended the high "carbo" intake.

No longer. Today, average office workers burn off less than eighty-five calories an hour, roughly two thousand calories a day, unless they exercise. Most of us can't continue the diet followed by our ancestors without turning into blimps.

As a result, there is a new trend in elegant dining. Where rich sauces were once an essential part of gourmet foods, today's *nouvelle cuisine* emphasizes imaginative blends, a lighter touch, and nutritional goodness.

California is at the forefront of this movement. The principles of what is known as California cuisine are almost Zen in philosophy: The essence of every ingredient must be preserved without change in flavor or vitamin loss. Fresh herbs are substituted for calorie-laden sauces. Ethnic ingredients are combined with a verve and daring that would make any United Nations official proud. Meats, fish, and poultry often are served grilled without rich adornments. And always there are vegetables—fresh, ripe veggies presented with originality and simplicity. The best of California cooking is a lean cuisine, created to nourish both our aesthetic spirit and our physical being.

This book is a celebration of the wonderful vegetables that grow so prolifically in the Golden State and, thanks to rapid transportation, are now finding their way all over the country and the world.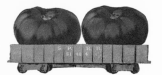

EARLY YEARS

When the family was growing green onions in the summer of '58, my favorite chore was making lemonade for the midafternoon break.

The first step to making lemonade was turning the TV on to the afternoon matinee so I could watch Fred Astaire twirl Ginger Rogers around a ballroom floor as I squeezed fresh lemons into a pitcher. With instinctive timing, I could stretch out the task until I sensed that my sisters and brother were on the verge of complaining about my extended absence. Then with proper ceremony, I marched out the door, holding the trayful of snacks aloft like a servant about to present the *grande entrée* to the king.

My turn at making lemonade was a welcome escape from a summer spent peeling, bunching, and tying green onions on the backyard lawn.

Like so many other "shade tree" farmers in California's San Joaquin Valley, Dad "employed" his family to plant and harvest whatever vegetables we happened to be growing that year. On family farms, most of the produce packing was done in the cool of the shadiest tree.

We weren't the only family working in the neighborhood. Across the road, the Smith kids were tending the tomato vines. Next to the chicken farm, Tommy was irrigating the corn fields. Everyone was expected to help out.

In California's Central Valley, which stretches from around Redding in the north to Bakersfield in the south, a distance of about four hundred and fifty miles, farming has been a way of life since the late nineteenth century.

GROWING REGIONS OF CALIFORNIA'S MAJOR FRESH MARKET VEGETABLES

1 TULE LAKE-BUTTE VALLEY
Horseradish, onions, potatoes

2 SACRAMENTO VALLEY
Dry beans, tomatoes

3 DELTA
Asparagus, sweet corn, onions, potatoes, tomatoes

4 BRENTWOOD-TRACY
Sweet corn, lettuce, tomatoes

5 SANTA CRUZ-SAN MATEO COAST
Artichokes, brussels sprouts, broccoli, cauliflower, mushrooms, peas

6 FREMONT-SAN JOSE
Broccoli, cauliflower, celery, sweet corn, garlic, lettuce, onions, peas, peppers, tomatoes

7 PATTERSON-NEWMAN
Dry beans, broccoli, cauliflower, sweet corn, lettuce, tomatoes, peppers

8 MODESTO-TURLOCK
Dry beans, carrots, sweet potatoes, tomatoes

9 SALINAS-WATSONVILLE
Artichokes, snap beans, broccoli, cabbages, carrots, cauliflower, celery, garlic, lettuce, mushrooms, onions, peas, spinach, potatoes, tomatoes

10 GILROY-HOLLISTER
Sweet corn, garlic, lettuce, onions, potatoes, peppers, peas, tomatoes

11 FRESNO-WEST SIDE
Dry beans, lettuce, onions, tomatoes

12 MERCED-ATWATER
Peppers, sweet potatoes, tomatoes

13 KINGSBURY-DINUBA
Sweet potatoes

14 CUTLER-OROSI
Tomatoes, spring vegetables

15 KERN-TULARE
Dry beans, sweet corn, carrots, garlic, lettuce, onions, peas, potatoes, sweet potatoes

16 SANTA MARIA-OCEANO
Artichokes, avocado, snap beans, broccoli, cabbages, carrots, cauliflower, celery, lettuce, peas, potatoes

17 OXNARD
Avocado, broccoli, cabbages, carrots, cauliflower, celery, cucumbers, lettuce, spinach, tomatoes

18 ANTELOPE VALLEY
Onions

19 LOS ANGELES-ORANGE COUNTY
Asparagus, avocado, snap beans, cabbages, carrots, cauliflower, celery, sweet corn, lettuce, mushrooms, peppers, tomatoes

20 CHINO-ONTARIO
Sweet corn, onions, sweet potatoes

21 PERRIS-HEMET
Carrots, onions, potatoes

22 OCEANSIDE-SAN LUIS REY
Avocado, snap beans, cabbage, lettuce, peppers, sweet potatoes, tomatoes

23 COACHELLA VALLEY
Asparagus, avocado, snap beans, carrots, sweet corn, onions, peppers, tomatoes

24 BLYTHE
Sweet corn, lettuce, onions

25 CHULA VISTA
Avocado, snap beans, cabbages, celery, cucumbers, lettuce, peppers, tomatoes

26 IMPERIAL VALLEY
Asparagus, broccoli, cabbages, carrots, cucumbers, garlic, lettuce, onions, tomatoes

SOURCE: *California Crop and Livestock Reporting Service* and *California Agriculture - 1983.*

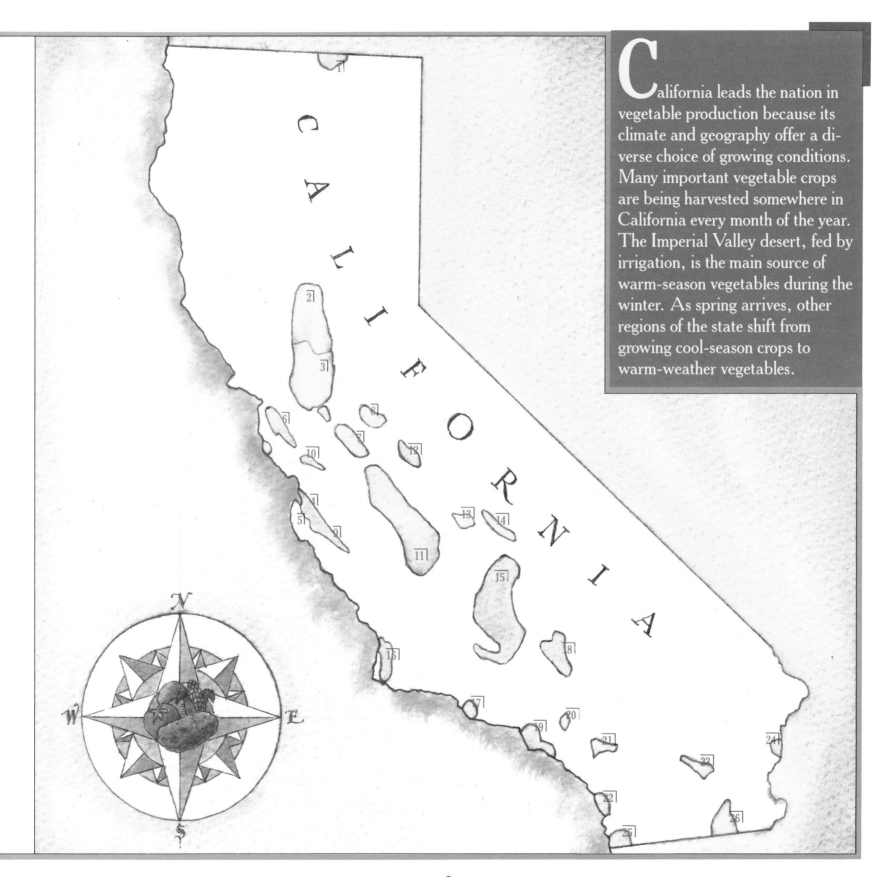

C alifornia leads the nation in vegetable production because its climate and geography offer a diverse choice of growing conditions. Many important vegetable crops are being harvested somewhere in California every month of the year. The Imperial Valley desert, fed by irrigation, is the main source of warm-season vegetables during the winter. As spring arrives, other regions of the state shift from growing cool-season crops to warm-weather vegetables.

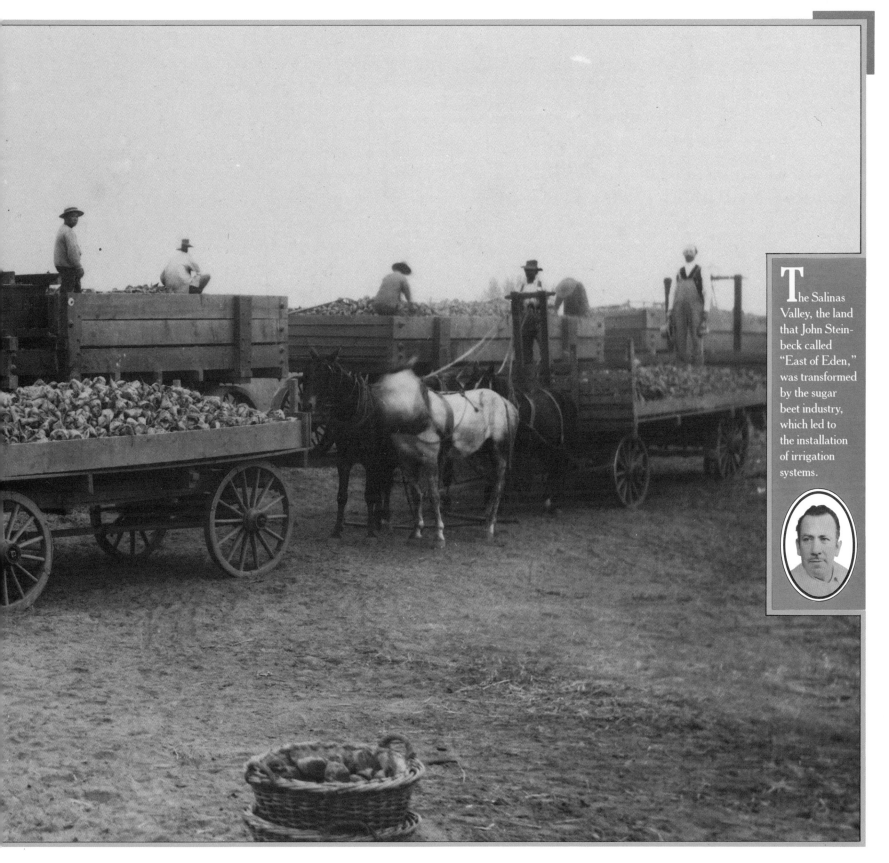

The Salinas Valley, the land that John Steinbeck called "East of Eden," was transformed by the sugar beet industry, which led to the installation of irrigation systems.

Everything grows there. You can drive for hours past green acres. Fresno County, located in the center of the state, leads the nation's counties in agricultural production.

FIRST SETTLERS

It's hard to believe that when the first settlers arrived during the gold rush of 1849, they couldn't envision the valley as the agricultural "Eden" it has become. In the summer, all they saw was a barren plain, the ground cracked for lack of moisture and temperatures hovering above one hundred degrees. Newcomers from the Midwest and East didn't know what to make of the region, which was wet and lush from about November through May and dry and forbidding from May through October. There were no sudden summer thunderstorms, nor was there ever any winter snow. The land defied familiar farming practices.

The would-be gold miners did not, however, come to farm, though many had previously been farmers. Their goal was to stake their claim, get rich, and go home.

Soon many found that mining was frustrating and unprofitable, while recognizing that farming offered a more assured route to riches. "Plant your lands; these be your best gold fields, for all must eat while they live," one new Californian advised his sons.

Food was extremely costly in the early years after gold was discovered on the American River in Sacramento. The burst in population happened too quickly for the Spanish rancheros to supply the demand. Much of the food came in by ship around Cape Horn.

Luther Burbank was a pioneer in developing new varieties of vegetables. Today, researchers with the United States Department of Agriculture and at various universities work on breeding vegetables that grow faster, taste better, keep longer, and contain more nutrients.

Those who turned to agriculture applied methods practiced back home beyond the Rockies, and grew the crops they knew best, such as wheat, oats, and barley. Dry-land farming, which relies on whatever moisture nature provides on a seasonal basis, was the common practice in the Midwest, but in the Far West it produced uneven results, since some crops didn't come into full maturity before the annual heat wave hit.

Beans were the first important vegetable crop grown in California. Until the gold rush, they played an insignificant role in the West. Enterprising farmers, however, quickly noted that miners were buying imported beans by the bushel to cook over the campfire by their claims. Soon bean vines were sprawling all over the state. By 1859, California had the highest return of beans in the nation. At the start of World War I, farmers were exhorted to grow even more beans for our soldiers overseas. In 1918, California produced more than eight and a half million bushels. Even after the war, beans remained the state's most important vegetable crop. Lima beans, native to Peru, were particularly well suited to California's climate and soil and made up about a third of the bean production.

IRRIGATING THE CENTRAL VALLEY

Still, California didn't realize its agricultural potential until irrigation practices became widespread. Without a pipeline of water, the fertile Central Valley was only suitable for farming half the year. Average annual rainfall ranges from seventeen inches in Sacramento to

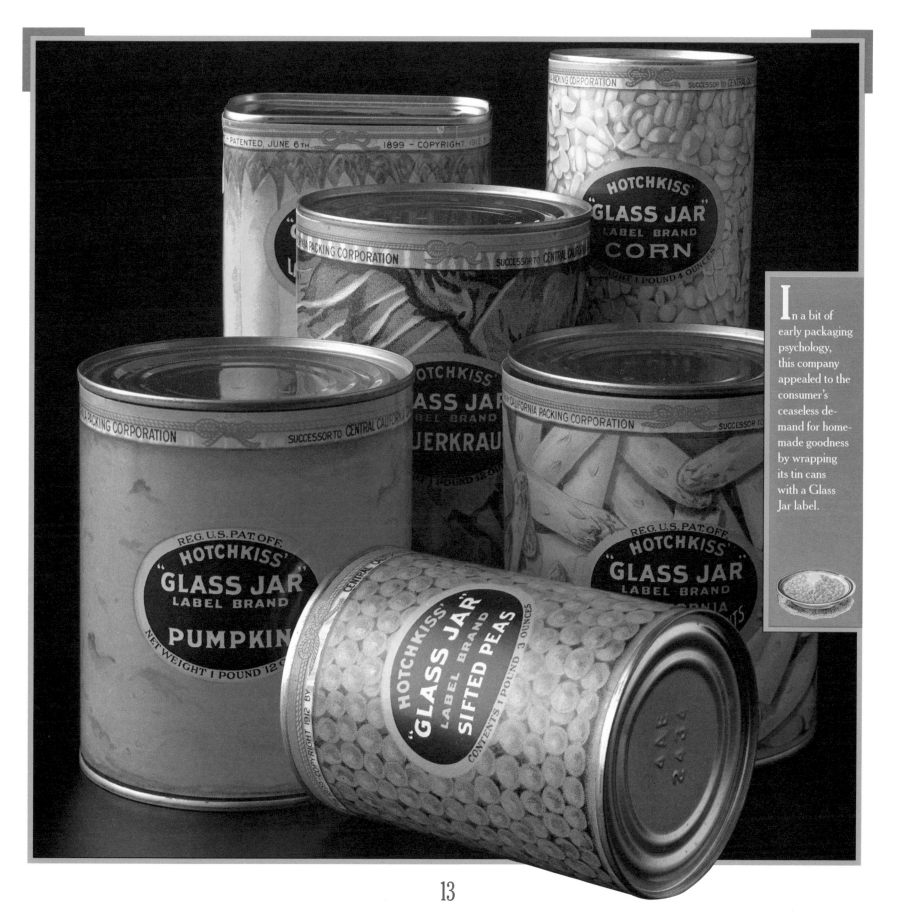

In a bit of early packaging psychology, this company appealed to the consumer's ceaseless demand for homemade goodness by wrapping its tin cans with a Glass Jar label.

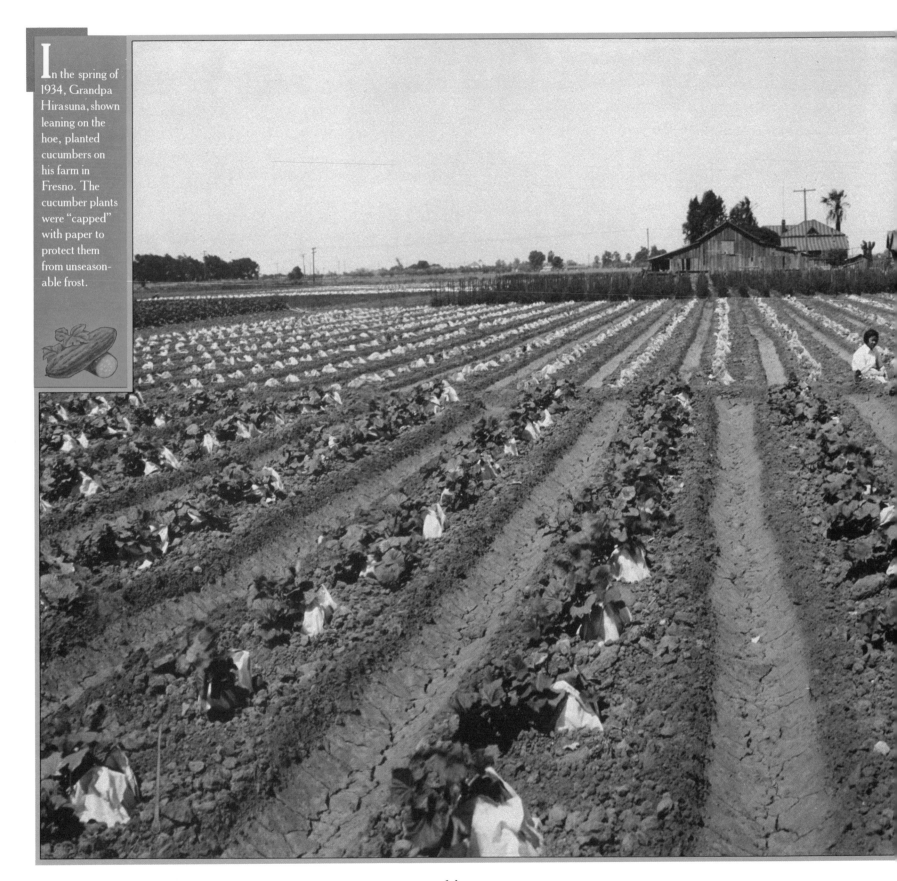

In the spring of 1934, Grandpa Hirasuna, shown leaning on the hoe, planted cucumbers on his farm in Fresno. The cucumber plants were "capped" with paper to protect them from unseasonable frost.

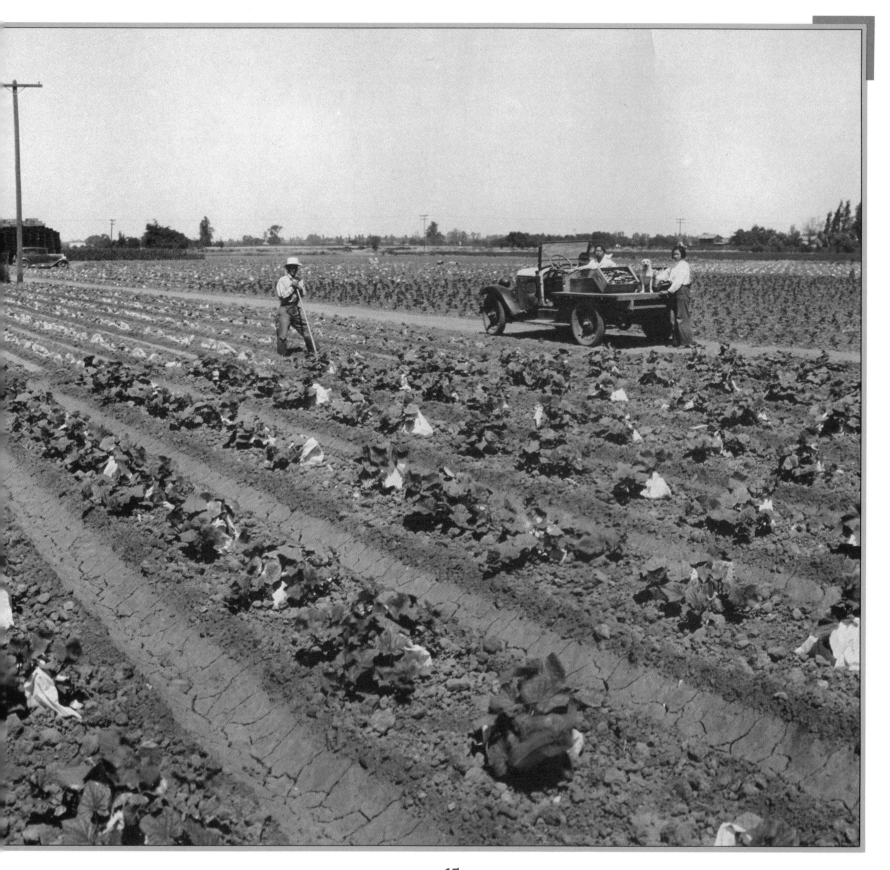

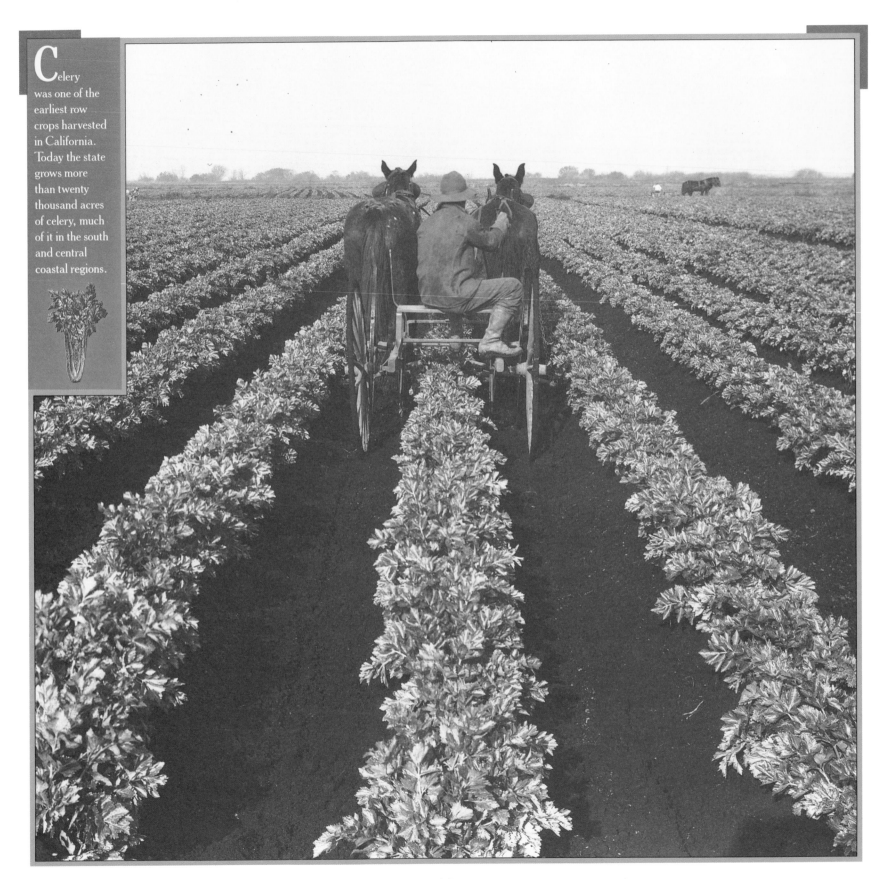

Celery was one of the earliest row crops harvested in California. Today the state grows more than twenty thousand acres of celery, much of it in the south and central coastal regions.

16

six inches in Bakersfield. It almost never rains from June through September.

The Spanish padres who began establishing mission outposts along the California coastline in 1769 were the first to apply irrigation methods, which they had learned in Mexico. During the Spanish and Mexican period, crops grown around Los Angeles were fed by water diverted from nearby streams. Near Sacramento, foothill farmers took advantage of the panned-out reservoirs and ditches abandoned by miners to carry water to their fields.

The cry to "redeem by baptism" the great Central Valley did not become a roar until the 1870s. Men, plows, scrapers, mule teams, and horses joined forces to carry off thousands of cubic yards of soil to create trenches for the new water system. Within a few years, canals, dams, and headgates had tapped the rivers that flowed through California. Despite this network of irrigation avenues, the initial delivery of water was undependable. Users downstream found that growers near the headgate received the heavy flow, while they only saw a trickling stream that was insufficient to feed their crops. Privately owned lateral ditches sometimes didn't receive any water at all. In 1876 when the Kings River, which fed the Fresno area, fell to historically low levels, cattlemen filed suits against the Fresno Canal and Irrigation Company to prevent them from diverting all the water. The battle for water at times became quite nasty. Saboteurs dynamited levees and irrigation facilities, and armed men stood guard over headgates.

At the Panama Pacific International Exposition held in San Francisco in 1915, Del Monte Corporation built a monument to canned vegetables out of its own products. Asparagus, string beans, peas, tomatoes, and spinach were the most commonly canned vegetables at the time.

Still, by 1889, more than one million acres, mostly in the arid central portion of the state, were under irrigation, and another forty thousand acres were fed by deep wells that were drilled to draw from the subterranean water table.

Our family farm depended on well water, as did every other ranch within several miles of us. One of the greatest catastrophes to befall anyone was when a well ran dry. Word of a dry well always aroused an outpouring of sympathy.

More than any other crop, vegetables are dependent on a continuous water supply. Unlike fruit trees which can drive their roots deep into the soil to tap the moisture below, vegetables have shallow roots that wither if not sufficiently nourished during the summer and early fall.

Once water was available in rural areas, pioneer farmers introduced an incredibly diverse array of vegetables. Much of this diversity was due to the lure of gold, which made California an ethnic melting pot.

IMMIGRANT CROPS

While other regions of the United States were settled by immigrant groups who came in waves from countries in distress, California's gold attracted fortune seekers from all over the country and all parts of the world. And like all pioneers, they brought with them seeds and cuttings of their favorite vegetables and fruits. Although potatoes, beans, cabbages, and other common vegetables were among the earliest crops grown, ethnic vegetables, like artichokes from the Mediterranean and *bok choy* from China, were planted for home use and later for the commercial market.

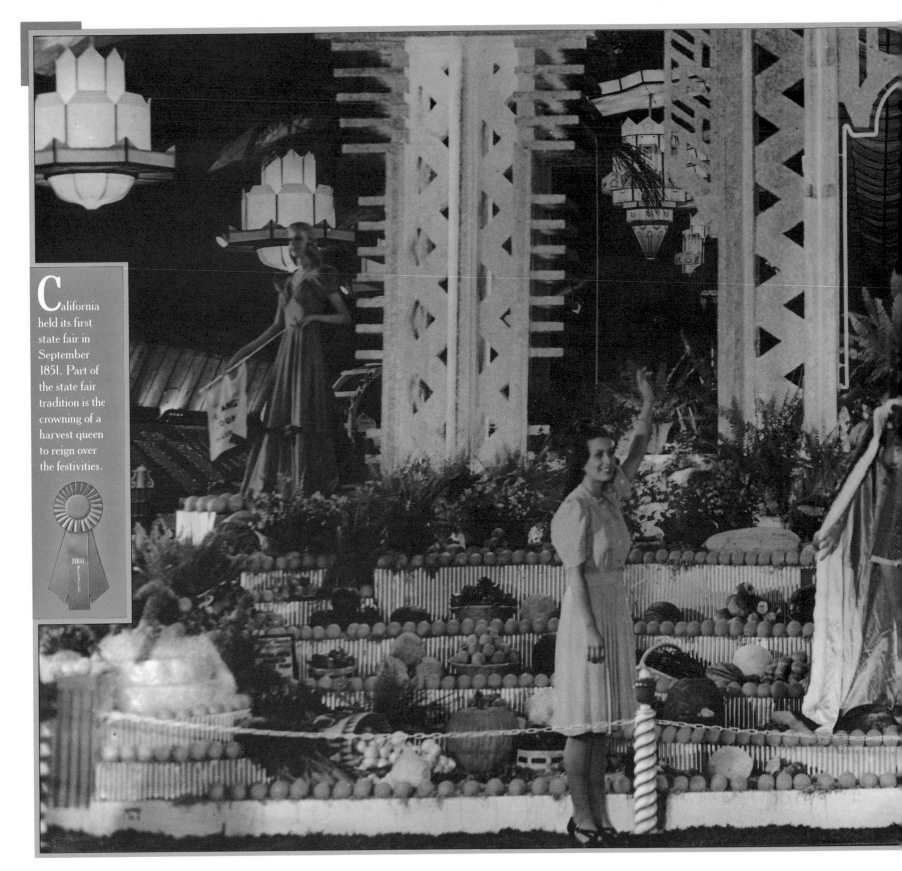

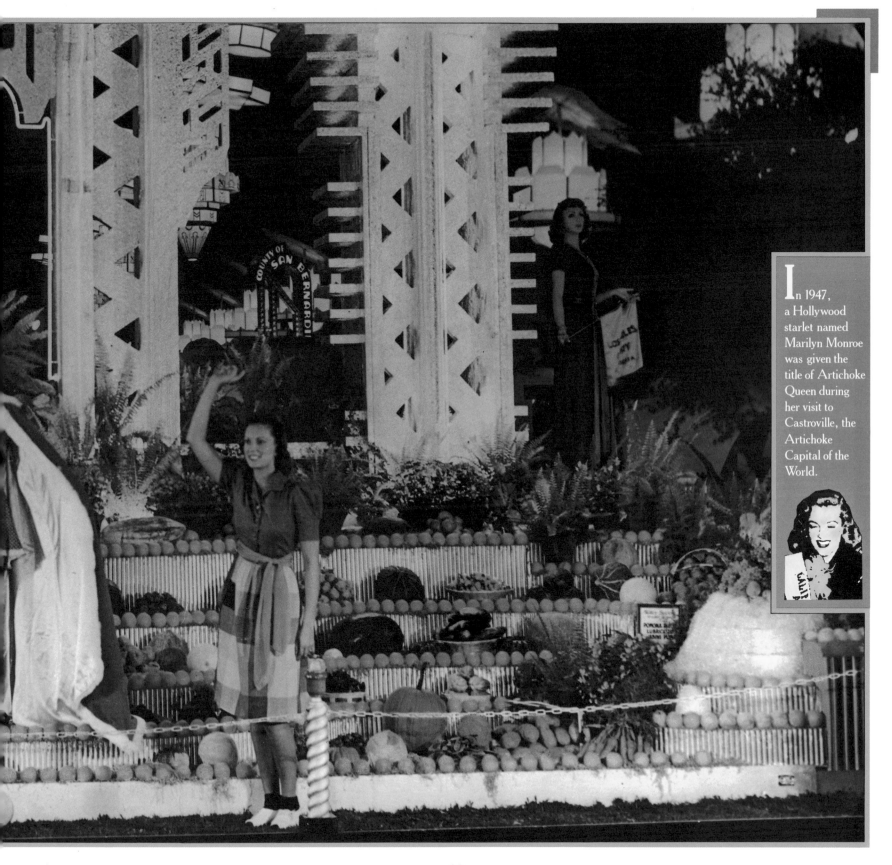

In 1947, a Hollywood starlet named Marilyn Monroe was given the title of Artichoke Queen during her visit to Castroville, the Artichoke Capital of the World.

In California, vegetable farming historically has been an immigrant business. Orchard crops, such as citrus and nuts, require a sizable capital investment and lengthy fruition time. Vegetables, on the other hand, demand little upfront cash and mature in a few months' time. On only a few acres of vegetables, a poor immigrant could eke out a living for himself and his family.

Grandfather Hirasuna, who came to California in 1907, was among the immigrant farmers. Speaking no English and having little money, he first worked as a migrant, traveling up and down the state with his blanket roll, following the harvest. Then later, with responsibilities for a "picture" bride and children, he settled in the Fresno area and leased a few acres of farmland.

By the late thirties, Grandpa had a twenty-acre ranch and a gasoline-powered tractor, his pride and joy. Many Japanese immigrants had much smaller plots, some as tiny as a half acre. But with careful planning and intensive labor, it was possible for families to make a living. The trick was to have a crop ready to harvest continuously. For example, they would plant two rows of carrots, followed by a row and a half of green onions, another few rows of potatoes and turnips or radishes. Since root vegetables did not require much ground space, they could be grown nearly on top of each other, often in double columns.

By staggering the planting, farmers could reap a harvest every week and immediately plow the vacant space and reseed it with the next crop. On such a farm, the work was never ending; there was never a lull between planting

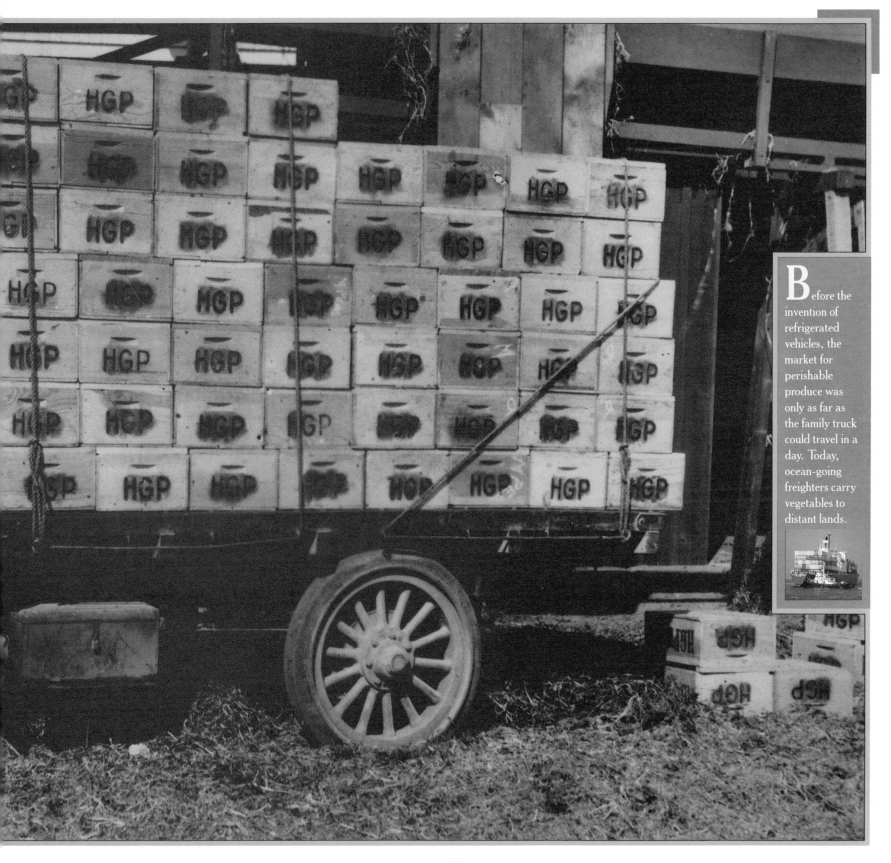

Before the invention of refrigerated vehicles, the market for perishable produce was only as far as the family truck could travel in a day. Today, ocean-going freighters carry vegetables to distant lands.

GARDEN GATE
"GATEWAY TO THE VALLEY OF GREEN GOLD"
Selected
VEGETABLES
PACKED AND SHIPPED BY
SALINAS MARKETING COOPERATIVE
SALINAS, CALIFORNIA
PRODUCE OF U.S.A.

LUXURY
BRAND
EARLY GARDEN
SUGAR PEAS
NET WEIGHT 1 LB. 4 OZ.

TWINS
ICEBERG
LETTUCE
GROWN, PACKED AND SHIPPED BY
M. L. KALICH & CO.
MAIN OFFICE
WATSONVILLE, CALIFORNIA, U.S.A.
PRODUCE OF U.S.A.

FIREFALL
PRODUCE OF U.S.A.
PACIFIC
FARM COMPANY
MAIN OFFICE
SAN JOSE, CALIFORNIA
Selected
Quality

KING
GROWN AND PACKED BY
F.S. AND F.E. KING
SACRAMENTO
CALIFORNIA

FAT
PRODUCE
OF U.S.A.
FAT PAK
REG. U.S. PAT. OFF.

EASTER BRAND
SUGAR PEAS
NET WEIGHT 1 LB. 4 OZ.
PACKED IN U.S.A.

EASTER BRAND
CALIFORNIA PACKING CORPORATION
MAIN OFFICE
SAN FRANCISCO, CAL. U.S.A.

EXTRA FANCY TOMATOES
DIAMOND
N
TOP & BOTTOM BRAND THE SAME

Cutting's Packing Co.
CUTTING'S

CAR
CALI
GROWER-PAC

WOO-WOO
BRAND
Selected FRUITS & VEGETABLES
Distributed by W. Fay Co., Los Angeles
PRODU

PRIDE of the RIVER
GREEN
ASPARAGUS
GROWN & PACKED BY G.W. LOCKE & SON, LOCKE, CALIFORNIA

PACKED AND
SHIPPED BY
T. O. TOMASELLO CO.
MAIN OFFICE
WATSONVILLE
CALIF.
DOMINATOR
BRAND
PRODUCE OF U.S.A.

CALIFORNIA
VEGETABLE UNION
PACKERS & SHIPPERS
MAIN OFFICE LOS ANGELES CALIF.
AMERIC

PAK BRAND

GROWER & PACKER L. R. HAMILTON, INC. REEDLEY CALIF.

shocking
Selected
VEGETABLES

PRODUCE OF U.S.A.

FRISCO
BRAND
CALIFORNIA VEGETABLES

PACKED BY MERRILL PACKING COMPANY SALINAS, CALIF. U.S.A.

CALIFORNIA STATE
BRAND

CALIFORNIA

NET WEIGHT 1 LB.

ASPARAGUS

CALIFORNIA
GIANT BRAND

GROWERS PRODUCE DISPATCH
SALINAS — CALIFORNIA

LETTUCE

RIER BRAND

ORNIA VEGETABLES

UPPER BRYAN SMITH FARMS BAKERSFIELD, CALIF.

NET WEIGHT NOT LESS THAN 28 LBS. WHEN PACKED.

PRODUCE OF U.S.A.

POLLY BRAND

NET WEIGHT 1 LB. 3 OZS.

PEELED TOMATOES
ITALIAN STYLE

TC

1 LB. 3 OZS.

PRODUCT OF
RIO GRANDE VALLEY
PACKED BY
TAORMINA COMPANY
DONNA, TEXAS

HEALDSBURG BRAND
STRING BEANS

Packed by T. S. MERCHANT & CO.
at HEALDSBURG CANNERY HEALDSBURG SONOMA CO. CAL.

GIRL

CALIFORNIA
CELERY

PRODUCE ★ OF U.S.A.

EL-SOL BRAND

FULL O' SUN

NN & SON
NO. CALIFORNIA

NET WEIGHT 28 LBS.

OH YES!
WE GROW THE BEST
CALIFORNIA
GREEN ASPARAGUS

PRODUCE OF U.S.A.

DiGiorgio
FRUIT
CORPORATION

PRODUCE OF U.S.A.

THE MARK OF MERIT

M

CIRCLE BRAND

SELECTED
VEGETABLES

PACKED BY MERRILL PACKING COMPANY SALINAS, CALIF.

and picking, whereas on ranches that concentrated on a single crop, like cabbages, there was a brief slow period before the cutting season.

In the Central Valley, farmers could follow a year-round planting program, because temperatures rarely dipped below thirty degrees and the ground never froze solid. Root vegetables, which aren't harmed by frost since the edible portion grows underground, comprised the major winter crop. In the summer, farmers switched to hot weather plants like peppers, tomatoes, cucumbers, and squash.

SALAD BOWL OF THE WORLD

The story along the central coast region was much different. There temperatures remain even and cool. In the summer, fog blowing in from the Pacific moderates any heat wave, keeping temperatures in the sixties. In the winter, sea breezes keep the weather above forty degrees.

Despite the ideal climate, the Salinas Valley, a one hundred and fifty mile plain nestled between the Gabilan and Santa Lucia mountains off the central coast, did not become the salad bowl of the world until about the 1920s. The early settlers raised cattle or wheat and barley, depending on rainfall to make things grow. At the end of the nineteenth century, however, a variety of beets was found to be a source for sugar, a lucrative commodity. Sugar beets grew well all over the state. Around 1897, Claus Spreckels constructed a sugar refinery in the Salinas Valley, and irrigation systems went into place to allow farmers to grow beets. Irrigation also enabled farmers to raise crops that demanded intensive agricultural methods.

During World Wars I and II, patriotic Americans were encouraged to plant "victory gardens." California growers increased production of dry beans to feed the soldiers fighting overseas.

With water available, the Salinas Valley and the central coast became the main region for cultivating many of the leaf vegetables native to the Mediterranean countries. The ocean breezes keep the leaves from becoming tough. Salinas has long earned the title Lettuce Capital of the World. Artichokes, broccoli, cauliflower, and brussels sprouts also thrive in the coastal region. This area boasts the most scenic agricultural drive in the country. From Half Moon Bay to Santa Cruz, there are acres of lush green artichoke fields that grow right to the edge of the cliffs, which drop straight down into the Pacific Ocean.

Until the 1950s, most of the fresh produce in the state was grown within truck-driving distance from large urban areas. In the fifties, Dad would take his vegetables to the produce market. Each evening he would load the pickup truck with crates of blemish-free vegetables and drive to the market around midnight. There buyers would check the array. If competition was limited, farmers could expect a good price. But if the market was glutted, then the prudent buyer would bide his time, waiting for prices to drop. Sometimes the market was totally overstocked and no buyers were to be found. On those nights, Dad would come home at sunrise with the produce still loaded on the truck—weeks, sometimes months, of work had come to naught. From those early years, I learned that farming was a risky business. You prayed for fair weather to give you a bountiful harvest, but if everyone enjoyed a great crop too, prices would plummet.

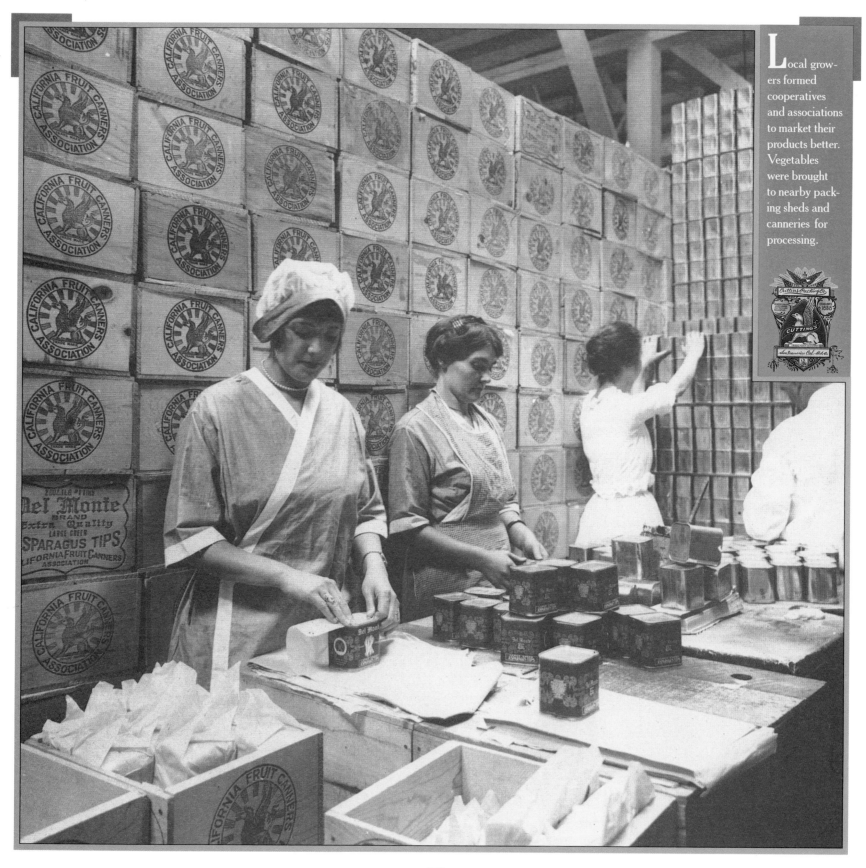

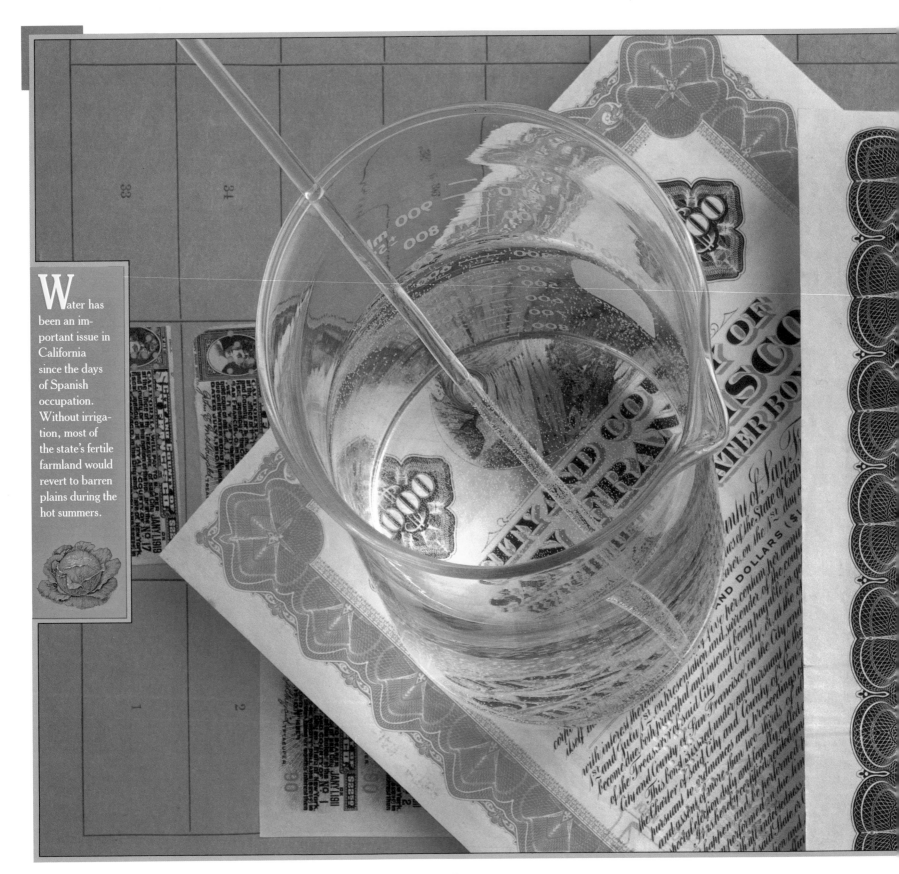

Water has been an important issue in California since the days of Spanish occupation. Without irrigation, most of the state's fertile farmland would revert to barren plains during the hot summers.

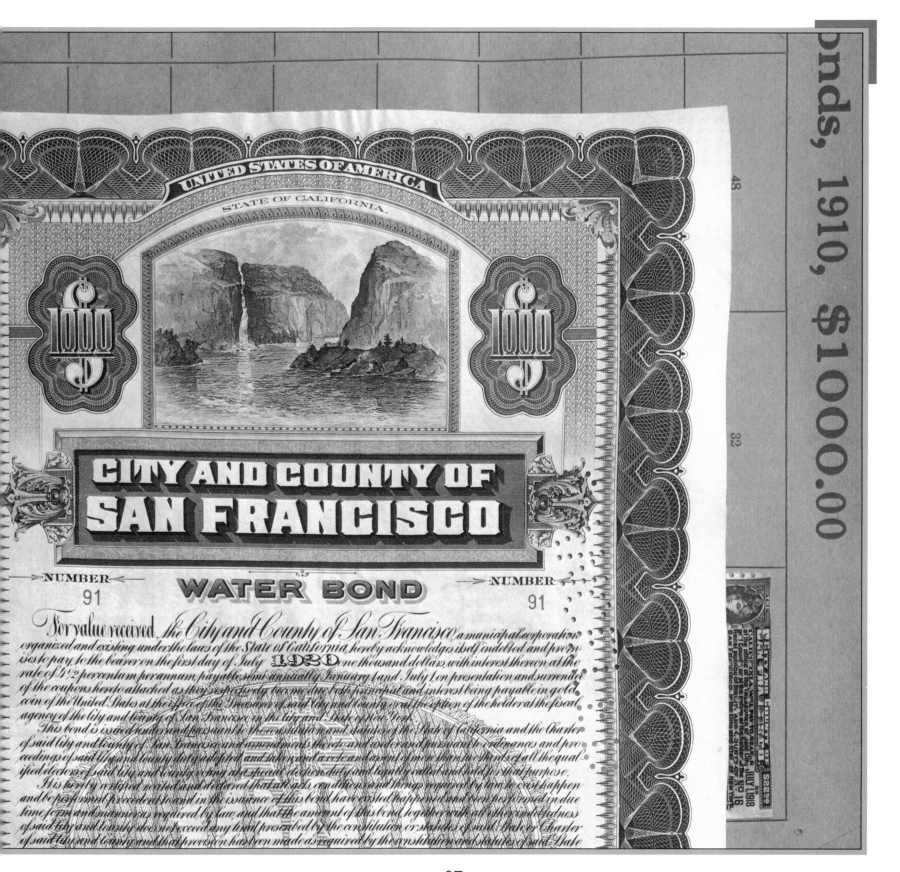

UNITED STATES OF AMERICA

STATE OF CALIFORNIA.

$1000 $1000

CITY AND COUNTY OF SAN FRANCISCO

WATER BOND

NUMBER 91 NUMBER 91

For value received, the City and County of San Francisco, a municipal corporation organized and existing under the laws of the State of California, hereby acknowledges itself indebted and promises to pay to the bearer on the first day of July 1920 one thousand dollars, with interest thereon at the rate of 4½ percentum per annum, payable semi-annually January 1 and July 1 on presentation and surrender of the coupons hereto attached as they respectively become due, both principal and interest being payable in gold coin of the United States at the office of the Treasurer of said city and county or at the option of the holder at the fiscal agency of the city and county of San Francisco in the city and State of New York.

This bond is issued under and pursuant to the constitution and statutes of the State of California and the Charter of said city and county of San Francisco and amendments thereto and under and pursuant to ordinances and proceedings of said city and county duly adopted and had and to a vote cast by more than two-thirds of all the qualified electors of said city and county voting at a special election duly and legally called and held for that purpose.

It is hereby certified recited and declared that all acts, conditions and things required by law to exist happen and be performed precedent to and in the issuance of this bond have existed happened and been performed in due time form and manner as required by law, and that the amount of this bond together with all other indebtedness of said city and county does not exceed any limit prescribed by the constitution or statutes of said State or Charter of said city and county and that provision has been made as required by the constitution and statutes of said State

To be a farmer is a lesson in faith. There are so many variables that are beyond the control of any conscientious grower. Untimely rain or heat can wipe out a crop. Rot sets in from dampness; sunburn damages or stunts vegetables. And, there are the ever-present bugs. Insect pests immediately head for the prettiest, the plumpest fruit on the vine.

Perhaps because farming is an act of faith, the end of a harvest is often marked by a festival as a celebration of faith rewarded. In ancient times, tribes made ritual sacrifices of fair maidens in homage to the corn god or the rice deity. Today we crown a harvest queen and hold a crepe-paper parade, led by the mayor of the town riding a shiny new convertible loaned by the local car dealership.

In years past, the end of the harvest was when the carnival came to town and parents had to make good on their promise to take the kids to the fair if they would help in the fields without complaining. It was also the time when the family splurged on the new spin-dry washer and replaced the worn-out car. Merchants always smiled when the crop was good.

FAST TRUCKS, BROADER MARKETS

The marketplace has changed since the fifties. Fast-moving, refrigerated vehicles that can carry goods across country and to foreign lands have turned vegetable growing into an agribusiness. Today, California accounts for nearly 50 percent of the production in the nation's twenty-two fresh market vegetables and more than 50 percent of the country's nine major processing crops.

Hollywood was just a farming region around 1910 when the movie industry discovered that the year-round sunshine was as good for making films as it was for growing citrus and vegetables. Movie makers, however, did preserve the image of the demure farm girl carrying her basket of vegetables from the market.

California is uniquely positioned to take advantage of this expanded marketplace. The state's temperate climate, which ranges from semitropical in San Diego County to desert dry in the Imperial Valley, to seasonally cool or hot in the Central Valley, evenly cool and mild along the central coast, and hot or freezing cold in the extreme north, enables California producers to tap the off-season market, both nationally and internationally.

In the winter, when most of the nation is shoveling snow, the Imperial desert enjoys balmy days that are perfect for growing tomatoes, peppers, lettuce, and other produce. Most of this produce is sold fresh, since demand is strong. As winter yields to spring, harvest time ripples northward. The southern part of the state has earlier springs than upstate. About the time Fresno County has completed its main harvest, San Joaquin County is ready to begin picking its vegetables. By early fall, Tule Lake at the Oregon border is ready to harvest its potato and onion crops. In the summer, trucks crisscross on the freeways, taking produce to canneries and packing sheds.

Many vegetables grow virtually year-round in some regions. If you plant them efficiently, you can harvest as many as three or four times in a year.

The expanded marketplace and mechanization have virtually eliminated the small family-operated farm. In the fifties and early sixties, the farmer carrying a shovel on his shoulder as he checked for breaks in the irrigation ditch was a familiar sight. Today automated sprinklers

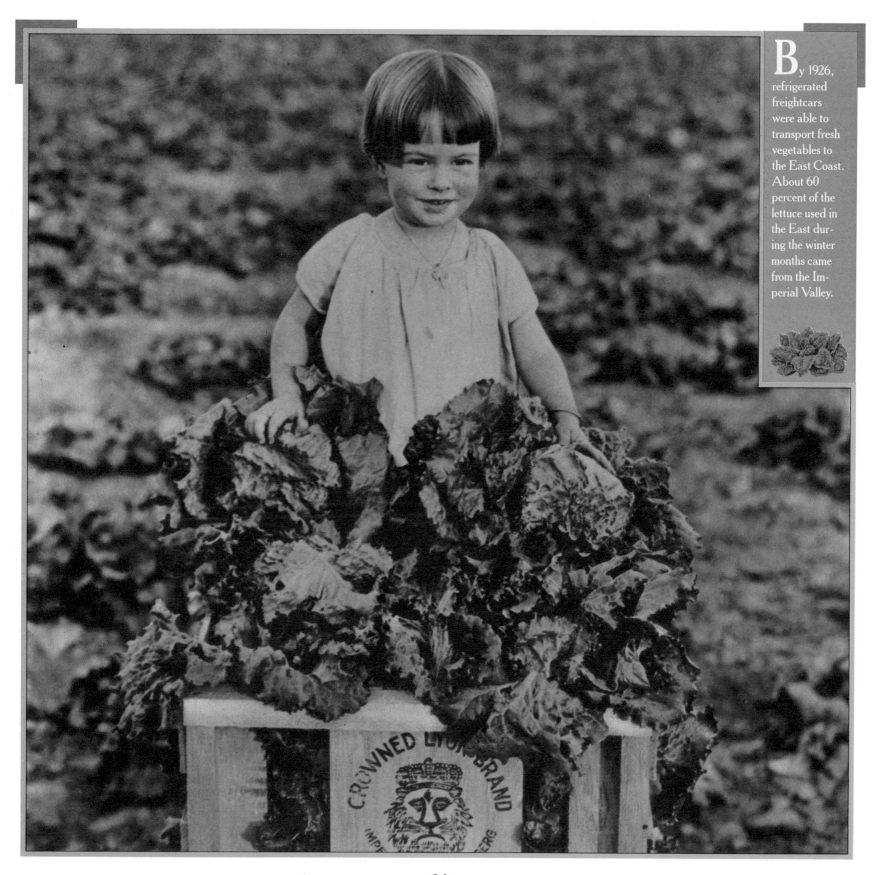

By 1926, refrigerated freightcars were able to transport fresh vegetables to the East Coast. About 60 percent of the lettuce used in the East during the winter months came from the Imperial Valley.

29

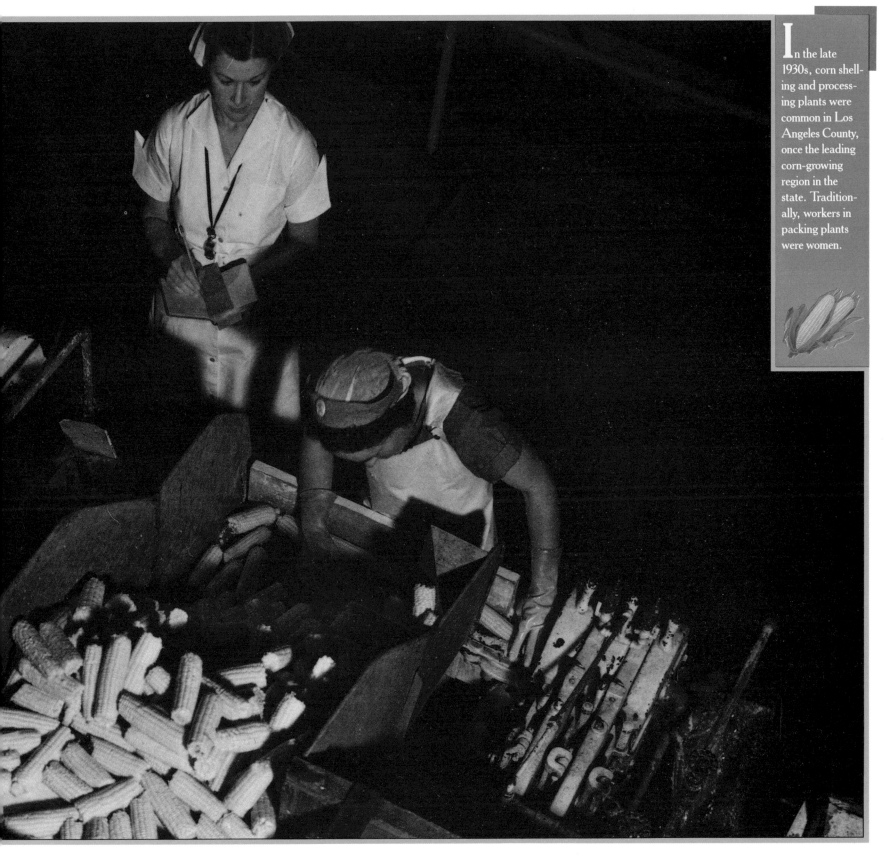

handle the task. Harvesting equipment, which often cost thousands of dollars, operate like mini-factories, completing the job of picking, sorting, and packing in one swift motion. Few vegetable crops are now harvested by hand. Fewer still are sorted and packed by families working together under the shade of the largest tree in the field. The five-acre vegetable patch is no longer economic either.

Although produce markets remain a part of the agricultural scene, there are now a number of middlemen—brokers, wholesalers, shippers, specialty suppliers, and others—who are necessary to handle vegetables in today's complex marketplace. There are restaurants that contract with farmers to grow specific crops, and still other farmers who are finding their own special niche, such as "baby veggies." Harvested when just mature, these tiny vegetables are as sweet and succulent as milk-fed lamb.

Fresh Produce in Winter

For consumers, these changes in agriculture have brought a cornucopia of fresh produce year-round. In the Midwest, where root vegetables stored in the cellar and canned goods made up the winter menu in the past, you can now find all kinds of fair-weather items. A California artichoke is as likely to appear on a dinner table in Chicago as it is in San Jose.

The availability of fresh produce, along with concern about high-cholesterol, fatty foods, has created a lively interest in vegetables, which were once considered merely an accompaniment to the main course. Abundant use of vegetables has come to be

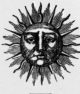

The sun shines twelve months out of the year in most parts of California. Warm-season crops like tomatoes are harvested year-round. In the winter, they are grown in the semitropical climate of San Diego County. In the spring and summer, the main harvest comes from the Central Valley.

identified as California cuisine. But not just the old standards—carrots, celery, and the like—are enjoying a revival. Interest in a lean cuisine has set off a quest for new vegetables, and California's broad ethnic mix is unearthing many greens that had been grown for home use alone.

As the gateway to the Pacific, California has a huge Asian population that is making *bok choy* and bitter melon as common as string beans. Previously only sold in ethnic markets, oriental vegetables are fast-growing commercial products.

So many vegetables, which were known only to individual ethnic groups, are coming onto the open market. Radicchio and cardoon are no longer just Italian vegetables. Jicama and chayote now are familiar to more than Mexicans. Daikon, which was strictly Japanese food a decade ago, is grown in three crop rotations a year in the Fresno area to keep up with demand. Certainly the Chinese have made a dozen or more exotic cabbages and gourds popular through stir-fry dishes.

In addition to "foreign" produce, "ag-biz" researchers are developing an array of vitamin-enriched super veggies that would make even Popeye pay attention.

For me, this all comes as a welcome surprise. Back in 1958, when I was peeling slimy onions hour after hour and lamenting loudly that nothing exciting ever happened in the "low crop" world, I had no idea that vegetables would someday become chic and desirable—the latest adventure in gourmet dining.

Veggies, your day has finally come!

33

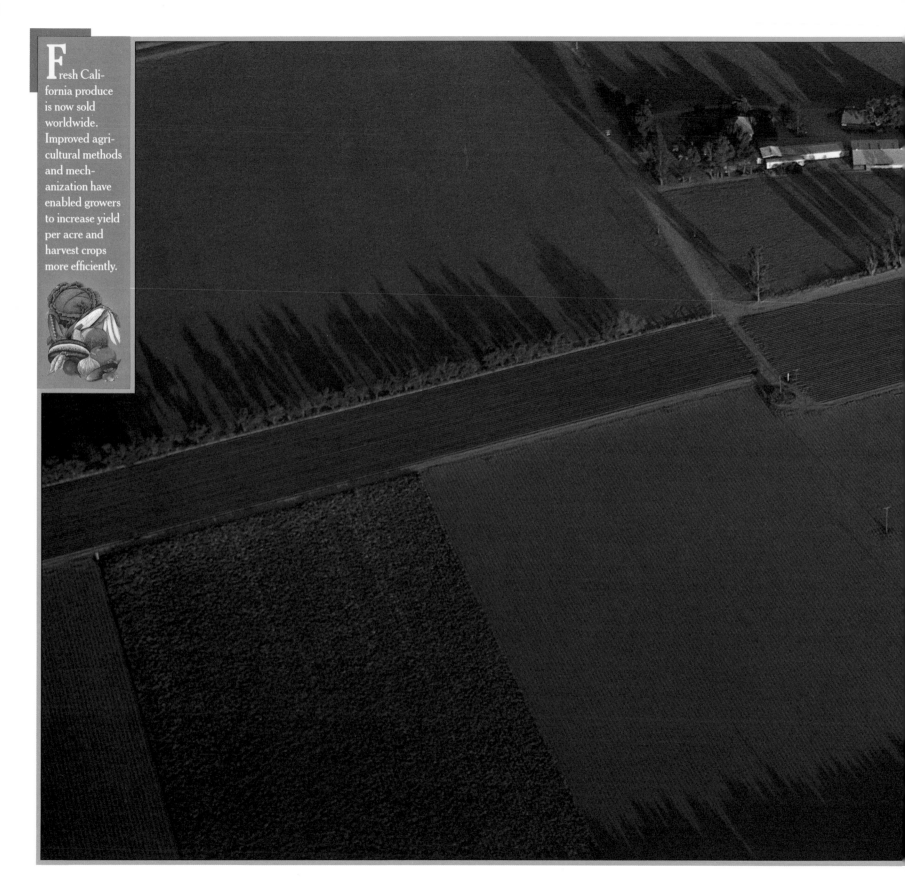

F resh California produce is now sold worldwide. Improved agricultural methods and mechanization have enabled growers to increase yield per acre and harvest crops more efficiently.

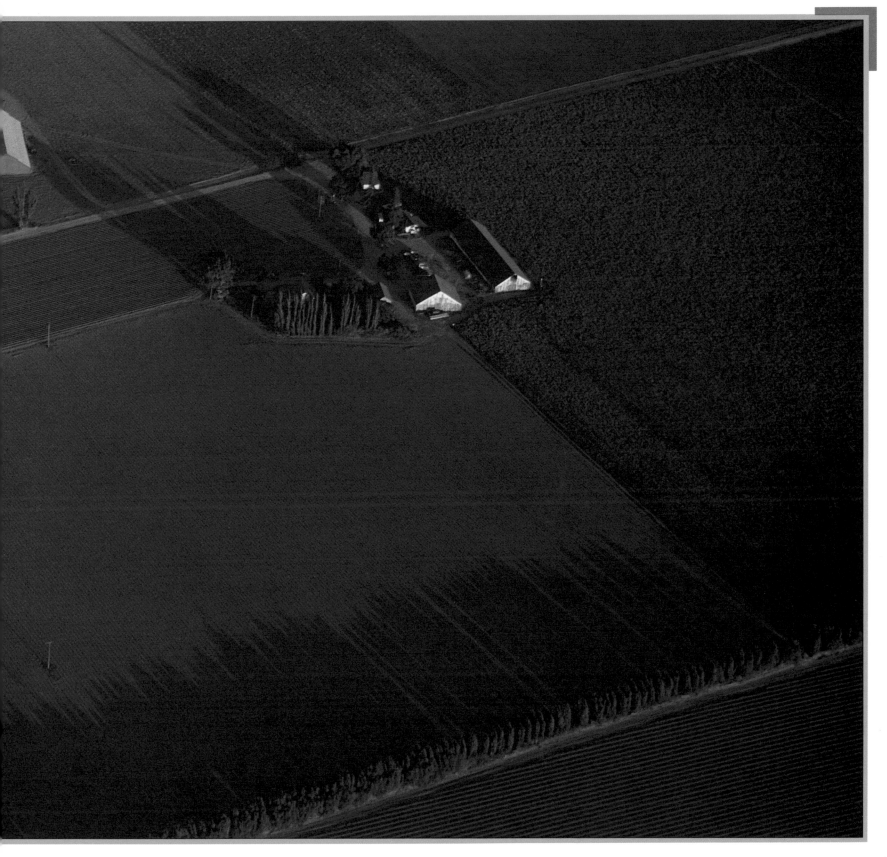

ALFALFA SPROUT

OTHER NAMES: *Medicago sativa.*

NUTRITION: *Vitamin C.*

PEAK SEASON: *Year-round.*

"Hippie fodder" is what a friend calls alfalfa sprouts, which made their appearance during the sixties.

But while most hippies have become aging yuppies, alfalfa sprouts are still "what's happening." They've endured right through punk, New Wave, and heavy metal—even to the point of being viewed as establishment food.

One reason for the popularity is that sprouts of any kind are healthful. In the sprouting process, starches are converted to easily digestible simple sugars, and the vitamin C content increases dramatically.

Alfalfa, which means "a fine green fodder" in Arabic, produces one of the tinier sprouts. Within a few days, seeds germinate to about an inch in length, with hair-fine roots and delicate green leaves.

Alfalfa sprouts are typically sold in their growing containers or in plastic bags. To buy, make sure the sprouts look fresh and crisp. Avoid any that appear soggy or limp.

To store, refrigerate. Use within a few days.

ARTICHOKE

OTHER NAMES: Cynara scolymus, *globe artichoke.*

NUTRITION: *Vitamins A and C, potassium, and calcium.*

PEAK SEASON: *60–70 percent of harvest between March and mid-May.*

For some reason, many people in the United States believe that the artichoke is one of those trendy new California vegetables, very tasty but so strange it seems like a put-on.

In truth, artichokes have enjoyed a noble history that extends back twenty-five hundred years. But even in the second century, people like Pliny the Elder thought artichokes were a put-on, too. "See how vaine and prodigal we be to serve up at our table . . . these thistles, which the very asses and other fourfooted beasts have wit enough to avoid and refuse for pricking their lips and muzzles," he jabbed.

Pliny proceeded to add that a single thistle commanded an exorbitant six thousand sesterces on the market, proving his sentiments were not widely shared.

The artichoke was considered aristocratic fare by the Romans, Greeks, and Egyptians. Perhaps because it was such a decadent food, it vanished from menus after the fall of the Roman Empire, only to reappear in Italy around the fifteenth century. Once again, it was the rage of European aristocracy. Then it faded away again in the nineteenth century, except in Italy, Spain, and France.

Italian farmers introduced artichokes to California around 1920. Today about eleven thousand acres of "chokes" are grown commercially in the state; about 85 percent of the nation's crop grows in the environs of the coastal town of Castroville, where mild temperatures keep the bracts from hardening and coming to flower. Castroville claims the title Artichoke Capital of the World.

Roughly 75 percent of the crop is eaten fresh. The rest is processed for marinated hearts and bottoms or for frozen hearts.

Artichokes are marketed in four different sizes, from about six inches to two in diameter. The large ones are more mature, with tougher bracts. The smaller ones can be eaten whole, because the bracts are still tender and the fuzzy choke, which becomes the flower, has not yet developed.

Eating a large artichoke presents a challenge to most novices. It's not exactly the best vegetable to serve for a romantic dinner date. Eating it involves breaking off each fibrous leaf with your fingers, dipping it in sauce, scraping off the fleshy bottom part of the leaf by pulling it through your clenched teeth, and then discarding the gnawed-over remains. From there, you must scoop out the fuzzy choke in the center to get at the nutty-flavored heart at the bottom. It's probably best to stick to the small artichokes that can be eaten whole with a fork until you are better acquainted.

To buy, look for globes with a nice gray-green color and no blemishes. The fall crop has a slight purplish tinge in the tips, which is natural.

To prepare the larger artichokes, trim the base so the artichoke can stand upright. Then using a scissor, cut off the sharp, pointed tips of the bracts and about an inch off the top. Rub the surface of the artichoke with a cut lemon to prevent discoloration. Boil until the leaves come loose easily.

After boiling, pull out the purple-tipped prickly leaves in the center of the artichoke, and use a spoon to scoop out the hairy choke to reveal the heart at the bottom. Serve with melted butter and lemon juice, mayonnaise, or plain yogurt blended with mustard.

To store fresh artichokes, place in a plastic bag, with a sprinkle of water to retain moisture, and refrigerate. They should keep for a week to ten days.

ASIAN CABBAGES

OTHER NAMES: Brassica chinensis, nappa, bok choy, *flowering cabbage, flat cabbage, mustard cabbage, sow cabbage.*

NUTRITION: *Vitamins A and C and potassium.*

PEAK SEASON: *Year-round.*

California is the place to come for any type of Asian cooking.

It's the gateway to the Pacific. In San Francisco alone, more than 25 percent of the residents are of Asian extraction. Naturally, you can find more Asian foods in California than in any other state in the nation. Many of the exotic Asian vegetables are part of the cabbage family.

Cabbages have been an important food source in all Asian countries since prehistoric times. Though each ethnic group has its own way of seasoning and cooking the vegetables, it is probably safe to say that most Asian cuisines combine chopped cabbages with meat and other ingredients in stir-fry and boiled dishes, or pickle the cabbages, as in the spicy Korean kimchee.

Archaeologists excavating the remains of a Yangshao farming village in Pan-p'o, northern China, unearthed Asian cabbage seeds that dated back to 5000 B.C.

Described here are three of the most commonly known Asian varieties.

Bok choy: This is sometimes called white cabbage because it has a crispy white stalk and wide green leaves. Its leaves are sturdy like romaine lettuce and its stalk tastes faintly like water chestnuts. *Bok choy* is probably the most popular leaf vegetable used in stir-fry cooking.

Nappa: Sometimes this long cylindrical cabbage is called Chinese cabbage, but *nappa*, its Japanese name, is more common. The Japanese use *nappa* exclusively, considering *bok choy* and other cabbages foreign food. Milder tasting than *bok choy*, *nappa* is frequently used in sukiyaki, *yosenabe*, and other one-pot Japanese dishes. The Koreans make kimchee from it and the Japanese pickle it in a salt brine.

Flowering cabbage: Called *choy sum* in Chinese, this is often considered the best of the Chinese cabbages.

It has yellow flowers, does not form a head, and has a mild flavor.

There are other cabbages, such as sow cabbage, baby *bok choy,* Swatow mustard cabbage, and flat cabbage, which have not found their way outside of the large Asian communities. Basically, they taste similar to other cabbages and can be cooked in the same manner.

To buy any of the Asian cabbages, look for fresh green leaves and crisp stems.

Bok choy and *nappa* will keep in the refrigerator for more than a week. When cooking, add the leafy part last, since it will soften faster than the stalk. But remember that the crunchy texture of the stalk lends interest to the dish, so don't overcook.

Choy sum is more perishable. Store in the refrigerator and use in three or four days.

ASIAN MELONS

OTHER NAMES: *Winter melon, fuzzy melon, bitter melon.*

NUTRITION: *Vitamin C.*

PEAK SEASON: *June through September.*

When Westerners think of melon, they imagine a sweet fruit, but in Asia there are several varieties of bland or

bitter melons that are used as vegetables.

Melons have been an important food to the Chinese since at least the T'ang dynasty in the seventh century. Most Americans have learned about these "vegetable" melons from eating at Chinese restaurants. There are three melons that are frequently used in Chinese cooking.

Winter melon: As large as a watermelon, it has a hard green rind that is frosted with a white coating. The flesh inside is juicy, white, and bland. Winter melon is most frequently used in soups because its almost neutral flavor picks up the taste of other ingredients. For banquets, the skin of the melon is decoratively carved and the soup itself is made in the rind, which acts as the cooking pot.

Fuzzy melon: This melon is used somewhat like a summer squash. It has a bland, spongelike texture, which absorbs whatever seasoning it receives. Try cooking it as you would a regular squash.

Bitter melon: This pebble-skinned melon deserves its name and is not for the timid diner. It has a wide following, however, and is used in foods in India, Sri Lanka, and Indonesia, among other countries.

There are several tips to keep in mind when preparing bitter melon. First, buy melons that are yellowish green; the very green ones are super bitter and the ripe yellow ones are too sweet. Second, blanch the halved melon in boiling water for a few minutes, then drain. Third, scrape the skin lightly, remove the seeds and pith, rub it with

salt, and let stand for about fifteen minutes, then wash and squeeze dry.

Outside of this advice, all I can say is that bitter melon is an acquired taste.

To buy, look for winter melons with a smooth, frosted green skin. Fuzzy melons should be fuzzy with green skin near the stem turning progressively yellower toward the tip. Bitter melons should be yellowish green.

Whole winter melons can be kept in a cool place. Mother leaves them in the garage for more than a month. Cut melons should be refrigerated and used in a week or two.

Fuzzy melon and bitter melon are more perishable. Place in the refrigerator and use within a week to ten days.

ASPARAGUS

OTHER NAMES: Asparagus officinalis.

NUTRITION: *Vitamins A and C and potassium.*

PEAK SEASON: *March through June.*

Much of California's asparagus grows in the black peat soil on the islands in the Sacramento—San Joaquin delta. Every so often a windstorm will arise when the loose soil is very dry. On those rare days you can see the black dust swirling off the asparagus fields like a tornado being born.

Peat storms were quite an event when I was growing up. If a storm hit when your windows were open, you

"Fat pullet with asparagus" was on the menu for a feast scheduled in Pompeii, but dinner was abruptly cancelled when the town became buried under the ashes of Mount Vesuvius. Wild and cultivated asparagus flourished throughout ancient Rome and Greece.

were sure to find a layer of black dust settled on everything in sight.

Still, it was a small price to pay for the treat of having the freshest, tenderest asparagus available. Asparagus, it is said, should be eaten the very day it is cut. That's when the flavor is fullest.

California provides the nation with about 70 percent of its fresh green asparagus—about 61 million pounds annually.

This member of the lily family has been cultivated for more than a thousand years. A native of the eastern Mediterranean and Asia Minor, its tender shoots were popular in the days of the ancient Greeks and Romans.

The Puritans brought "sparagrass" seeds with them to the New World, and the vegetable reportedly thrived in colonial gardens in 1672. The Puritans considered asparagus a great spring tonic, "pleasant to the taste" and "gently loose the belly," explained English herbalist John Gerard. It was also a treatment for kidney and liver ailments, heart trouble, jaundice, and bee stings.

Asparagus has a strong odor, just like its cousins, onion, garlic, and leek. Most insects are turned off by the smell, which means this vegetable can be grown relatively pest-free.

Although insects aren't a problem, harvesting is. Asparagus is not conducive to mechanical picking, so workers must cut the spears by hand. They clip the stalks about ten to twelve inches long, leaving on part of the woody portion to hold in the moisture. From there, stalks are quickly packed and placed in an icy bath to prevent rot. Asparagus is one of the most perishable vegetables on the market.

To buy, look for spears that have compact tips and good green color.

To store, refrigerate with a damp paper towel around the cut end. Break off this woody portion before cooking. Eat as soon as possible.

AVOCADO

OTHER NAMES: Persea americana, *alligator pear,* abogado.

NUTRITION: *Vitamins A, B, C, and E, potassium, iron, and magnesium.*

PEAK SEASON: *Year-round.*

Avocado has an incomparably sensuous texture. Creamy with a delicate nutlike flavor, it has the opulent feel of soft butter on the tongue.

Maybe because it tasted so sinfully rich, the avocado was considered a culinary treasure by the Aztec Indians of Mexico. Aztec emperor Montezuma II proudly presented it to Hernando Cortez in 1519, giving it a place of honor among other gifts of gold and turquoise.

Spanish sailors treasured this fruit for practical reasons. On long voyages back to Europe, they used it as a butter substitute. Avocados came to be known as "midshipman's butter" because they could be stored without refrigeration and had a creamy, naturally fresh flavor.

George Washington sampled this fruit too, on a trip to Barbados in 1751. He reportedly found the "agovago pears" abundant and very popular there and to his liking.

The avocado tree, which is related to the laurel, grows in semitropical climate. Orchards can be found from Santa Barbara down through Peru. The first avocado tree was planted in California by Henry Dalton in 1848. Today, southern California harvests about six hundred million avocados each year.

With so many avocados available, it seems hard to believe that many people around the country still consider them exotic and have never tasted one. They just think of avocado as that "green stuff" that goes into guacamole.

Actually, avocado is much more versatile. Although it is botanically a fruit that is more often used as a vegetable, it can be served with cheese and other fruits, too. Avocado halves can be topped with crab meat or chicken to make a light luncheon salad, or can be served *au natural* with a little lemon juice and a dash of salt. Sliced avocado goes well in green or fruit salads and in sandwiches, omelets, and tostadas. It can even be made into a cold soup.

Some people avoid avocado because it tastes so rich they feel it must be bad for them. The truth is that it contains eleven vitamins, five vital minerals, plus protein with all nine essential amino acids. Half an avocado has twice the potassium of a medium-size banana, which is recognized as a rich source of potassium. Avocado is low in sodium and sugar and has no cholesterol. It is recommended by the American Heart Association.

California avocados are available year-round. The Fuerte, a hearty variety that can withstand frost, is in stores from November through May. It is pear shaped with smooth green skin. The pebble-skinned Hass, which originally took root voluntarily in the backyard of Rudolph Hass, is in season from April to November. Hass is more oval in shape with purple-black skin. Other varieties are also on the market, assuring a constant, plentiful supply.

Avocados have the strange distinction of ripening only after they are picked from the tree. Most avocados are sold firm and must be softened before eating.

To buy, look for unblemished avocados, whether purplish black or green. The flavor is virtually the same. Let them ripen in a warm, dry spot like the kitchen counter until they are soft, but not mushy, to the touch. At that point, if you are not ready to use them immediately, store in the refrigerator.

BEANS, DRIED

OTHER NAMES: Phaseolus vulgaris, *lima, kidney, garbanzo or chick pea, blackeye, pink, small white.*

NUTRITION: *Protein, amino acids, vitamin B complex, iron, calcium, phosphorus, and potassium.*

PEAK SEASON: *Year-round.*

Where would the world be today if not for the common dried bean? Nutritious, nonperishable, and easy to pack, dried legumes have been the food staple of travelers for thousands of years.

Sailors ate it on their way to new worlds. Pioneers, prospectors, and the cavalry cooked up pots of beans over the campfire. Even nomadic tribes that crossed the Bering Strait into Alaska brought some along.

High in protein, vitamins, minerals, and fiber, beans have historically been considered the poor man's meat.

Different kinds of beans originated in every part of the world. In each place, they played an important role in the diet. Broad beans, also called fava or horse beans, originated in North Africa and have been common to Europe since the Bronze Age. Ancient Greek, Roman, and Egyptian aristocracy found the broad bean loathsome, but the peasants ate it regularly.

Asians prize the soybean and mung bean, which they have cultivated for thousands of years.

But it was the Americas that supplied the world with the greatest variety of beans. From Peru to Canada, explorers found Indians eating all types of beans.

Kidney beans have been excavated from pre-Incan tombs in Peru. Lima (correctly pronounced lee-ma, as in Peru, though Americans

American Indians from Peru to Canada grew a variety of beans that were unfamiliar to Europeans. Lima beans were called "little dove" by the Incas of Peru because their blossoms resembled birds in flight.

pronounce it with a long *i*) beans were called "little dove" by the Incans because their blossoms resembled doves in flight. Kidney and navy beans were indigenous to Central America. And white beans were used by New England Indian tribes to teach the colonists how to make the now-famous Boston baked beans.

California is the second largest supplier of dried beans in the nation. Although beans aren't indigenous to the state, pioneer farmers began growing them to supply the miners during the gold rush, and for several decades

thereafter, beans were the leading vegetable crop produced in California.

Dry-bean harvesting is done in two stages. In mid-summer when the pods are plump with beans, vines are cut and laid in windrows to dry. Later, a combine harvester shells the pods and scatters the thrashed vines.

Today, California commercially grows about a dozen types of dried beans, some of which can be purchased fresh during harvest season. The most common ones grown in the state are listed here.

Lima: Also called butter beans for their creamy, delicate flavor, limas come in two sizes, baby and large. Asians often use ground limas to make confections. This bean is usually sold in the frozen food section.

Kidney: There are light red and dark red kidneys. The dark ones are mostly sold in cans and used in salads. The light reds are sold dry and made into chili, refried beans, and creole dishes.

Garbanzo: A native of the Near East, garbanzos are also called chick peas. They are mostly sold in cans.

Blackeye: A favorite of the South, this white bean with a black eye is sold dry and frequently is cooked with pork and chicken.

Pink: This bean is sold dry and is often used in

Mexican cooking and in chuckwagon bean-pot dishes.

Small white: Sold dry, this is the bean that is used to make Boston baked beans. It has a firm texture that holds up well under long, slow baking.

Dried beans are normally sold in bulk. Before using, sort carefully, discarding any broken or damaged ones.

To improve digestibility (beans are sometimes blamed for causing flatulence), soak the beans for one to two hours, discard water, and rinse beans well. After slow cooking, again discard the cook water. Tests show no important amounts of essential nutrients are lost.

Generally speaking, the colored and dappled beans take longer to cook than small whites and garbanzos, and the blackeyes cook most quickly.

Store dried beans in a dry, cool place.

BEAN SPROUT, MUNG

OTHER NAMES: Phaseolus aureus, moyashi, sai dau nga choy.

NUTRITION: *Good source of protein, amino acids, vitamins A and C, and minerals.*

PEAK SEASON: *Year-round.*

There are those who believe that bean sprouts were discovered during the health-food movement of the

1960s—my exroommate, for one. I still remember the day in 1969 when she excitedly explained the virtues of bean sprouts as she prepared a mayonnaise and sprout sandwich for me. I nearly gagged.

Sprouts, as any "true" Asian will tell you, were never meant to be served with mayonnaise, or bread, for that matter.

Bean sprouts have been cultivated in Asia for thousands of years. They're used for stir-fry dishes, salads, and egg foo yung. The sprouts most commonly sold in Asian markets are from mung beans.

It takes about five days to germinate the beans, which are kept damp and in an even environment of sixty-five to seventy degrees.

Germinating the beans actually helps convert their starches into a more easily digestible form. Mung sprouts are exceptionally high in protein, as well as vitamin C.

When buying, look for crisp white sprouts, with the slightest hint of leaves emerging from the head.

Refrigerate in a plastic bag and use as soon as possible. When using, rinse lightly but leave the hull intact, since it contains both vitamins and flavor.

BEET

OTHER NAMES: Beta vulgaris, *red beet*.

NUTRITION: *Vitamins A and C, potassium, and other minerals; stalks contain vitamin A, calcium, and iron.*

PEAK SEASON: *June through October.*

Sinus problems? Try sniffing beet juice. ". . . conveyed up into the nostrils (the juice) will purge the head," advises John Gerard, sixteenth-century herbalist. Nicholas Culpeper, another authority from that period, concurs, adding that it "purgeth the head, helpth the noise in the ears and the toothache."

It probably didn't do much for the sinus sufferer's appearance, though, since beets leave a deep-red stain.

Most people prefer to partake of beets through a more traditional route.

Beet roots are believed to have been developed by German farmers in the Middle Ages. Early on, cooks used both the red root and the leaves, which were cooked as a potherb. The Russians are famous for turning beets into borscht soup.

Many people prefer to buy canned beets, because the fresh ones, though easy to cook, take so long to become tender. Large fresh beets must be boiled covered for one to two hours. Before boiling, cut off the leaves, but leave just a bit of the stems. If you cut into the bulbs, the red juice "bleeds" during the cooking. When you can easily pierce the beets, remove from the pan, peel away the outer skin (it will slip off easily), and slice. In julienne strips, beets are a colorful addition to salads. Or you can serve them alone with lemon juice or mayonnaise.

Boiled beet stalks can be served with butter and other seasonings. My family prefers to eat them with lemon juice and soy sauce.

To buy beets, choose small-sized roots with firm, smooth skin. If the leaves are attached, they should not look wilted.

To store, refrigerate in a plastic bag. Beets will keep for about three weeks.

N icholas Culpeper, a seventeenth-century apothecarist who believed the stars ruled our health, claimed that beets could cure jaundice, bloody flux, blisters, dandruff, running sores, sinusitis, and baldness.

BELGIAN ENDIVE
bel' · jen en' dīve

OTHER NAMES: Cichorium intybus, *witloof*, chicon.

NUTRITION: *Vitamins B_1, B_2, and C.*

PEAK SEASON: *November through April.*

Belgian endive is one of life's little ironies. Back in the mid-nineteenth century, economy-minded Europeans were substituting common chicory roots for imported coffee beans. As fate would have it, some chicory roots stored in a dark cellar sprouted anemic-looking leaves, which a Brussels horticulturist developed into one of the most expensive gourmet vegetables in the world.

Although they are grown in parts of California, Belgian endives are still relatively costly because they must go through a double-sprouting process. In early summer endives are planted in the ground and allowed to develop normal green foliage and strong tap roots. In the fall, plants are unearthed and leaves are cut off just above the roots. The roots are then placed upright in sand or in a hydroponic solution and stored in a dark, cool location. Deprived of sunlight, the roots produce pale, cylindrical sprouts, which are tender and crisp and have a slightly bitter taste.

Belgian endives are typically served raw in salads or braised. Although they are expensive, only a leaf or two is needed to give a salad a zesty lift.

To buy, choose crisp, tightly closed sprouts that are creamy white with yellowish green tips. Avoid any with blemishes.

Refrigerated in a plastic bag, endives will keep for two or three days. Do not cook them in an iron pan; they will turn black.

BROCCOLI

broc'cō·li

OTHER NAMES: Brassica oleracea italica.

NUTRITION: *Vitamins A and C, iron, calcium, phosphorus, and potassium.*

PEAK SEASON: *Year-round.*

Broccoli is one of the most agreeable members of the cabbage family. The flowering shoots have a much milder taste than cabbage heads.

A native of the Mediterranean and Asia Minor, it's been known in that region for nearly two thousand years. For some reason, broccoli's popularity didn't go much beyond the Mediterranean. In the eighteenth century, the English dubbed it "Italian asparagus," which sounds like a Monty Python joke, given broccoli's appearance.

In the United States, only ethnic Italians were familiar with this flowering cabbage until around 1920. Then the D'Arrigo brothers, vegetable farmers from the San Jose area, decided this was a product that had broader appeal than just with native Italians. They shipped a trial supply to Boston and from

Broccoli means "little sprouts" in Italian, but for some unknown reason, eighteenth-century Englishmen called it Italian asparagus. In the 1920s, ethnic Italian farmers in California launched a campaign to promote this flowering cabbage.

there it was an instant success story. Today, most people do not think of broccoli as an ethnic vegetable.

California produces about 96 percent of all the broccoli sold in the United States.

Green Duke is the most popular variety grown. It is a deep sage green with a purplish tinge on the buds. To buy, choose buds that are tightly closed, with compact clusters and stalks that appear tender. Do not buy any broccoli showing yellow flowers through the buds; it's

too old and will taste woody.

Broccoli is sold frozen, too, and has a good flavor, but it is so easy to cook, if fresh bunches are available, buy them. For the amount, they are slightly less expensive.

Refrigerated in a plastic bag, fresh broccoli should keep for about four days.

BRUSSELS SPROUT

OTHER NAMES: Brassica oleracea gemmifera.

NUTRITION: *Vitamins A and C, potassium, and iron.*

PEAK SEASON: *Mid-August through April.*

This cute little cabbage, which was developed in Belgium in the sixteenth century, tends to arouse strong emotions in a number of people. It's a vegetable that you either love or hate.

Like those who dislike lamb because they were forced to eat mutton, brussels sprout haters may have been prejudiced by old sprouts. Older sprouts tend to have a strong cabbagy odor and flavor and coarse texture, while the young ones are mild and delicate.

Still, it's hard to truly hate brussels sprouts if you've seen

them on their stem. The miniature cabbages look like golf balls on tall stalks. About 75 percent of the nation's supply grows within a fifty-mile radius of Santa Cruz.

To buy fresh brussels sprouts, look for small, firm, green ones. Avoid those that look puffy with yellowing leaves. With brussels sprouts, the smaller the better.

To store, refrigerate in a plastic bag. Eat within a couple of days.

BURDOCK ROOT

OTHER NAMES: Arctium lappa, gobo.

NUTRITION: *Vitamin B complex and fiber.*

PEAK SEASON: *Year-round.*

Even people who don't like Japanese foods like *kimpira,* a stir-fry dish made with carrots and burdock root, which the Japanese call *gobo.* (See recipe.)

When they ask what the uncut root looks like, however, they tend to give up on making *kimpira* themselves because *gobo* looks so rootlike. It's dirt brown, long, and ugly. Nothing you would consider eating, if you hadn't tasted it.

Most outdoors people have seen the wild burdock plant before. It's often called "beggar's buttons," because the prickly burs attach them-

selves to everything they come in contact with—animals, hikers, other plants.

Europeans in the Middle Ages were able to look beyond this thistle's irritating traits. The root was considered a treatment for gall and kidney stones, eczema, and scurvy. Infusions of the leaves were used for stomach disorders, and a leaf poultice was applied to alleviate swelling from gout and inflamed bruises. The seeds were also used for skin diseases.

Folk remedies still recommend burdock as a blood purifier and remedy for skin problems.

In Japanese cooking, only the root is used. It is added to sukiyaki, *oden,* and other one-pot meals and made into side dishes, such as the already-described *kimpira.* Burdock root is fibrous and slightly sweet. It absorbs the flavor of whatever sauce it is cooked in.

The main point to remember when cooking with fresh burdock root is to scrape off the brownish gray outer surface with a dull knife to reveal the white meat inside. If you scrape enough *gobo,* it will discolor your fingers, just like when husking walnuts from their green outer covering.

Scraped *gobo* immediately starts to lose its whiteness, so place the root in water quickly. If the root is thicker than three chopsticks together, cut it in half or quarters, or pound it lightly with a mallet if you are using it whole.

To buy, choose a long (about eighteen inches), thin *gobo* that is not branched. The fat roots are frequently as tough as twigs or corky hollow at the core. Avoid any roots that are limp and dry.

To store, refrigerate damp, but not wet, in plastic bags. Or do as Grandmother does in winter, place the root in a wet paper sack and bury it in the backyard until you are ready to use it. Refrigerated it will keep for about a week. If the ground remains damp and cool, buried *gobo* will keep indefinitely.

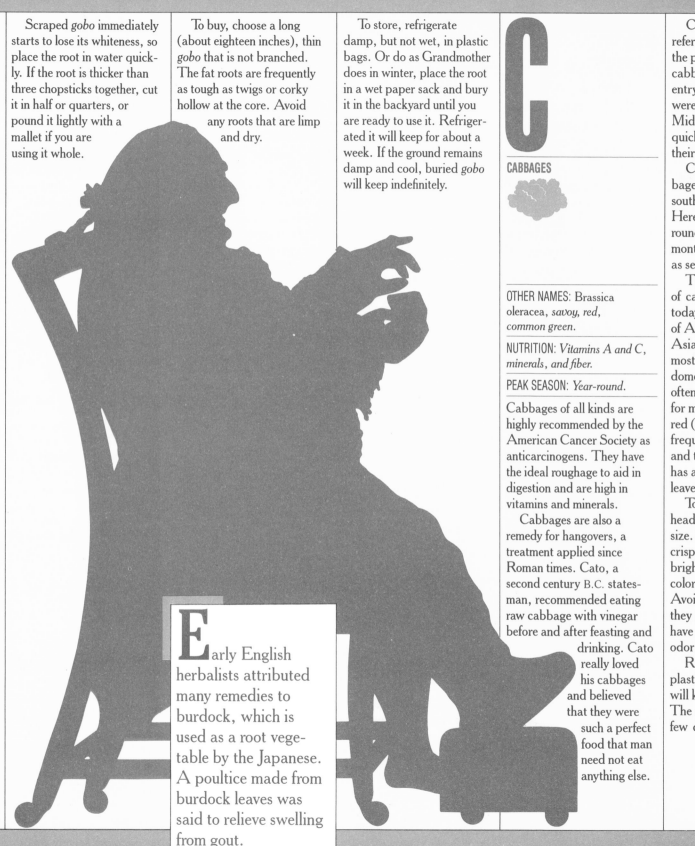

Early English herbalists attributed many remedies to burdock, which is used as a root vegetable by the Japanese. A poultice made from burdock leaves was said to relieve swelling from gout.

C

CABBAGES

OTHER NAMES: Brassica oleracea, *savoy, red, common green.*

NUTRITION: *Vitamins A and C, minerals, and fiber.*

PEAK SEASON: *Year-round.*

Cabbages of all kinds are highly recommended by the American Cancer Society as anticarcinogens. They have the ideal roughage to aid in digestion and are high in vitamins and minerals.

Cabbages are also a remedy for hangovers, a treatment applied since Roman times. Cato, a second century B.C. statesman, recommended eating raw cabbage with vinegar before and after feasting and drinking. Cato really loved his cabbages and believed that they were such a perfect food that man need not eat anything else.

Cato, of course, was referring to kale or collards, the primitive versions of cabbage. (See individual entry.) Head cabbages weren't developed until the Middle Ages, and were quickly preferred because of their storability.

California's prime cabbage-growing region is the south and central coast. Here cabbages grow year-round and, in the summer months, mature as fast as seventy days.

There are several kinds of cabbages on the market today, including a number of Asian varieties. (See Asian cabbages entry.) The most common ones are the domestic green cabbage, often used in cooking and for making sauerkraut; the red (or purple) cabbage frequently used in pickling; and the green savoy, which has a loose head, crinkly leaves, and a milder flavor.

To buy, look for firm heads that are heavy for their size. The leaves should be crisp, fresh looking, and a bright shade of whatever color the cabbage comes in. Avoid whitish, puffy heads; they are too mature and will have a strong cabbage odor when cooked.

Refrigerate cabbages in plastic bags. The firm heads will keep for a week or more. The savoy will keep only a few days.

CARDOON

cär·doon'

OTHER NAMES: Cynara cardunculus, *cardoni.*

NUTRITION: *Vitamins B complex and C and trace of protein.*

PEAK SEASON: *November through February.*

Some say that the globe artichoke descended from cardoon, and others believe that they are merely cousins. Both come from the Mediterranean region and were known during the Roman Empire.

Cardoon is an edible thistle that looks like a huge, mean celery with spiky leaves. The fleshy, whitish green midrib is the part that's eaten. The stalk is blanched in the field by covering it with cardboard.

An Italian friend says that *cardoni* is a vegetable to "die over." She serves it boiled with an anchovy sauce or topped with Parmesan cheese. It also can be breaded and deep fried. In Italy and France, it's quite a popular vegetable. Cardoon tastes mildly like artichoke.

Until recently, Italian-American farmers grew cardoon only for home use or for sale to ethnic markets, but lately it has appeared in large supermarket chains.

To buy, find a bunch with crisp white stalks.

Keep refrigerated in a plastic bag until ready to use. It will store for about two weeks. The inner stalks are tender and can be eaten raw. Pare the stringy outer fiber as you would celery. Remember that blanched cardoon discolors quickly, so add a little lemon juice or vinegar to cold water if served raw.

CARROT

OTHER NAMES: Daucus carota.

NUTRITION: *Extremely high in vitamin A and selenium. Also contains other vitamins and minerals.*

PEAK SEASON: *Year-round.*

The average American eats about ten pounds of carrots a year. Carrots have been known since the Bronze Age, but they have only been enjoyed since about the sixteenth century, because the primitive ones tasted awful.

The bright orange, sweet roots we think of as carrots

Ladies in the court of James I wore the feathery leaves of the carrot as a decorative touch in their hats. Carrots belong to the same botanical group as Queen Anne's lace, which grows wild along many country roads.

today are believed to have been developed by the Dutch in the Middle Ages. By the seventeenth century, they were cultivated all over Europe. During the reign of James I in England, ladies of the court even took to wearing the feathery leaves in their hats.

A member of the parsley family, the early carrots were considered medicinal and credited with alleviating kidney and bladder diseases, menstrual ailments, dropsy, and flatulence, among other problems.

California supplies more than 50 percent of the carrots sold in the nation.

Carrots are an excellent source of vitamin A; a single carrot far exceeds the minimum daily requirement.

To buy, choose carrots with bright orange color that don't look limp, dried out, or cracked. Slimmer carrots tend to be sweeter and have a smaller fibrous core.

To store, refrigerate in a plastic bag. Farmers call carrots "hardware" vegetables because they store for a long time. Carrots will keep for at least two weeks.

CAULIFLOWER

OTHER NAMES: Brassica oleracea botrytis.

NUTRITION: *Vitamins A and C, iron, and other minerals.*

PEAK SEASON: *Year-round.*

Pliny, the second-century Roman naturalist, described at length how a cauliflower plant produced heads one after another year-round, thereby causing its own demise. "So fruitful, until in the end her own fertility is her death," he dramatically explained. "For in this manner of bearing she spends her heart, her self and all"

Ironically, Pliny's tragic vegetable is a delicate white shade.

Cauliflower, from the Latin term meaning "cabbage flower," has been cultivated in the Mediterranean and Asia Minor for more than two thousand years. Actually, the cauliflower head is not a cluster of flower buds, as one would believe, but the tips of a mass of closely compacted stems. These chlorophyll-free stem tips are fast growing and quite tender.

Cauliflower was known throughout Western Europe by the sixteenth century; however, it didn't become an important vegetable in the United States until about 1920.

Today California grows roughly 75 percent of the cauliflower produced in the nation. Most is grown in Monterey County.

As cabbages go, cauliflower has a mild flavor, and can be served either raw with dipping sauce or cooked. You can cook a cauliflower whole (but don't eat the woody base) or cut it into flowerets.

When buying, look for "curds," as the stem tips are called, that are firm and creamy colored with no bruises.

To store, refrigerate in a plastic bag. It will stay fresh for about five days. Remember, old cauliflower takes on a strong odor and flavor.

Ancient Greek athletes on the Isthmus of Corinth vied for crowns made of celery with the same zeal that today's Olympic contenders go for the gold. In the early 1900s, celery tonic was touted as a great nerve builder.

CELERY TONIC

The Magic Elixir for Strength, Health and Vitality!!

OTHER NAMES: Apium graveolens dulce, *Pascal.*

NUTRITION: *Vitamins A and C, sodium, and potassium.*

PEAK SEASON: *Year-round.*

In the early seventies some dieters claimed that celery had "negative calories"—in other words, it burned off more calories eating it than the celery itself contained.

Apparently this was false, even though an average celery stalk has only about seven calories. This claim was just one of many miracles attributed to celery.

The height of the celery craze was at the turn of the century. There were celery soft drinks, celery gum, celery soup, and celery elixirs. Even Sears, Roebuck & Company listed a celery tonic—"a great nerve builder"—in its 1897 catalog.

A member of the parsley family, celery has been known for thousands of years. It grew wild in the Mediterranean and had a bitter taste. The Greeks and Romans, however, viewed this ancestor of today's celery as a medicine rather than a food. Wild celery reputedly acted as a stimulant, diuretic, and a tonic for hysteria. It wasn't until the sixteenth century that a milder, domesticated variety was developed in Europe. This celery was adopted as a table food and was used to flavor stews and meats.

Celery is still changing. Until the 1930s, most bunches were sold blanched white; farmers blocked out the sunlight to keep the chlorophyll from developing. Pascal, the most common variety sold today, is a healthy green shade with a crisp texture.

California supplies more than 60 percent of the nation's production. Like so many other vegetables grown in the state, harvesting is year-round, beginning in southern California in the fall and moving up the coast as the seasons change.

Celery can be eaten either raw or cooked. The outer stalks are stringy and must be pared. If you are making soups or stews, use the leaves, too. They are edible and flavorful.

Buy bunches that are crisp with fresh leaves. In plastic bags, they will keep in the refrigerator for about two weeks.

CHAYOTE
cha·yo'·tay

OTHER NAMES: Sechium edule, hop jeung gwa, *mirliton*, choko, *christophene*.

NUTRITION: *Protein*.

PEAK SEASON: *Year-round*.

Chayote is a curious vegetable. It's a tropical summer squash that was grown by the Aztecs and Mayans in Mexico long before the discovery of the New World.

The Spanish explorers took it back to Europe and, from there, introduced it to parts of Asia. In tropical areas, chayote is a familiar gourd. It's eaten in Latin America, Australia, Indonesia, the Caribbean, North Africa, China, and the southern United States.

Chayote has one large seed and is shaped like a deeply ridged papaya. To the Chinese, chayote resembles the hands of a praying Buddha. Buddhist monks grow this gourd, perhaps because of its religious symbolism.

Until recently in the United States, chayote was thought of as a Mexican or Chinese vegetable, or as a special squash used in creole food. Now it has become

Most cultures eat the gourd of the chayote, however, other parts are useful, as well. The root swells up like a sweet potato and tastes vaguely like yam. The spring shoots can be eaten like asparagus. And the plant fibers can be woven into baskets.

one of those "new discovery" vegetables, the latest curiosity in the local supermarket.

In tropical regions, this sprawling vine is an evergreen, but in California it is a perennial, renewing itself each spring.

Chayote has a bland taste and firm texture and can be used much like any other summer squash. It needs fairly strong seasoning. In New Orleans, chayote, or mirliton as it is called there, is often boiled, then the inside flesh is scooped out, mashed, combined with seafood or meat and seasonings, and stuffed back into the shell. Chinese recipes sometimes call for it to be cubed and added to soup.

To buy, choose firm, young chayote with a nice pale green color. The young gourds have tender skin that need not be peeled.

To store chayote, refrigerate in a plastic bag. It should keep for two to three weeks.

CORN, SWEET

OTHER NAMES: Zea mays, *maize*.

NUTRITION: *Vitamins A and C, protein, amino acids, minerals, and carbohydrates*.

PEAK SEASON: *June through October*.

Corn is the only cereal native to the Americas. It also goes by its Indian name maize, meaning "bread of life." Indian cultures from the Iroquois of the Great Lakes and the Zunis of the American Southwest to the Mayans and Aztecs of Mexico and the Incas of Peru prized this cereal as the sustainer of life.

At Machu Picchu, the Incas built life-size corn plants of silver and gold and housed them in temples.

The harvesting of corn was cause for ritual celebration. The Aztecs, who believed that corn ears were phallic symbols of fertility,

would ceremoniously tear out the heart of a handsome male prisoner to appease the corn goddess.

Perhaps to convince the goddess that she wasn't receiving a pathetic victim in return for her ears of corn, the Aztecs crowned the prisoner with a wreath of roasted corn ears and named him "God of the Gods." He was treated like a king for an entire year. In his final days, he was even given four "wives" for his pleasure. Then, in symbolic exchange, the priests ripped his heart out as one would husk corn.

The Aztecs also sacrificed young girls, but girls weren't treated as royally.

Among scientists, corn has the distinction of coming

During World War I, Herbert Hoover, who was in charge of relief efforts, considered sending corn as emergency food to Allies in Europe, but gave up the plan because Europeans considered corn nothing more than chicken feed.

from dubious ancestry. Although botanists have been able to find wild forms of almost every domesticated vegetable, corn is the exception. The question of corn's parentage is still not conclusively resolved.

When Columbus' men found natives growing corn in Cuba, they described it as "a grain they call maize, which is well tasted, bak'd, dryed and made into flour."

The Europeans did none of that when it was introduced to the Old World. Corn was used mainly as chicken feed. Even today, only a few European dishes, such as the Italian specialty called *polenta*, are made from corn.

Certainly corn on the cob is an all-American food, but

it is a fairly recent one. Sweet corn is a hybrid that wasn't developed until about the mid-nineteenth century. Before then, corn was not commonly used as a vegetable, but as a grain.

California is not the nation's leader in corn, as any Iowan will firmly tell you. The state does, however, grow several varieties of sweet corn.

If at all possible, buy corn from a local source and eat it the day it is picked. As soon as the ear is torn off the stalk, its sugar begins converting to starch. Anyone who has tasted old corn knows that it's bland, gummy, and sticks to the teeth. Fresh-picked corn can be eaten raw, or after boiling for a few minutes. It is sweet, tender, and unbelievably succulent.

Buy corn only when it is in season. Check for ears with fresh green husks and golden, but not dry, silk threads. If your greengrocer isn't looking, peel the husk back slightly to see if the kernels look young.

When corn is out of season in your area, buy it frozen, either on the cob or in kernel

form. Because it is processed immediately before it turns starchy, frozen corn is usually very good.

As far as storage goes, the word is don't. Use fresh corn the day you buy it. Keep it in the refrigerator until you are ready to cook it.

CUCUMBER

OTHER NAMES: Cucumis sativus.

NUTRITION: *Small amounts of vitamins and minerals.*

PEAK SEASON: *May through early September; hothouse varieties are available year-round.*

If you're stranded in the desert with only one vegetable to eat, let it be a cucumber. It's 96 percent water.

Ever since cucumbers were discovered in India and Egypt about three thousand years ago, they have been used to quench thirst. The pharaohs fed them to the slaves building the pyramids in the hot sun. Desert caravans carried a provision of whole cucumbers for refreshment. The Bible tells that the exiled children of Israel yearned for the cucumber's cooling taste. Its smooth skin stores moisture like a jug.

In Japan one of the most famous folk tales is about a *kappa*, an amphibious creature that loved cucumbers. The *kappa* had a saucer-shaped head that had to be

kept filled with water. The creature was quite polite and harmless, unless deprived of its ration of cucumbers. To keep the *kappa* satisfied, every summer mothers would toss a token cucumber into the swimming hole so the creature wouldn't seize their children in anger. At sushi bars today, the cucumber roll is nicknamed *kappamaki*.

Over the centuries, a variety of lotions, ointments, and home remedies have been concocted to utilize cucumber's moisture-retention properties. It's said to soften skin, soothe tired eyes, and alleviate sunburns. Try a slice of cucumber over each eye after a long day; it takes away the burn.

Of course, cucumbers are good as food, too. They add a refreshing touch to salads, are indispensible as pickles, and wonderful as a cold summer soup.

This member of the squash-gourd family is easy to hybridize. It comes in a range of sizes and shapes, from the fifteen-inch long Japanese cucumber to the round yellow lemon cucumber and the tiny pickling variety.

When buying, choose firm, medium-sized cucumbers with bright green skin. Avoid the jumbo sizes, which are typically older and have larger seeds and a drier texture.

Do not peel or slice a cucumber until you are ready to use it. The skin holds in the moisture. Refrigerated in plastic wrap, it should keep well for about a week.

D

DAIKON
die'·kone

OTHER NAMES: Raphanus sativus longipinnatus.

NUTRITION: *Vitamins A, B₁, B₂ and C, calcium, and iron.*

PEAK SEASON: *Year-round.*

If you're going to eat lots of rice, you have to eat daikon, the Japanese say. Daikon, which translates as "large root," contains diastase, an enzyme that aids in the digestion of starches. Being a rice-loving people, the Japanese make this white radish a part of their daily diet.

Daikon grows to about eighteen inches long and has a juicy, slightly peppery flavor.

The Japanese have at least a hundred ways to cook with daikon. Raw, it can be grated and eaten with fish or meat. It's added to *miso* (fermented bean paste) soup. It's used to make flowers for a garnish, and is that stringy white stuff that's put with *sashimi* (raw fish) in Japanese restaurants. It can be shredded with carrots and dressed with a sweet vinaigrette for a salad. Or it can be cut into chunks and put in stews. A nice characteristic of daikon is that while it will get soft when cooked, it won't dissolve.

Takuan, pickled daikon, is as popular in Japan as pickled cucumbers are in America. In the seventeenth century, Priest Takuan invented a method of drying daikon in the sun and then preserving it in rice bran and salt by pressing the mixture with a heavy stone. Some say that Takuan's tombstone is shaped just like the pickling stone.

Until a few years ago, daikon was sold only in bunches, because it was assumed only Asians were buying it. Today it can be bought by the single root or even a half root.

When buying, look for firm radishes with smooth white skin. Remember, the summer crop is usually a bit spicier than the winter crop because it gets less water.

To store, refrigerate in a plastic bag. It should keep crisp for more than a week.

E

EDIBLE CHRYSANTHEMUM

OTHER NAMES: Chrysanthemum coronarium, *garland chrysanthemum*, shungiku, tong ho.

NUTRITION: *Vitamins B and C and minerals.*

PEAK SEASON: *Late August to early March.*

Chrysanthemum is not only Japan's national flower; one variety is a very popular vegetable.

The edible chrysanthemum is called *shungiku* by the Japanese or chop suey greens and is harvested for its aromatic leaves and flower buds. Since the buds are sold unopened, it's not an attractive plant. The Japanese treat it as a leafy vegetable, serving it alone as a side dish like spinach or combining it with meats and other vegetables. The flavor is quite strong, so cook it before eating.

If *shungiku* isn't available, you can substitute ordinary garden chrysanthemum leaves. The leaves can be dipped in batter to make tempura. Flower petals can also be blanched and added to salads. Actually, the petals don't have much flavor, but they do have great color.

Shungiku is sold in bunches in Asian markets. To buy, pick the ones with firm leaves and tightly closed buds. Avoid any bunches that look wilted or yellow.

Refrigerate in a plastic bag. Use within about four days.

EGGPLANT

OTHER NAMES: Solanum melongena, *aubergine*, nasubi.

NUTRITION: *Small amounts of vitamins and minerals.*

PEAK SEASON: *July through August.*

This native of India is part of the so-called deadly nightshade family, which includes potatoes and tomatoes. It was introduced to Europe in the thirteenth century, brought in via the Middle East along the silk route from China.

The Arabs, who received this "egg fruit" from China around the fourth century, probably have the greatest number of ways of preparing it. In fact, it's considered part of the "bride price" to have a repertoire of dozens of eggplant recipes. In Turkey there's a dish called *imam bayeldi*, which is stuffed eggplant simmered in olive oil. Translated as "swooning *imam*," it is said that when the religious leader's wives served this dish, he swooned in ecstasy.

The French, who call eggplants *aubergine*, are famous for their *ratatouille*, a tasty vegetable stew consisting heavily of eggplant.

Most people in the United States are familiar with the large, purple globe eggplant. There are several other varieties, including long, oval ones that the Japanese call *nasubi*.

There are also small egg-shaped white varieties, which may explain how the vegetable got its name.

Eggplant was part of the cargo that came into Europe via the Middle Eastern silk route. At first it was greeted with distrust. The Italians called it a mad apple, and herbalist John Gerard claimed it had "mischievous qualities."

Eggplants are sort of spongy and bland, which make them exceptionally versatile. They absorb the flavor of whatever they are cooked with, while supplying a certain bulkiness that acts as a meat "extender."

To buy, look for eggplant with taut, shiny skin. Old eggplants develop bitter skins and tough seeds.

Refrigerated in a plastic bag, eggplants will keep for about five days.

ENDIVE AND ESCAROLE

OTHER NAMES: Cichorium endivia crispa, *curly-leaf endive;* Cichorium endivia latifolia.

NUTRITION: *Vitamin A and iron.*

PEAK SEASON: *Year-round.*

Escarole and endive are like fraternal twins, which creates some confusion.

Although they look like they belong to the lettuce family, botanically they are chicories. And, being chicories, both are slightly pungent.

Endive grows in a loose head and has crisp, curly, ragged-edged, narrow leaves. The outer ones are green, becoming progressively yellower toward the heart.

Escarole is a broad-leaved endive. Its leaves curl a bit and its heart is a pale yellow, too.

The two are related to the Belgian endive, also called witloof, which is a blanched broad-leaved chicory sprout, but their relationship is very distant.

Produce stores sometimes mark endive as escarole and both as chicory, and it all gets very confusing, especially if you have sent someone else to do the shopping and he or she doesn't know which one you meant.

Endive and escarole date back to ancient times. In France, however, they weren't considered a food until about the fourteenth century.

Europeans often add these leaves to soups and other cooked dishes, but in the United States, they are mostly used raw in salads.

To buy, look for tender, crisp leaves with no sign of wilting.

Refrigerated in plastic bags, they will keep for about three days.

ENOKITAKE MUSHROOM
ē' · no · key · tah · kay'

OTHER NAMES: Flammulina velutipes, *snow puff, golden needle.*

NUTRITION: *Vitamins B and C, potassium, iron, and phosphorus.*

PEAK SEASON: *Year-round.*

I was first introduced to this delicate white mushroom in Kyoto, Japan, several years ago. A friend brought out a huge bowlful of enokitake, which she added to sukiyaki. These mushrooms had such a wonderful silky texture that, much to the astonishment of my host, I proceeded to eat about a pound of them, ignoring everything else on the table.

Enokitake are enchanting to look at. They have tiny caps and spaghetti-thin stems, joined in a cluster at the base.

In the mid-1970s, a Japanese-American farmer in the Fresno area began cultivating this mushroom for the American market. The mushroom is spawned in a sterilized mixture of rice bran, water, and sawdust in a dark, temperature-controlled room.

Enokitake mushrooms have become an intriguing new addition to California cuisine. They appear in salads or as a garnish at fancier restaurants. Raw enokitake have a crisp, mild flavor.

In Japanese cooking, these mushrooms are added to one-pot dishes, like sukiyaki, *mizutake*, and *shabu shabu*, or are floated in clear soup. When cooking, be sure to put them in last because they will toughen if overcooked. At Japanese markets, you can also find enokitake that have been preserved in a sweet sauce.

Enokitake are sold in three-and-a-half-ounce clusters in plastic wrap. They are sensitive to environmental changes, so check the stems to see that they are not turning brown and soggy.

Store the mushrooms in their original plastic wrap in the refrigerator. Kept cold, they should remain fresh for about five days.

Before using, trim off the fibrous base and separate the stems.

F

FENNEL

OTHER NAMES: Foeniculum vulgare, *finocchio*.

NUTRITION: *Vitamin A, potassium, and calcium.*

PEAK SEASON: *October through May.*

Fennel tastes like licorice and looks like a celery gone berserk.

Finocchio, or Florence fennel, a native of Italy, is the variety eaten as a vegetable. Shorter than common fennel, which grows wild in parts of California and is collected to make dried-flower arrangements, finocchio has feathery leaves and a swollen base, which is firm, white, and crisp.

In Mediterranean countries, fennel is a common vegetable, known since the time of the ancient Romans.

Thought to be medicinal, fennel has been used at varying times as an infusion for the eyes and as an herb to increase the milk supply of nursing mothers.

Fennel is a winter vegetable, available from about October through May. It can be eaten raw, served with a little salt and pepper and olive oil, or boiled and served hot with butter or Parmesan cheese.

To buy, choose crisp, firm bulbs with fresh-looking leaves. Refrigerate in a plastic bag. They will keep for about four days.

G

GARLIC

OTHER NAMES: Allium sativum.

NUTRITION: *Trace minerals; however, credited with many medicinal values.*

PEAK SEASON: *May through June, and late August.*

You don't need a road map to find the annual garlic festival in the little town of Gilroy just south of San Francisco. Just follow your nose. You can smell the aroma, or odor, depending on how you feel about the pungent herb, from miles around.

Ninety percent of the garlic in the United States comes from California, much of it from Gilroy, the self-proclaimed Garlic Capital of the World.

This member of the onion family has been cultivated in nearly every part of the globe for thousands of years, and has been controversial just as long.

Believed to have originated in Siberia, garlic was said to keep away evil spirits and vampires. Although Horace detested the smell, other Romans and Greeks valued this tiny bulb for its energy-giving powers. The Romans considered it an aphrodisiac. The Egyptians fed it to their slaves. A few garlic cloves were even found in King Tut's tomb. In Europe, garlic was introduced by the Crusaders returning from the Holy Land.

Folk medicine attributes dozens of remedies to this herb. Many of its reputed medicinal properties have survived the test of science over the centuries. Garlic is said to act as a purgative to the gall bladder and liver, alleviate asthma and rheumatism, and serve as an antiseptic, among other remedies. Recently there is mounting evidence that garlic aids in reducing high blood pressure. If nothing else, it is a wonderful substitute seasoning for those on low-sodium diets.

Certainly garlic's antiseptic properties have been substantiated. During World War I, England used tons of garlic to cleanse wounds.

Even without all these wonderful medicinal claims, alliophiles (garlic lovers) cherish this lily bulb because it imparts a delicious flavor to any dish. It is the seasoning of choice for most gourmets. The fragrance of garlic enhances casseroles, meats, and salads, and serves to stimulate the appetite.

In California, several million tons of garlic are harvested each summer. After the bulbs are lifted from the ground, they are left in the sun to cure. The papery sheath that forms around each clove retains moisture and flavor.

When buying, pick plump bulbs with clean tissuelike skin. Avoid bulbs that are soft, spongy, or shriveled. Also, avoid those that are stained or sprouting on top. Each bulb should have about ten to twelve cloves.

Do not refrigerate garlic or store it in plastic. Keep in a cool, dry, well-ventilated place. Or preserve garlic cloves in olive or vegetable oil. Refrigerate the preserved garlic for up to three months.

In days of old, people hung garlic wreaths in their homes and wore cloves around their necks to ward off evil spirits and disease. The Balkans rubbed garlic on their doorknobs and window frames to discourage vampires.

GREEN BEAN

OTHER NAMES: Phaseolus vulgaris.

NUTRITION: *Vitamins A and B, potassium, and magnesium.*

PEAK SEASON: *Year-round.*

From Peru to Canada, the Indians of the Americas cultivated varieties of beans, some of which they ate green in their pods.

These green beans, which are often called snap or string beans, became an instant hit with colonists. John Josselyn wrote in the seventeenth century, "Indean beans, falsely called French beans, are better for Physic and Chyrurgery than our garden beans."

John Gerard wrote in *Herball*, published in 1597, that "boiled in their pods before they are ripe, and buttered, they do not engender wind, but make a delicate meat. They loose the belly, provoke urine and ingender good bloud."

If anything, green beans have increased in popularity over the centuries. They are one of the "safest" vegetables to serve guests with finicky taste.

To buy, pick out those with smooth, crisp pods and almost invisible seeds. Beans should be green and blemish-free.

To store, refrigerate in a plastic bag. Fresh green beans will keep for about four days.

H&J

HORSERADISH

OTHER NAMES: Armoracia rusticana, *red cole.*

NUTRITION: *Vitamin C.*

PEAK SEASON: *April through May, and October through early December.*

Horseradish, which is part of the mustard family, was considered a drug before it became a condiment.

Believed to be native to east-central Europe, the peppery root was used to expel worms from children, quell persistent coughs from influenza, stimulate the whole nervous system, and cure scurvy. Its high sulphur content made it a good plaster to treat rheumatism, gout, and other aches.

Apparently, the Germans were the first to treat horseradish as a condiment, slicing it thin and mixing with vinegar to eat with meat and fish.

This practice caught on in England and France in the seventeenth century.

Today grated horseradish mixed with vinegar is a popular condiment for prime rib, corned beef, and other meats. Added to tomato sauce, it's used as a seafood dip.

Horseradish has to be grated or somehow bruised to release the volatile oil that gives it a hot flavor. Exposed to air, the root loses some of its pungent strength.

In California, horseradish has been grown in the Tule Lake marshlands since around the end of World War II. The cold climate and four-thousand-foot-high elevation of this northern California region help develop what is considered the whitest, finest-fleshed, and most fiery horseradish grown in North America. Tule Lake growers claim that the area's short growing season and hard frost bring out the intense flavor of the root.

Fresh horseradish root is usually sold in grocery stores around Passover, since it is considered one of the seven bitter herbs used in Jewish religious observances.

To use fresh horseradish, peel off the outer skin and grate the root. Be careful; the sting is worse than peeling onions.

Most people prefer to buy prepared horseradish in bottles, which is wise, unless you like the pain of grating it. I used to watch a neighbor grate fresh horseradish and he would sit there, crying and grating and exclaiming how wonderfully powerful it was. To each his own.

The prepared kind will keep for months in the refrigerator. Its potency, however, diminishes with time.

Fresh horseradish root can be kept in the refrigerator for a month or longer, or stored in the freezer indefinitely.

JERUSALEM ARTICHOKE

OTHER NAMES: Helianthus tuberosus, *sunchoke.*

NUTRITION: *Vitamin B, iron, phosphorus, and insulin.*

PEAK SEASON: *October through March.*

Jerusalem artichoke is a victim of gross misrepresentation, which probably explains why it hasn't been widely embraced as a food.

It all started back in 1605, when Samuel Champlain saw the Indians on Cape Cod growing this tiny gnarled tuber. He described it as tasting like a globe artichoke, which is in the thistle family.

Champlain took the root back to Europe, where it was cultivated in Italy, among other countries. The Italians called it *girasole,* meaning "turning to the sun," because its yellow blossom acted like a sunflower.

The English somehow managed to pronounce *girasole* as "Jerusalem," and hence we end up with the name Jerusalem artichoke. The English also called the tuber "potato of Canada," apparently not realizing that Cape Cod was farther south.

In the seventeenth century, Jerusalem artichokes were quite familiar and it was not necessary to explain that they were not an artichoke or a potato or from Jerusalem. "Boiled tender, peeled, sliced and stewed with butter and wine, they were esteemed a dish for a Queene," noted apothecarist John Parkinson in 1629.

Common in colonial days, Jerusalem artichokes disappeared from menus in the United States more than a century ago.

Then, sometime in the 1960s, Frieda Caplan, a southern California food wholesaler, reintroduced this native Indian tuber to the marketplace. Caplan spiffed up its image by renaming it "sunchoke" because it is part of the sunflower family.

Sunchokes look a bit like a ginger root knob in size and color and can be cooked like a potato. The thin brown skin can be peeled or left on. Eaten raw, the sunchoke has a nutty flavor and a crunchy texture like a water chestnut.

To buy, choose small, firm tubers with clean skin and no blemishes. Store dry in the refrigerator or in a cool place. Moisture will cause them to mold. Raw Jerusalem artichokes will keep for about a week.

JICAMA
he' · ka · ma

OTHER NAMES: Pachyrrhizus erosus; *yam bean root*, sa gord.

NUTRITION: *Vitamins A, B, and C, calcium, and phosphorus.*

PEAK SEASON: *August through October.*

California's large Mexican population undoubtedly introduced jicama to the state. In Mexico, it is served raw as an appetizer with a little lime juice, chili pepper, and salt. Jicama, which is called *sa gord* in China, has been part of the Asian diet since the seventeenth century, when it was introduced into the Philippines by the Spaniards. The Chinese use it much like water chestnuts in stir-fry dishes.

Jicama is a surprisingly versatile tuber. Eaten raw it has a sweet, crisp flavor. It goes well in both vegetable and fruit salads. Or you can bake, boil, or braise it, add it to stews like turnip, or shred it and sauté it in butter.

Jicama is one of the ugliest vegetables you'll ever see. Sandy brown, shaped like a hot-air balloon, and weighing from one to six pounds, you'd never retrieve it from the ground if you weren't aware of its great taste.

The jicama plant is a member of the morning glory family. The leaves and ripe seedpods are slightly toxic and narcotic. To get the edible jicama tuber to develop underground, you must keep pinching the delicate flowers from the vine. Each plant produces one tuber.

When buying jicama, choose small ones that are solid and without blemishes. Small, young jicama are more tender and flavorful.

To prepare, remove the brown outer skin, which is tough and fibrous. If you plan to eat the jicama raw, cut the white fleshy meat into sticks about the size of french fries. If you've chosen a good jicama, you'll become a fan for life.

Unpeeled jicama will keep in the refrigerator for at least two weeks. Do not cut until you are ready to serve because it will dry out.

KAIWARE DAIKON
kai' · wah · le die' · kone

OTHER NAMES: Raphanus sativus.

NUTRITION: *Vitamin C.*

PEAK SEASON: *Year-round.*

Kaiware daikon is Japan's answer to alfalfa sprouts. This trendy Asian seed sprout is making a hit in Japanese markets and gourmet restaurants in California.

Kaiware daikon means "broken clam radish," probably because the tiny green leaves vaguely resemble a clam shell if you stretch your imagination w-a-a-a-a-y out.

These sprouts have a tangy, mustardy bite, and are terrific with *sashimi* (raw fish) and meat or on a sandwich.

Seventeenth-century French explorers found Indians at Cape Cod growing Jerusalem artichokes. They took the roots to Europe where they were first esteemed a dish for a queen, then later despised because they grew so prolifically.

The seeds are easy to sprout. You can grow them on a clean damp sponge in the kitchen. One tablespoon of seeds produces about three-fourths cup of sprouts. Sprouts are usually harvested when they are about two to four inches long.

In Asian markets, kai-ware daikon is sold in sealed plastic packages. Refrigerate immediately. It will keep for about a week.

KALE AND COLLARDS

OTHER NAMES: Brassica oleracea acephala, *Chinese kale.*

NUTRITION: *Vitamins A, B, C, and E, iron, calcium, potassium, and phosphorus.*

PEAK SEASON: *December through April.*

Before cabbages developed heads in the Middle Ages, there were kale and collards, which are essentially the same. The difference is that kale has curly leaves, while collards has broad smooth ones.

When the ancient Romans and Greeks mentioned cabbages, they were talking about the loose-leaf kale, which originated in Asia Minor and proliferated in the Mediterranean.

Invading Celts took the leafy vegetable home to northern Europe, and the Vikings carried it to Scotland, where the Scots gave it the name kale.

In recent decades, kale and collards have been snubbed as the humble food of sharecroppers. Too bad, because they are inexpensive and are very high in vitamins and minerals.

Kale and collards are "macho" vegetables that thrive under adverse conditions and actually increase their sugar content when exposed to a little frost. They are usually sold fresh in the winter months.

Chinese kale is also sold during the cooler seasons. Called *gai laan,* it looks and tastes more like broccoli and, in fact, is often called Chinese broccoli. It forms a stalk with oval leaves and white flowers. The Chinese stir-fry it, but it can also be prepared just like broccoli.

To buy kale and collards, look for crisp, green, tender leaves. Avoid any that are turning yellow or wilted.

Refrigerate in plastic bags. They will keep for about five days.

KOHLRABI

kōhl·rä′bi

OTHER NAMES: Brassica oleracea.

NUTRITION: *Vitamin C, potassium, calcium, and magnesium.*

PEAK SEASON: *June and July.*

A kohlrabi looks like a vegetable from outer space. It's an anemic-green bulb with gangly tentaclelike stems sprouting from all sides.

Kohlrabi, however, is not extraterrestrial. It originated in northern Europe and, as its German name implies, this cabbage-turnip is a member of the cabbage family.

Although kohlrabi looks like a root, it is actually the swollen base of the stem from which leaves sprout. The bulb can get as fat as a grapefruit, but it's best to buy it when it's about the size of an orange. The big bulbs tend to be older, more woody in texture, with a very fibrous outer skin. If the skin turns out to be tough, peel it off. Most stores sell kohlrabi bulbs without the leaves and stems. If you are lucky enough to find them attached, they are edible, too.

Kohlrabi can be eaten raw, steamed with butter, or cooked in broth.

Refrigerated in a plastic bag, it will keep for about a week.

L

LEEK

OTHER NAMES: Allium porrum.

NUTRITION: *Vitamin C, calcium, phosphorus, and potassium.*

PEAK SEASON: *September to November, and May.*

To the Welsh, leeks have a special meaning. It's the emblem of Wales, which commemorates the victory of King Cadwallader over the Saxons in A.D. 640. To keep from shooting each other in battle, the Welsh soldiers wore leek leaves in their hats to distinguish themselves from the enemy. Each year on St. David's Day, Welshmen wear leeks to celebrate the victory.

The ancient Egyptians and Romans ate a kind of leek, too. Emperor Nero, who took his musical talents seriously, is said to have eaten leek every day to improve his singing voice.

Leeks apparently improved other areas as well. John Parkinson, a seventeenth-century apothecarist, prescribed that "the greene blades of Leekes being boyled and applied warme to the Hemorrhoids give a great deal of ease." This folk remedy has not withstood the test of time, however.

The leek looks more like its kin, the lily, than its cousins, onion and garlic. It also looks a bit like a monstrous green onion and has a mild onion flavor.

In France, the leek is called the poor man's asparagus, but in the United States, it is mostly thought of as something that goes in soup.

Leeks can be used in a variety of ways — braised, boiled, or snipped into salads. The key is not to overcook them because they turn mushy and slimy.

To buy, find leeks that are blanched white at the base and have tightly rolled leaves with nice pale green color.

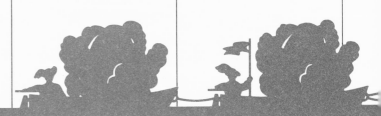

Leek layers tend to hold soil, so cut off the unusable upper portion, remove the tough outer leaves, split lengthwise, and rinse thoroughly.

It is preferable to use this vegetable as soon as possible. But refrigerated in a plastic bag, it will keep for two or three days.

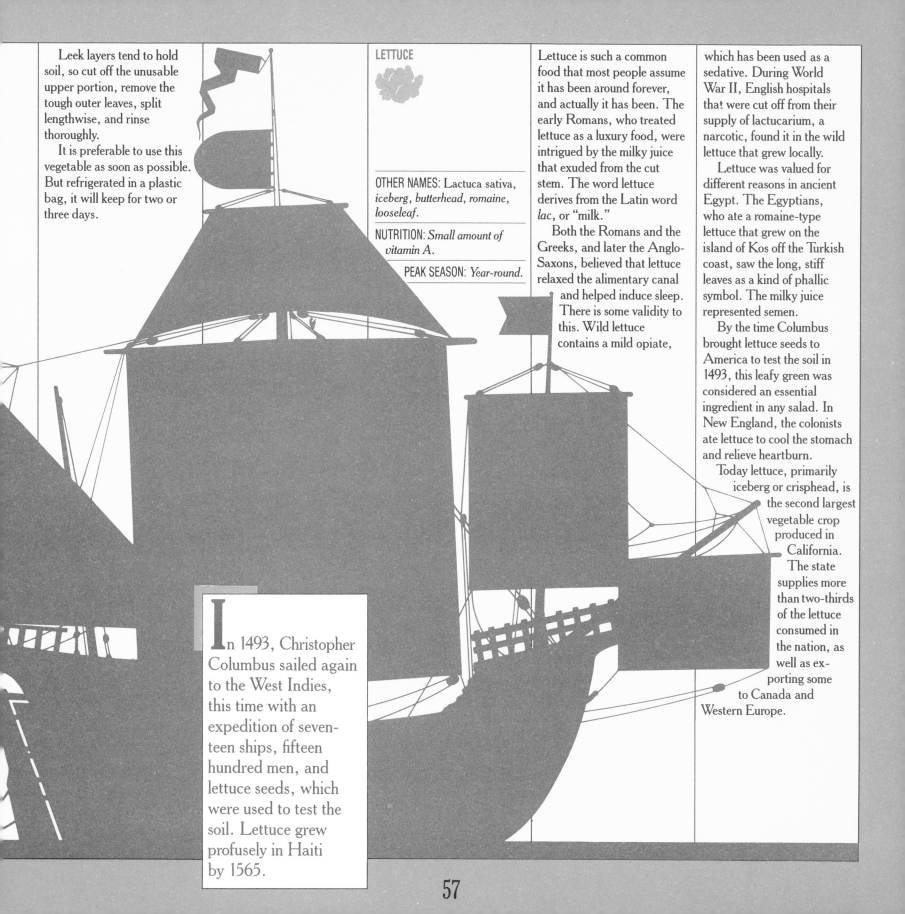

LETTUCE

OTHER NAMES: Lactuca sativa, *iceberg, butterhead, romaine, looseleaf.*

NUTRITION: *Small amount of vitamin A.*

PEAK SEASON: *Year-round.*

Lettuce is such a common food that most people assume it has been around forever, and actually it has been. The early Romans, who treated lettuce as a luxury food, were intrigued by the milky juice that exuded from the cut stem. The word lettuce derives from the Latin word *lac*, or "milk."

Both the Romans and the Greeks, and later the Anglo-Saxons, believed that lettuce relaxed the alimentary canal and helped induce sleep. There is some validity to this. Wild lettuce contains a mild opiate, which has been used as a sedative. During World War II, English hospitals that were cut off from their supply of lactucarium, a narcotic, found it in the wild lettuce that grew locally.

Lettuce was valued for different reasons in ancient Egypt. The Egyptians, who ate a romaine-type lettuce that grew on the island of Kos off the Turkish coast, saw the long, stiff leaves as a kind of phallic symbol. The milky juice represented semen.

By the time Columbus brought lettuce seeds to America to test the soil in 1493, this leafy green was considered an essential ingredient in any salad. In New England, the colonists ate lettuce to cool the stomach and relieve heartburn.

Today lettuce, primarily iceberg or crisphead, is the second largest vegetable crop produced in California. The state supplies more than two-thirds of the lettuce consumed in the nation, as well as exporting some to Canada and Western Europe.

In 1493, Christopher Columbus sailed again to the West Indies, this time with an expedition of seventeen ships, fifteen hundred men, and lettuce seeds, which were used to test the soil. Lettuce grew profusely in Haiti by 1565.

Such a broad market came about because the shipping problems that existed a century ago have been largely solved. For lettuce growers, one of the most poignant scenes in the movie *East of Eden* was when Adam Trask's scheme to ship freight-car loads of lettuce to New York on beds of ice literally melted away. The film incident, which takes place in Salinas in 1917 before the advent of refrigerated boxcars, was probably close to reality.

For decades, lettuce farmers have sought either a better way to ship lettuce or a lettuce that ships better.

In 1975, United States Department of Agriculture researchers successfully developed a new kind of iceberg (crisphead) lettuce called "Salinas," which displayed many of the fine qualities that lettuce farmers dream about. Salinas has great taste and texture, good color, resistance to the dread tipburn, adaptability to different growing environments, and, particularly important, resistance to bruising over long journeys.

Four types of lettuce predominate the market in California:

Iceberg, or crisphead, has a firm head that reaches about six inches in diameter.

Butterhead is a smaller, looser-headed lettuce with tender, delicately flavored leaves that bruise easily.

Romaine, or cos, has long, stiff leaves with a crisp, coarse texture; it cooks well because the leaves won't dissolve.

Looseleaf doesn't form a head, but grows in a circular patch. Its reddish leaves are tender, curly, and extremely delicate, tearing and bruising with handling.

To buy, look for fresh green outer leaves and no browning on the cut end. Avoid any lettuce that has wilted or torn leaves. Any whitish colored crispheads should be avoided, too; it's a sign of age.

To store, refrigerate in a plastic bag. Butterhead and looseleaf will store for about five days. Romaine and crisphead will keep somewhat longer.

LOTUS ROOT

OTHER NAMES: Nelumbo nucifera, renkon, ho.

NUTRITION: *Carbohydrates, protein, and vitamin C.*

PEAK SEASON: *Late September through February.*

The lotus is a lily that grows in muddy waters, and from its huge leaves blooms the most beautiful pink flower. It is said that Buddha emerged from the lotus flower, like a symbol of man's rebirth from the filth and sadness of this world. Statues of the praying Buddha always show him sitting on a lotus flower or leaf. The Buddhist wheel of life is a cross section of the lacy lotus root.

In Asia, the lotus is not only revered as a symbol of Buddhism, but is also treated as a food plant, with edible leaves, seeds, and roots.

The root, which is actually a rhizome (fleshy underwater stem shaped like a sausage), is eaten like a vegetable. It has a mild, somewhat sweet, and very crunchy texture. The brown outer layer must

The great statues of Buddha often have him sitting serenely on a lotus petal. In Buddhism, the lotus, which grows in mud, is a symbol of man's transcendence over a world of ugliness and sorrow.

be peeled off first, then the inner flesh can be boiled or dried and made into flour. Chinese wedding pastry is made from lotus flour because, though the cake can be broken in half, the slightly sticky texture will bind it together again, thus symbolizing the unbreakable bond between the couple. In Chinese characters, the sign for lotus root means "continuous children."

The Chinese also use lotus leaves to wrap steamed foods, the seedpods for medicine, and the puréed seeds for pastry.

In Japanese cooking, lotus roots are frequently used to decorate food. Its lacy pattern can be cut in a variety of interesting ways. Plus, it can easily be tinted different shades to appear even more festive. Lotus root is a popular ingredient in *oden*, a vegetable stew, or can be served alone as a side dish.

Americans are probably most familiar with the round seedpods, which make attractive dried-flower arrangements.

In Asian markets, lotus root is sold fresh in the fall. To buy, look for hard, brown roots about six inches long. It should not be scratched or blemished because dirt can get into the fleshy meat inside.

To prepare, scrub well, cut off the ends, and peel the outer dark skin. Lotus root does not taste good raw. It can be boiled, fried, braised, or cooked with other ingredients.

To store, keep in the refrigerator. Lotus root will keep for several weeks.

MUSHROOM

OTHER NAMES: Agaricus campestris, *field mushroom*, *Hawaiian brown*.

NUTRITION: *Vitamin B, amino acids, iron, selenium, and copper.*

PEAK SEASON: *Year-round.*

Mushrooms are fungi that live in darkness, feeding off other organic matter. Lacking chlorophyll, they're unable to photosynthesize nourishment from sunlight. They have no roots, leaves, flowers, or seeds.

These mysterious characteristics have fascinated and tempted man since prehistoric times. In the second century, Pliny described the death of Emperor Nero's captain of the guards from mushroom poisoning. "What pleasure men should take thus to venture upon so doubtful and dangerous a meat," he wondered.

Pliny's opinion aside, the Romans still considered mushrooms ambrosia, food for the gods (or at least the higher income bracket).

For those who approach the eating of wild mushrooms with trepidation, the commercially grown variety has been a godsend.

Even though mycologists swear there's nothing that compares with the strong flavors of wild mushrooms, those of us who don't have the time or inclination to study up on what is safe and tasty feel content to

Sensuous, mysterious, and sometimes dangerous, mushroom has been considered a decadent food since earliest times. Herbalist John Gerard claimed that these fungi were eaten "more for wantonness than for need."

have fungi we can buy at our neighborhood store.

The French were the first to produce a sterilized mushroom spawn on a commercial scale at the end of the nineteenth century.

In the United States, mushrooms are spawned in an environment that's more antiseptic than a hospital—even the air is filtered to keep out bacteria. Technicians dress like surgical-operating teams when working with the sterilized mushroom spores. The mushrooms themselves do not feast off suspicious, unknown materials, but on synthetic compost.

When shopping for common mushrooms, look for tan or white ones with closed caps that do not show the undergills. Avoid any that are chipped or have black spots. Mushrooms are highly perishable.

To store, refrigerate in a paper bag or open basket to allow the mushrooms to breathe. Placed in plastic bags, they turn soggy. Cover the mushrooms with a damp paper towel to supply some moisture. They dry out easily, too. Stored properly, fresh mushrooms will keep for about a week.

Remember that mushrooms should not be washed before use; they will lose their special texture. Wipe them off gently with a damp towel.

OKRA

OTHER NAMES: Hibiscus esculentus, *gumbo;* Luffa acutangula, *Chinese okra*, cee gwa.

NUTRITION: *Vitamins A and C, calcium, and potassium.*

PEAK SEASON: *July through October.*

Okra is like a homely woman with a beautiful personality. Those who take the time to look beyond the surface will discover that this is a vegetable worth knowing.

But okra has been handicapped by prickly hairs on its finger-shaped pods, tough fibers when old, and a tendency to turn slimy when boiled.

Southerners, of course, know that this member of the hibiscus family, which was introduced from Africa, has many redeeming qualities. In the South, okra is considered an essential ingredient in creole dishes, most notably

gumbo, which is what okra was called in its native Africa. Southerners have found dozens of ways to serve okra – pickled, fried, stewed, and boiled. In stews, it acts somewhat as a thickener. Okra tastes exceptionally good cooked with tomatoes. (Warning: Don't try it boiled unless you are really fond of okra. To phrase it euphemistically, it gets mucilaginous.)

By and large, outside the South, okra has been shunned. But recent interest in regional cuisine has brought okra into some of the most unlikely meat-and-potato homes.

African okra should not be confused with the huge Asian variety (*Luffa acutangula*), which has crisp skin and a squashlike taste. It is used in stir-fry cooking. Chinese okra, called *cee gwa*, does not turn slimy, but becomes bitter and fibrous when old.

To buy African okra, find small (one to four inches), crisp pods that are free of blemishes.

To buy Chinese okra, choose gourds that are about a foot long, with firm, ridged skin and a fresh dark green color.

Refrigerated in plastic bags, both types of okra will keep for about a week to ten days. Use before they go limp and discolor.

ONION

OTHER NAMES: Allium cepa, *dry onion, green bunching onion, shallot.*

NUTRITION: *Protein, calcium, phosphorus, iron, and vitamins B and C. Green onions also have vitamin A.*

PEAK SEASON: *Year-round.*

The statement that Easter lilies and dry onions are related seems as preposterous as suggesting that Princess Grace and Phyllis Diller were twins.

The former case is true, however. The elegant lily family contains a branch of aromatically opinionated cousins that includes onions, garlic, leeks, chives, scallions, shallots, and asparagus. Although each has a strong and distinct personality, there's a family resemblance. All are rich in sulphur, which brings out their powerful flavor and also makes them stink when they rot.

Indigenous to Central Asia, these lilies of the field have been cultivated since biblical times. Onions, leeks, and garlic were foods the exiled children of Israel cried out for as they wandered through the desert.

Pliny writes that the ancient Egyptians invoked the onion when taking oaths. In Greece, onions were considered an erotic stimulant. They were also said to help phlegmatic temperaments.

Medieval Englishmen loved the pungent lilies, too. "Wel loved he garleek, oynons and eek leekes," Chaucer writes in *Canterbury Tales*.

No less a statesman than George Washington is noted for his fondness of onions.

Onions have never declined in popularity over the ages. They contribute flavor to cooked dishes and many types taste wonderful raw.

There are hundreds of varieties of onions on the market today. California ranks first in the United States for dry onion production, providing virtually all of the fresh-market dry onions, and about 60 percent of the dehydrated onions.

Dry onions are typically harvested by hand. The bulb is ready when the neck

Onion was the favorite vegetable of the founding father of the United States. George Washington apparently ate it with no inhibitions about bad breath, but he and Martha weren't noted for their passion either.

weakens, causing the hollow leaves to topple. Once the bulbs are pulled and sheared of their leaves and fine roots, they are bagged and left in the field for several days to cure before transporting to packing sheds.

Dry onion bulbs come in many shapes, sizes, and colors: elongated, flat, and round, in yellow, purple, and white. In California, the sweet Italian reds are popular served raw. Bermudas, which usually have yellow skin, are also mild and frequently used for hamburgers.

To buy, select hard, firm bulbs with clean papery skin. Avoid any that are soft, wet, or sprouting.

Store in a dry, cool, well-ventilated location. When sliced, wrap in plastic and refrigerate. Whole onions should keep for about four weeks. If they start to sprout or turn soft, use quickly. There is nothing more foul smelling than rotting onions.

Green onions: California also grows several thousand acres of green bunching onions, sometimes called spring onions or scallions. These onions are frequently used in Asian cooking. Milder than many dry onions, they are also served raw in relish plates and salads.

To buy, make sure the green leaves are crisp and unbruised.

Refrigerated in plastic bags, they should keep for about a week.

Shallots: Shallots are shaped somewhat like garlic, with tissue-wrapped cloves, but they taste like a delicate dry onion. Shallots are frequently used in French cooking and considered more of a gourmet herb than regular dry onions.

To buy, look for plump, firm bulbs. Avoid ones that look shriveled.

To store, keep in a dry, cool, well-ventilated place. They should hold for about a month.

P

PARSNIP

OTHER NAMES: Pastinaca sativa.

NUTRITION: *Carbohydrate, vitamins A and C, and potassium.*

PEAK SEASON: *October through January.*

Parsnips look like an anemic version of their cousin, the carrot.

Centuries ago, parsnips grew wild in most parts of Europe. Emperor Tiberius, however, preferred those

cultivated on the banks of the Rhine, Pliny reports.

The Irish made a kind of beer from these sweet roots. The Dutch used them in soup.

All kinds of medical miracles were attributed to parsnips. John Gerard writes in the sixteenth century that parsnips "provoke urine and lust of the bodie: they be good for the stomacke, kidnies, bladder and lungs." Indeed, parsnips were said to treat cancer, asthma, and consumption, along with toothaches and swollen testicles.

Maybe because some of these medical miracles proved false, parsnips were later relegated to animal fodder.

Parsnip is not a common vegetable anymore, even though most people have heard of it. The root is tasty, but it is tougher than carrots. Americans frequently serve parsnips glazed with brown sugar and fruit juice at Christmas, probably honoring a tradition passed down through the generations.

As a change of pace, you might try adding parsnips to stews, cooking them like carrots, or shredding them for salads.

To buy, select small, smooth parsnips. Avoid large ones because they have woody cores and are fibrous.

Refrigerated in a plastic bag, parsnips will keep for nearly a month.

PEA

OTHER NAMES: Pisum sativum.

NUTRITION: *Protein, amino acids, vitamins A, B, and C, magnesium, and iron.*

PEAK SEASON: *March through May.*

Archeologists dig up pea finds everywhere. A team unearthed peas that dated to 9750 B.C. at Spirit Cave in Thailand. Five-thousand-year-old peas were found in the Bronze Age Lake Dwelling in Switzerland. They were discovered in the ruins of Troy, and are known to have been eaten during China's Han dynasty in 206 B.C.

Until the seventeenth century, peas were eaten dry. Sailors took them along on long sea voyages. Peasants used them as a staple food during the Dark Ages.

Then suddenly — perhaps a new strain developed — it became the rage to eat them fresh. Catherine de Medici, who included her chef and her favorite vegetables as part of her bridal trousseau,

brought along green peas when she went to Paris to marry Henry II. Fresh peas were exotic then and carried a price tag to match.

Thomas Jefferson considered peas his favorite vegetable and grew them at Monticello. For several generations, the image of mother sitting on the porch shelling peas was part of the American scene.

Maybe because they have been around forever, peas are rarely served by those who are into *nouvelle cuisine.* Those who eat peas usually buy them frozen.

Peas are a classic vegetable, however, and they are best when fresh. Sweet and succulent, they are worth the extra time in shelling.

To buy, pick small, shiny green pods. The big, faded pods will taste old and starchy.

Refrigerate unshelled peas in a plastic bag and eat them as soon as possible.

PEPPER

OTHER NAMES: Capsicum frutescens grossum.

NUTRITION: *Vitamins A, B, and C.*

PEAK SEASON: *May through December.*

The fifteenth-century search for the Spice Islands wasn't motivated by a simple passion for exotic spices. It had to do with rank meat, which ground peppercorns (*Piper nigrum*) went a long way to disguise. Without refrigeration, spoilage was rapid and even edible meat smelled foul.

Christopher Columbus, however, unwittingly pulled a fast one over on Queen Isabella. Since Columbus had never seen peppercorns grow, he leaped to the conclusion that the capsicum peppers he found growing in the West Indies were the much-sought-after *Piper* kind. It took awhile for the Europeans to discover that Columbus' mistake wasn't a total loss after all.

Today, capsicums play an important role in cooking around the world. Peppers tend to crossbreed easily, even in one's own garden.

There are literally hundreds of varieties. California is a leading producer of many of them.

Capsicum peppers are basically divided into two groups: sweet-mild and hot-spicy.

The bell pepper is the sweetest and largest variety. It is typically sold green. Later in the season, you can often buy red, yellow, and purple ones. The bright-colored ones have merely been allowed to ripen longer on the vine and are sweeter.

Other mild varieties are the Hungarian and Anaheim peppers, which are long and thin.

A favorite way to cook the mild peppers is to roast them on the stove till the skin blisters. Wash off the charred skin, remove the seeds, and slice. They go well with both meat and fish.

Then there's a whole host of hot chili varieties; *serrano*, yellow wax, and *jalapeño* are the most common California chilies.

When cooking with chilies, don't rub your eyes or skin before washing your hands. The hot "oil" that is located in the membrane of the inner skin of the chili can burn.

When buying, choose firm, crisp peppers without dark or soft spots. Unless you are stuffing a bell pepper, don't worry about the shape; it won't alter the taste.

Peppers should be refrigerated in plastic bags, where they will keep for about a week.

POTATO

OTHER NAMES: Solanum tuberosum.

NUTRITION: *Vitamins B_1, B_2, and C, iron, carbohydrates, potassium, calcium, and phosphorus.*

PEAK SEASON: *Year-round.*

Of all the vegetables known in the Western world, the potato played the largest role in altering the course of history, because it was frequently foisted on the poor to quell hunger rebellions.

Native to the Andes in Peru, white potatoes were cultivated by the Incas long before the arrival of the Spanish conquistadores in 1532. The Incas even had a method of freeze-drying the tubers for later use.

After ravaging the Incan civilization, the Spanish conquerers carried off a supply of potatoes to feed their men, and left some behind in the Spanish colony in Florida. Probably by bartering with local Indians, potatoes found their way to the doomed Roanoke colony. When

Sir Francis Drake rescued Sir Walter Raleigh from Roanoke, potatoes were among the plants they carried home.

Raleigh planted the "Virginia" potato in his native Ireland in 1586, and, according to legend, gave some to his neighbor, who didn't have the vaguest idea what part of the plant was edible. He ate the seed berries, which were terrible, and in disgust, had his gardener yank out the plant and burn it. By chance, the gardener tasted the roasted tubers, thus discovering the first baked potato.

To the poor of Ireland, who suffered most from frequent famines, potatoes

were a godsend. An acre and a half of them could feed a family of six for a year. "Seeds" for the following crop came from the "eyes," or undeveloped buds, of the potatoes. Compared with

The War of the Bavarian Succession is known as the "Potato War" because enemies tried to seize control of the potato crops that fed the armies. Frederick the Great, on the other hand, fed potatoes to his prisoners of war.

other food crops, they required little labor. By the late eighteenth century, the average Irishman was eating about eight pounds of "spuds" a day.

Meanwhile, although potatoes were credited with saving the British colony in Bermuda from starvation, the Puritans in Virginia dropped the potato, so to speak, as soon as they began to grow other crops, because it wasn't mentioned in the Bible.

In England, the rich disdained potatoes as peasant food until nearly the end of the nineteenth century.

The tuber fared little better in Europe, where it was used as animal fodder and avoided because it was believed to cause leprosy.

Frederick William I of Prussia, realizing its nutritive value, ordered his subjects to plant potatoes, under threat of losing their noses and ears. Potatoes became so important to the region that the War of the Bavarian Succession in 1778-79 is known as the "Potato War" because enemies vied for control of the potato crop that fed the armies.

The French did not see the nutritional value in potatoes until agronomist Antoine-Augustin Parmentier was taken prisoner by the Germans during the Seven Years' War. Fed only potatoes for three years, Parmentier found he survived in good condition. Once home, Parmentier proposed that potatoes "could be substituted for ordinary food," thus calming the hungry peasants. In 1785, Louis XVI, in danger of losing his head, embraced the idea and went so far as to wear a potato blossom on his lapel and throw a big party at which

was served only dishes made from the once-disdained tuber. Marie Antoinette pinned potato blossoms in her hair, and had a set of china painted with the potato flower motif. Although this first potato public relations campaign ended unhappily for Louis and Marie, it did succeed in making the potato a popular French vegetable.

By the mid-nineteenth century, much of the potato controversy had ended, when disaster struck. In 1845, a "black rot" attacked the potato crop of Ireland, causing widespread famine. During the three-year blight, a million and a half Irish citizens died. Another million emigrated to the United States. In Ireland, animosity still exists against the British who were accused of coming to the rescue too late.

The potato has been both a blessing and a curse to the poor. Used as a means of oppression, it also gave the poor the strength to withstand the oppressors.

In the United States today the only controversy surrounding potatoes involves whether they are fattening or not. Actually, a medium-sized potato has less than a hundred calories. It's high in carbohydrates, iron, potassium, calcium, phosphorus, and vitamins B_1, B_2, and C. If you don't load it with butter, sour cream, and other junk, it's a very good diet food.

California is the sixth largest producer of potatoes in the country. In the winter and spring months, about 50 percent of the nation's production comes from the state.

To buy, look for potatoes that are blemishless and with no greenish cast or sprouting eyes. Greenish, sprouting potatoes will taste bitter.

Potatoes stored in a dry, cool place (not the refrigerator) will keep for about three weeks.

R

RADICCHIO
rah′ · dē · key· o

OTHER NAMES: Cichorium intybus, *Italian lettuce.*

NUTRITION: *High in vitamins A and C.*

PEAK SEASON: *Year-round.*

Radicchio came into prominence with the pasta craze. It's a wild Italian chicory, related to the root chicories, and is enjoyed for its bitter red leaves.

A Salinas rancher says that every lettuce farmer in the area is trying to grow radicchio because it commands high prices. It sells for about six times more than common head lettuce.

Radicchio is an unpredictable plant, however. Sometimes it goes to seed before a "head" is fully developed. It also germinates erratically and is susceptible to mildew. Plus, radicchio is slow growing, taking more than a hundred days to reach harvest stage. All these factors combined make radicchio a risky crop, but the market price supplies the incentive.

Pasta restaurants in California serve radicchio raw in salads. My favorite way is grilled with lemon juice and olive oil. The grilling seems to take the edge off the bitterness. When cooked, the regal red leaves turn a dull brown, but that doesn't harm the flavor.

To buy radicchio, look for firm to hard heads, with deep purple-red leaves and white midribs. A lighter color at the fringe of the leaves is okay. Mature radicchio tends to have a mellower flavor than the young heads.

To store, refrigerate in a plastic bag. Radicchio leaves have a tougher texture than lettuce and will store for nearly a month.

RADISH

OTHER NAMES: Raphanus sativus.

NUTRITION: *Vitamin C.*

PEAK SEASON: *Year-round.*

"All radishes breed wind wonderfull much, and provoke a man that eateth of them to belch," wrote Pliny in the second century.

Pliny also reported that the best radishes grew in Egypt, fed by the brackish waters of the Nile.

Radishes originally came from China and Middle Asia, but were known in ancient Rome, Greece, and Egypt. The pharaohs included radishes in their rations to slave laborers.

In England and Europe, these tangy roots were eaten raw with salt and pepper, or with salt and butter and bread. Their stimulating peppery taste make them a favorite for appetizers.

In the United States, the cherry-sized red radish is the most common variety sold, but radishes come in all shapes, sizes, and colors, including black.

Radishes can be cooked like turnips, but they taste best raw. In Japan, the radish stems and leaves are frequently pickled in a salt brine.

These attractive roots make beautiful garnishes, too. The small red ones can be cut into flowerets.

To buy, look for crisp,

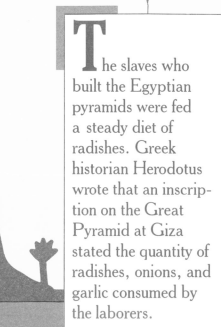

The slaves who built the Egyptian pyramids were fed a steady diet of radishes. Greek historian Herodotus wrote that an inscription on the Great Pyramid at Giza stated the quantity of radishes, onions, and garlic consumed by the laborers.

well-formed, smooth radishes with fresh green leaves. If the leaves are yellowed, or the bulb is cracked and wilted, avoid it. Old radishes turn spongy and dry from the center.

Remove tops of radishes and refrigerate in plastic. Fresh radishes keep for about a week.

RHUBARB
rōo'bärb

OTHER NAMES: Rheum rhaponticum.

NUTRITION: *Vitamin C.*

PEAK SEASON: *January through March.*

Rhubarb is one way to separate the newcomers from the native Californians.

Ask a transplanted midwesterner about rhubarb and he'll spend twenty minutes telling you about his mother's rhubarb pies, puddings, preserves; you name it and she made it from this slightly sour red stalk. Rhubarb is a cold-weather vegetable, the first harvest of spring.

Although rhubarb grows well in parts of California, it does not have the same nostalgic appeal to native Californians, because we have so many other vegetables and fruits to choose from all winter long.

Not surprisingly, edible rhubarb is a native of Siberia and was introduced to Amer-

A medicinal rhubarb that was valued as a laxative commanded high prices in medieval Europe. Marco Polo carried rhubarb back from China in a bamboo basket, but the plant couldn't survive in the hot Italian sun.

ica by eighteenth-century Russian fur traders. The Russians, who established a trading outpost in Alaska, discovered that rhubarb was one of the few plants that thrived in the arctic cold and its antiscorbutic properties saved them from contracting scurvy.

In Europe an Asian variety of rhubarb, *Rheum officinale*, was valued for its medicinal properties. Since about 2700 B.C., the Chinese used the powdered root as a purgative, a treatment for bacillary dysentery. The Europeans paid high prices for this drug, since the rhubarb variety could not be cultivated on the Continent.

Europeans did not start eating the Siberian variety of rhubarb until late in the eighteenth century. Benjamin Franklin sampled fresh

rhubarb in Scotland and sent seeds back to the colonies. Although it was sold commercially, rhubarb didn't become a common spring dish in the United States until the late nineteenth century.

The only part of the rhubarb that is eaten is the reddish pink stalk, which is quite tart and typically cooked with sugar. The leaves are poisonous. In the Midwest, it is eaten as a cooked fruit and even called a pie plant.

To buy, look for crisp red stalks that are thick but not woody.

To store, refrigerate in a plastic bag. Use within a couple of days.

SALAD SAVOY

OTHER NAMES: *Brassica oleracea*

NUTRITION: *Extremely high in vitamins A and C and calcium.*

PEAK SEASON: *Year-round.*

This is one of the newest, and certainly the most decoratively beautiful, vegetables on the market.

Developed by Moore Marketing International in Salinas, salad savoy looks like an ornamental cabbage with lovely white, pink, and red curly leaves. It was introduced to the marketplace in 1984.

Salad savoy emerged from the kale-cabbage family and has a cabbagy flavor. Although it is tempting to display this vegetable for its breathtaking beauty, it should at some point be cooked and eaten because it is rich in vitamins. It has 400 percent more vitamin A, 20 percent more vitamin C, and 80 percent more calcium than broccoli, which is a nutritious source of all of the above.

While cooking this cabbage seems as tragic as boiling a rosebud, take heart, because it doesn't lose its color when cooked.

To buy, look for the most beautiful head you can find — crisp, firm leaves and deep colors.

To store, refrigerate in a plastic bag. Use within a week.

OTHER NAMES: Lentinus edodes, *oriental black mushroom, golden oak mushroom.*

NUTRITION: *Vitamin B, protein, calcium, and phosphorus.*

PEAK SEASON: *Year-round.*

Until recently, shiitake mushrooms were available in the United States only in dry form. You had to soak them in warm water until they got puffy before cooking them.

Japanese cooks find shiitake indispensible in sukiyaki, sushi and hundreds of other preparations. These large mushrooms, which have a unique pungent flavor, lend a distinct taste to any dish, even when slivered. Many Japanese recipes call for saving the soaking water to use as stock.

In the late seventies, logs impregnated with germinated shiitake spores began appearing as novelty items. I bought one to surprise Grandma with genuine, fresh, homegrown shiitake.

For several weeks I nursed that log on my kitchen table, spraying it down every morning and evening and keeping it sheltered under a plastic tarp. Finally, a single mushroom emerged and grew to about four inches wide at the

cap. That was the one and only mushroom the log produced. It weighed about four ounces and cost me eighteen dollars excluding my labor.

Fortunately, shiitake mushrooms are being grown commercially in California. They are still quite expensive, and sometimes scarce, but the difference in taste over the dry kind is worth the cost.

Shiitake, which is spawned on inoculated logs of a *shii* tree, is the most common mushroom used in Asian cooking. Dark brown and sweetly pungent, it's a popular ingredient in sukiyaki and makes a flavorful broth.

Shiitake connoisseurs say that the best mushrooms have caps with a network of cream-colored fissures. My only shopping advice is to make sure that the mushroom looks moist and fresh with no dark spots showing rot.

To store, refrigerate shiitake in a basket or on a plate and cover with a damp (not wet) thin cloth to hold in moisture. Fresh shiitake should keep for about a week and a half.

SHISO
shē′ · sō

OTHER NAMES: Perilla frutescens, *beefsteak plant,* ji soo.

NUTRITION: *Calcium, phosphorus, and vitamin B.*

PEAK SEASON: *April through November.*

Many people have shiso growing in their yards and aren't even aware of its food value. Called beefsteak plant in the United States, shiso is often used as ground cover in landscaping.

Shiso, which comes in purple and green varieties, is an aromatic herb with a refreshing mintlike flavor. It is gaining familiarity outside the Asian community largely through sushi bars, which chop the leaves and add them to various *nigiri sushi.*

This herb is a must in Japanese home gardens in California. Shiso leaves, cut up fine, are served with *sashimi* (raw fish). The leaves and seeds (which are left on their stem) are deep fried in batter for tempura. And the purple shiso leaves are indispensible in making *umeboshi* (pickled sour plums). The leaves dye the plum a bright red color. In Japan, shiso/ume-flavored chewing gum and candies are as common as peppermint ones are in this country.

The Chinese call the herb *ji soo* and use it in similar ways.

Shiso leaves are very thin and highly perishable. Some Asian markets sell shiso as a potted plant in the produce section. Recently I've also seen leaves packaged in plastic bags.

Shiso is easy to grow. Every fall my parents let a few shiso plants go to seed and each spring hundreds of shiso sprouts come up voluntarily.

This is an herb that deserves wider recognition. If you are growing it for ground cover, you might try a chopped up leaf or two when serving fish.

To buy, find unwilted green or purple leaves.

Shiso leaves must be refrigerated in a plastic bag until ready to use. They will only keep for a day or two at most.

SNOW PEA

OTHER NAMES: Pisum sativum macrocarpon, *Chinese sugar pea,* hoh laan.

NUTRITION: *Protein, vitamins A and C, and minerals.*

PEAK SEASON: *April through June; October through December.*

These edible peapods were popularized in the United States in Chinese stir-fry dishes and people have come to think of them as Asian.

However, the Cantonese name for peas is *hoh laan,* which means foreign legume. Peas arrived in China, via southwestern Asia, around the seventh century. The edible peapods originated in Europe sometime in the nineteenth century and quickly became a hit with the Chinese.

The species that we have come to consider Chinese sugar peas has a crisp flat pod and an almost invisible seed.

For those unfamiliar with snow peas, treat them somewhat like green beans. Snap off the ends and string them. Serve snow peas whole.

Sweet and crisp, raw snow peas are fashionable as *crudités.* Parboiled and buttered, they go well with meat and fish dishes. Or you can cook them the traditional stir-fry way. Just remember to keep cooking to a minimum to retain flavor and texture. Add them last if you have other ingredients that require longer cooking time.

To buy, look for crisp, flat pods with no bulging peas. Big peas are a sign of age.

Refrigerate unwashed snow peas in a tightly closed plastic bag to retain their natural moisture. Use within two or three days.

SPINACH

OTHER NAMES: Spinacia oleracea, *Chinese spinach,* ong choy, een choy.

NUTRITION: *Vitamins A and C, iron, and folic acid.*

PEAK SEASON: *Year-round.*

In grammar school, we often were served a blackish green mushy substance, which we were told was spinach. "Eat it all," the teacher ordered, "so you can grow as strong as Popeye the Sailorman."

Few kids ate it because most of us didn't want to look like toothless, bowlegged, long-waisted, muscularly deformed Popeye — no matter how strong he was.

Unfortunately, many people formed their opinion of spinach based on the dreadful canned stuff of the fifties.

Fresh spinach is an entirely different vegetable. Tender and delicately flavored, it's wonderful in a variety of cooked dishes and served raw in salads. And it's not at all hard to prepare.

Spinach was originally cultivated by the Persians around the sixth century. It was brought to Europe by the Moors when they invaded Spain, and presented to China as a gift from the King of Nepal in the seventh century.

Today, California is the nation's leading producer of spinach, providing about half of the fresh and processed supply. Two types of Asian spinach also are grown and sold in California. Water spinach, or *ong choy,* looks somewhat like regular spinach, but has jointed hollow stems and arrow-head-shaped leaves. *Ong choy* can be eaten raw or cooked. The Chinese put it in soup or add it to stir-fry dishes. Westerners can cook it like ordinary spinach.

Chinese spinach, or *een choy,* does not resemble Western spinach in appearance or taste. It has small, fuzzy oval leaves, comes in green or red, and is sold with the roots intact. The taste is slightly sweet and tangy. It can be cooked in the same way as regular spinach.

Don't overcook spinach; three to five minutes will do. Be sure to press out the water before seasoning.

When buying spinach of any kind, check for fresh, unblemished leaves. Be sure to wash spinach thoroughly, because it grows in sandy soil that clings to the inner stems.

Refrigerated, spinach will keep in plastic bags for two or three days.

Vitamin-rich spinach gave Popeye the Sailorman bulging muscles and the con-fidence to rescue Olive Oyl from brutes and bullies. Popeye, how-ever, had the annoying habit of gulping spinach with his pipe in his mouth.

SQUASHES

OTHER NAMES: Cucurbita maxima, Cucurbita pepo.

NUTRITION: *Vitamins A and C.*

PEAK SEASON: *Year-round.*

The saying "as American as apple pie" should be revised to read "pumpkin pie." Pumpkins, along with several hundred sister squashes, are true American natives, while apples, as we all know, came from Eden. What's more, pumpkins were almost singu-larly responsible for keeping the Pilgrims alive during the long harsh winter after their crops failed.

Squashes, corn, and beans were American Indian staples. The Indians not only ate squashes, but they used the gourds to make water jugs, bowls, and ceremonial masks, and they wove the stringy fibers of some varieties into cloth.

Squashes come in so many colors, shapes, sizes, and textures that they defy simple description. The most com-mon classification system is according to the summer and

winter seasons, which isn't really valid in temperate climate regions like California, where many types grow virtually year-round.

For practical purposes, summer squashes have soft edible shells and small edible seeds. The widest variety of summer squashes is available in the summer, naturally.

Some of the most popular summer squashes include the zucchini (see individual entry), which is dark green and shaped like a cucumber; cocozelle, also called Italian marrow, which is similar to a zucchini, but with medium-green skin; yellow crookneck, a pale yellow, sometimes bumpy-skinned squash with a curved neck; and pattypan, or scallop, which is disc shaped and pale green with scalloped edges. All of these can be eaten whole — skin, seeds, and all.

Winter squashes have hard inedible shells and big seeds, some of which can be roasted and eaten. Winter varieties usually mature in the fall and will keep longer than summer squashes.

The most popular winter squashes include the pumpkin; acorn squash,

also called the table queen, which is blackish green with shades of yellow and a shape like a huge acorn; butternut, which has cream-colored skin, deep orange meat, and a large cylindrical shape; hubbard, which looks like the pumpkin's ugly stepsister with its warty, greenish black skin; kabocha, which is blackish with shades of orange and yellow and is almost as ugly as the hubbard; and spaghetti squash,

which looks like a small butternut and has flesh which, when cooked, forms strands that resemble spaghetti.

Winter squashes are usually cooked in their shells, and then the meat is cut or scooped away from them.

In California, some specialty farms are now offering a limited supply of squash blossoms, which can be stuffed or deep fried. Zucchini, pattypan, and

crookneck are the most commonly used blossoms.

If you have a home garden or a friendly source, pick the blossom when the squash is barely formed, about two inches in length. It's best to

F ew foods are more American than pumpkin pie. Pumpkin kept Pilgrims alive during their first winter, as this Pilgrim song reveals: "We have pumpkin at morning, and pumpkin at noon. If it were not for pumpkin, we would be undoon."

pick the flower in the early morning when it is fresh and in full bloom. Wash carefully under gently running cold water. If you aren't preparing it right away, stick the cut stem in a glass of water and place in the refrigerator or a cool location until you are ready for it. Keep in mind that if you pick too many blossoms, you won't have any full-grown squashes to eat.

To buy summer squashes, look for ones that are medium sized with tender skin. Huge summer squashes should be avoided. To buy winter squashes, look for hard, unblemished shells.

To store, refrigerate summer squashes in a plastic bag and use within a few days. Winter squashes will keep without refrigerating for months, unless they have been cut. Once cut, they must be used immediately.

SWEET POTATO

OTHER NAMES: Ipomoea batatas.

NUTRITION: *Very high in vitamin A. Also contains vitamins B and C, iron, and phosphorus.*

PEAK SEASON: *Late July through October.*

On the tombstone of Kon-yo Aoki, who died in 1771, is the inscription, "The Grave of Professor Sweet Potatoes."

Aoki was sort of the Johnny Appleseed of Japan, except that he planted sweet potatoes over the land to keep the poor from starving to death. What Aoki figured rightly was that sweet potatoes are among the most nutritious vegetables around. Acre for acre, sweet potatoes have twice the food value of rice and demand far less water to grow.

Thanks to Aoki, sweet potatoes are one of Japan's most popular treats. *Yaki-imo*, roasted sweet potatoes, are sold from sidewalk carts, much like we sell roasted chestnuts.

The sweet potato didn't originate in Japan, however. It was one of the New World foods found by Christopher Columbus in 1493. Called *batatas* by the Haitians, sweet potatoes were cultivated by Indian cultures from Peru up through the southern United States. Except in Spain and Portugal, this American root did not catch on in European diets.

Portuguese farmers were the first to introduce this crop to California. They planted the Jersey variety, which has cream-colored skin and dry, meaty flesh. This was the kind grown most commonly in Portugal. Sometime in the thirties, two other varieties were cultivated, the Jewel and the Garnet. Both of these sweet potatoes have moist orange flesh and are

At Jamestown, Virginia, colonists planted sweet potatoes as early as 1617, but shunned white potatoes, because they were believed to cause leprosy and other diseases.

often mistakenly called yams. No yams, however, are grown in California.

Although yams and sweet potatoes look alike and taste somewhat alike, the yam is from a subtropical shrub native to Africa, while the sweet potato is from the American morning glory family. Since both were introduced to Europe about the same time, they are often confused and, to this day, the Jewel and Garnet are sold as yams in stores.

Another misconception is that sweet potatoes and white potatoes are related. Actually, white potatoes are tubers, while sweet potatoes are swollen roots.

Today California is the third largest producer of sweet potatoes in the country. About 80 percent of this crop grows within a fifteen-mile radius of Livingston in central California.

Sweet potatoes have to be "cured" as soon as they are harvested. Within an hour after the roots are pulled from the ground, they are placed in a special room and subjected to temperatures of 85 degrees F. and humidity of 90 percent for about four to seven days. This condition heals the wounds and scars incurred during harvesting and forms a new layer of cells under the skin, which inhibits decay and retains moisture. Once cured, the sweet potatoes are immediately placed in cool storage to await shipment.

To buy sweet potatoes, look for ones that are firm, smooth, and reasonably blemish-free. Small potatoes are ideal for baking. The larger ones can be sliced, then steamed or fried. They also can be mashed and grated for use in a variety of recipes.

To store, keep in a dry, cool place. Do not store in a plastic bag or place in the refrigerator.

SWISS CHARD

OTHER NAMES: Beta vulgaris.

NUTRITION: *Vitamins A, B, and C, and iron.*

PEAK SEASON: *Year-round.*

Swiss chard is actually a type of beet that doesn't develop a big red root. Instead it has a swollen midrib stem that can

range in color from crimson to white. Chard tastes somewhat like spinach and can be cooked in the same manner.

Swiss chard was known to the ancient Greeks and Romans. Several varieties were available in Europe by the sixteenth century.

To buy, look for plump stalks with fresh, tender leaves.

Refrigerate in a plastic bag. Use within a day or two.

TOMATILLO
toe · ma′ · tea · yo

OTHER NAMES: Physalis ixocarpa, *husk tomato.*

NUTRITION: *Vitamin C.*

PEAK SEASON: *September through November.*

If you are fond of Mexican food, you probably have tasted tomatillo. It's the basic ingredient in *salsa verde*, the green sauce that is often served with tacos and over enchiladas.

A native of Mexico, the tomatillo looks like a tiny, green tomato housed in a paperlike husk that looks similar to the ornamental fruit of a Chinese lantern plant. It doesn't taste like a tomato, however. The flavor is tart, and the texture is firmer and seedier than a tomato.

Although tomatillo tastes best with Mexican dishes, it can be sliced and added to tossed green salads.

To buy fresh tomatillos, look for berries with a deep green color and tan husks.

Store tomatillos in the refrigerator, but do not place in a plastic bag. In an airtight container, the berries spoil rapidly. Tomatillos will keep for about ten days.

TOMATO

OTHER NAMES: Lycopersicon esculentum, pomodoro, *love apple.*

NUTRITION: *Vitamins C and A, potassium, and iron.*

PEAK SEASON: *May through October.*

It took nearly four hundred years for much of the Western world to overcome its fear of tomatoes. When the Spanish conquistadores carried this New World fruit back to Europe, no one would eat it because it was part of the deadly nightshade family.

The conquistadores, of course, had picked up several tantalizing *tomatl* recipes from the Latin American Indians, which they prepared back home. In Spain, where tomatoes soon flourished, fear yielded to curiosity and the berry quickly became an important part of the diet. The Portuguese and Italians followed suit. But the French and English, though intrigued, refused to eat the pretty berry. They grew the

Although the Spanish conquistadores reported that the Aztecs and Incas ate tomatoes regularly with no ill effect, early Europeans greeted the American fruit with distrust because botanically it belonged to the deadly nightshade family.

tomato as an ornamental plant, but let the fruit die on the vine, so to speak. The French romantically called tomatoes *pomo d'amore*, or "love apple."

Even in America, Thomas Jefferson described the tomato as "a type of Spanish cantaloupe." He apparently didn't eat it either.

The Creoles in New Orleans finally brought tomatoes into the kitchen

in 1812. But it was another forty years or so before widespread fear of tomatoes diminished in the United States.

Commercial harvesting of tomatoes began in this country around 1860.

Even then, the tomato's troubles weren't over. Botanically, tomatoes are fruits, which confused many people because they are most often used like vegetables. In 1893, the Supreme Court reclassified the tomato as a vegetable, even though it isn't.

Today, California grows about a third of the nation's fresh tomatoes and about 85 percent of its processing tomatoes. Most of the fresh tomatoes go to market firm, but not yet ripe. Store-bought tomatoes must mature at room temperature before eating. There's a dramatic difference in color, flavor, texture, and juiciness in vine-ripened ones. If you can find a local source, buy tomatoes when they are rich red and juicy.

In stores, choose tomatoes with the deepest red color. They should smell like tomatoes and yield when gently pressed with the palm. If a tomato is still slightly green, place it in a paper bag to help it emit ethylene gas, which ripens it.

Do not refrigerate tomatoes, unless they are overripe. Cold temperatures (below fifty degrees) destroy fresh tomato flavor, texture, and aroma. Ripe tomatoes can be kept in the refrigerator for a few days.

TURNIP

OTHER NAMES: Brassica rapa.

NUTRITION: *Vitamins A and C.*

PEAK SEASON: *Year-round.*

Turnips have been eaten since antiquity. They were cultivated in China during the Chou dynasty in 200 B.C. They were also known to the early Romans, but they are most closely identified with the northern Europeans, since turnips are one of the few vegetables to survive the freezing winters.

Turnips are part of the cabbage family. The most common variety is round and white with a purplish crown and has an ever-so-faint peppery flavor. Turnips are frequently confused with the bland yellowish orange rutabaga. This is a shame, since rutabagas, in my opinion, are vegetables of last resort.

Turnips give a special flavor to stews and soup stock. They can be boiled and served with butter or served raw in relish plates.

The Japanese frequently pickle turnips, leaves and

all, in a salt brine to eat with rice.

To buy, choose small to medium firm roots with smooth skin. If you plan to use the leaves, find tops that are fresh and green.

Refrigerated in plastic bags, the roots should keep for about three weeks. The greens will only keep for a few days.

WATERCRESS

OTHER NAMES: Nasturtium aquaticum, sai yeung choy.

NUTRITION: *Vitamins A and C, calcium, and iron.*

PEAK SEASON: *May through July.*

For thousands of years, people went into the woods to gather wild watercress that grew in the streams. Watercress is one of the oldest edible plants known to man.

Related to the mustards, this pungent herb was called *nasturtium* by the early

Romans, which meant "convulsed nose." Pliny said it was a brain stimulant. The ancient Greeks called it *kardamon*, or "head subduer."

From earliest times, however, the primary value of watercress was its powerful antiscorbutic properties. Greek, Roman, and Persian soldiers ate it regularly to prevent scurvy and never went on a campaign without it. The Romans even left some behind in England, where it came to be considered a very refined food for the upper crust.

Watercress, which is native to Asia Minor and the Mediterranean, also plays an important role in Chinese folk medicine as a "cooling" food.

In America, colonists planted it soon after they arrived.

Until recently, watercress wasn't sold in many supermarkets. Though easy to grow, it's highly perishable when picked. The leaves wilt and turn yellow soon after they are out of water.

To buy, choose only fresh green bunches. Keep refrigerated in a plastic bag and use as soon as possible.

Y & Z

YARD-LONG BEAN

OTHER NAMES: Vigna sesquipedalis, *asparagus bean*, dow gauk.

NUTRITION: *Protein, vitamins A, B$_1$, B$_2$, and C, and minerals.*

PEAK SEASON: *June through September.*

Yard-long beans, which look and taste somewhat like a string bean, do not, thank God, have to be stringed.

Long beans are stringless, limp in texture, and have comparatively small seeds. And they grow to nearly three feet in length.

Long beans are not related botanically to the string bean. They originated in tropical Asia and have been eaten there for thousands of years.

These beans go great in almost any stir-fry dish. Or you can cook them like regular green beans. Cut them into about two-inch lengths before preparing.

To buy, look for beans with fresh green texture, small seeds, and no dark blemishes. Long beans are usually sold tied in bunches and coiled.

To store, refrigerate beans in a plastic bag. They will keep for about four days.

ZUCCHINI

OTHER NAMES: Cucurbita pepo, *courgette, Italian squash.*

NUTRITION: *Vitamin C.*

PEAK SEASON: *Year-round.*

Anyone who has grown zucchini knows that it is a squash that resents being forgotten.

You look at it one day and it is the size of a finger with a pretty orange-yellow flower at the tip.

A few days later a monstrous green bomb glares out from the prickly leaves.

Zucchini proliferate faster than rabbits and grow to the size of watermelons if you don't keep a close eye on them.

Zucchini, called *courgette* in France and England, was not widely known in America until the 1950s. Now this Italian summer squash grows like a weed in most backyard gardens. If ignored even for a few days, zucchini will wreak revenge by growing to the size of a watermelon.

To avoid the invasion of the monster zucchini, buy them at the store. This summer squash is available year-round, and the price remains comparatively low.

To buy, look for zucchini that are about eight to ten inches long with dark green skin. The small sizes can be eaten skin, seeds, and all.

To store, refrigerate in a plastic bag. They will keep for about a week.

Around 1880, Spanish papermakers manufactured cigarette paper made from watercress because they believed that the aquatic plant would prevent lung cancer. Watercress cigarette paper had a strange green color.

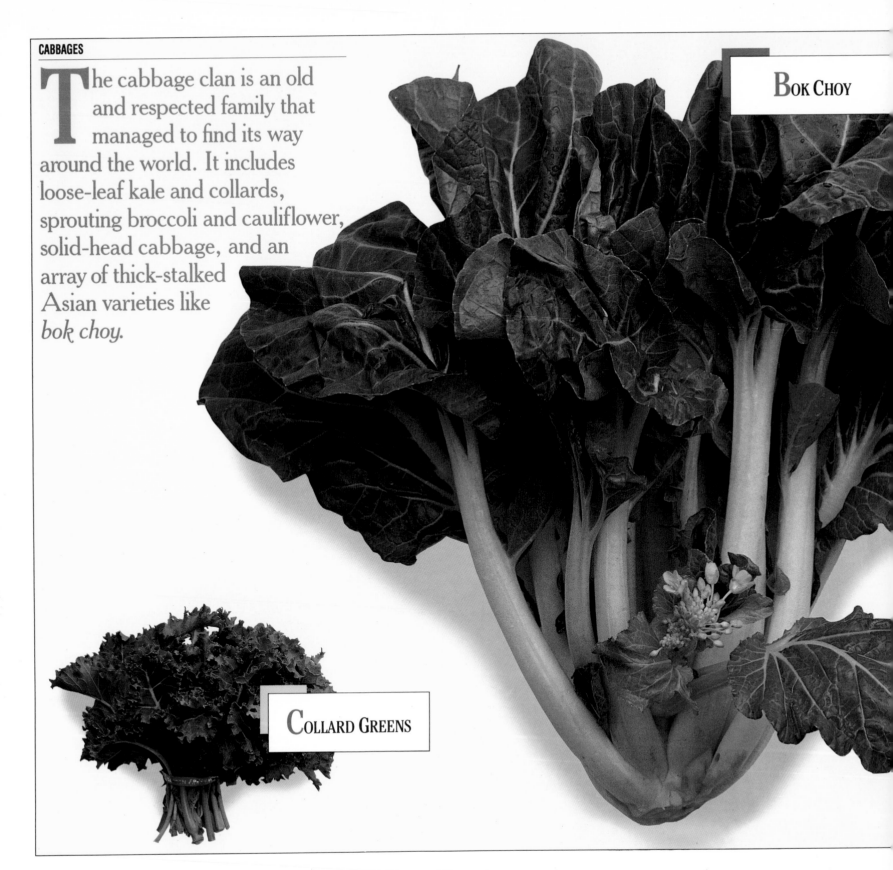

The cabbage clan is an old and respected family that managed to find its way around the world. It includes loose-leaf kale and collards, sprouting broccoli and cauliflower, solid-head cabbage, and an array of thick-stalked Asian varieties like *bok choy.*

BOK CHOY

COLLARD GREENS

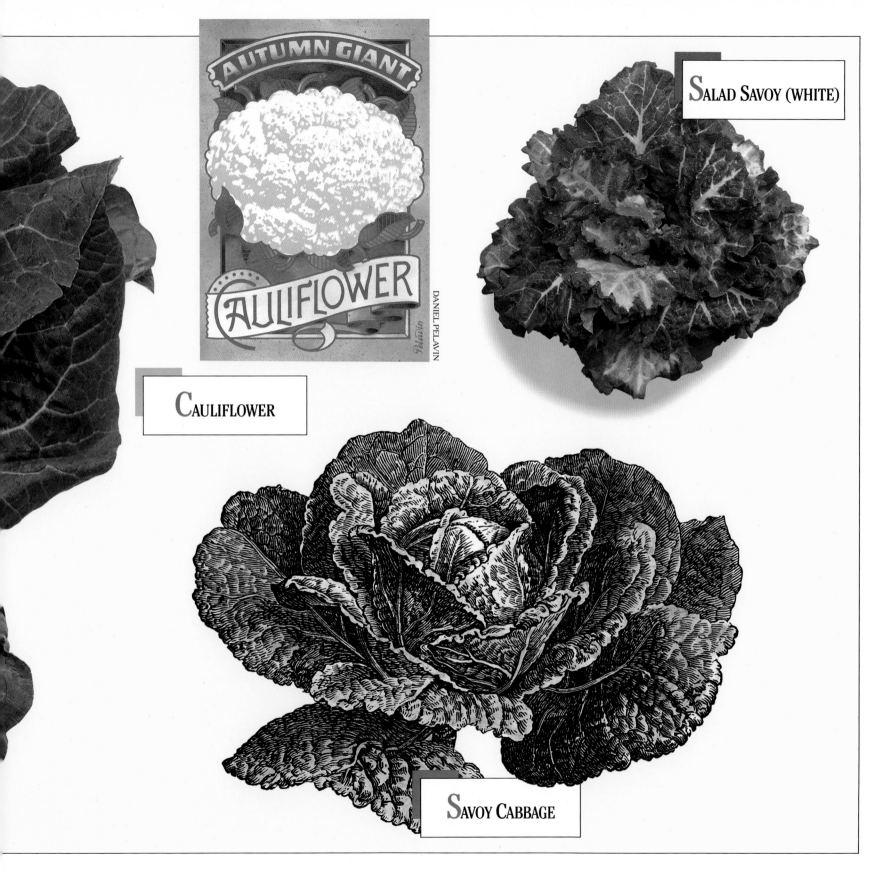

AUTUMN GIANT

CAULIFLOWER

DANIEL PELAVIN

Pelavin

SALAD SAVOY (WHITE)

CAULIFLOWER

SAVOY CABBAGE

75

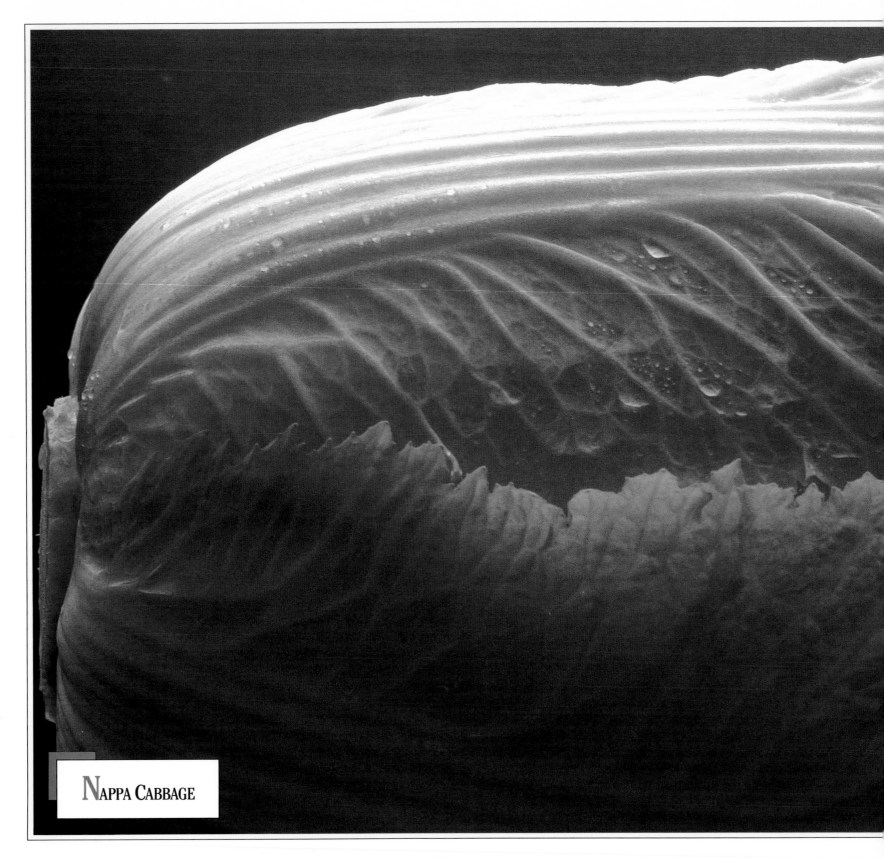

NAPPA CABBAGE

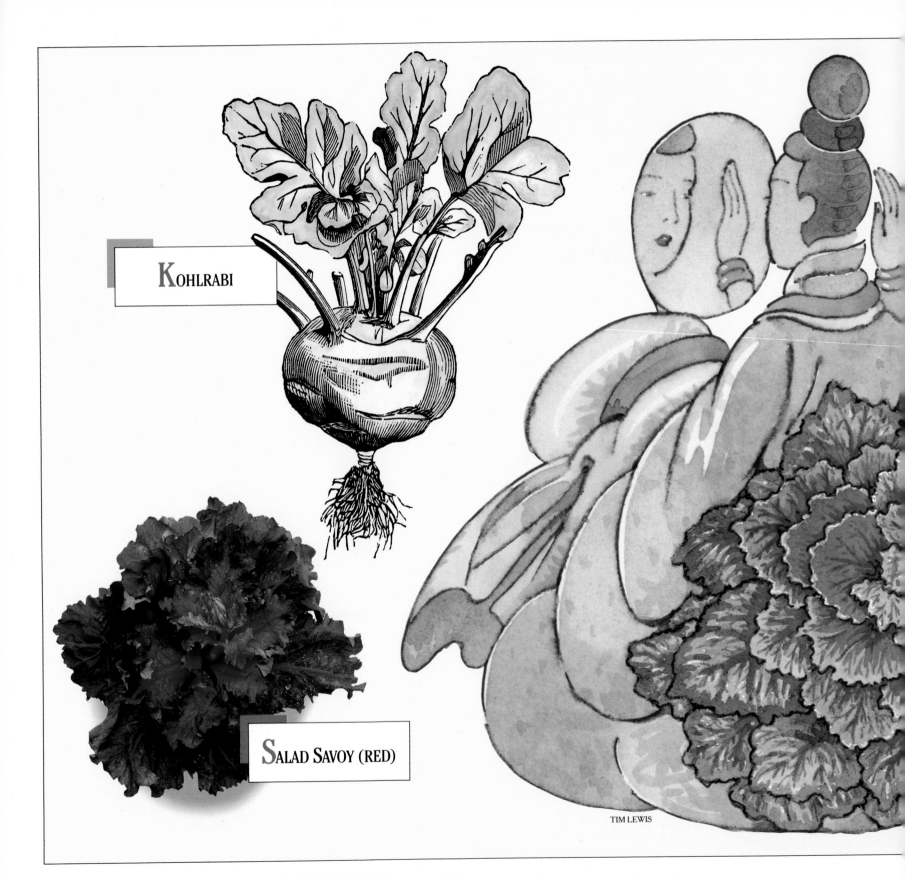

Kohlrabi

Salad Savoy (red)

TIM LEWIS

78

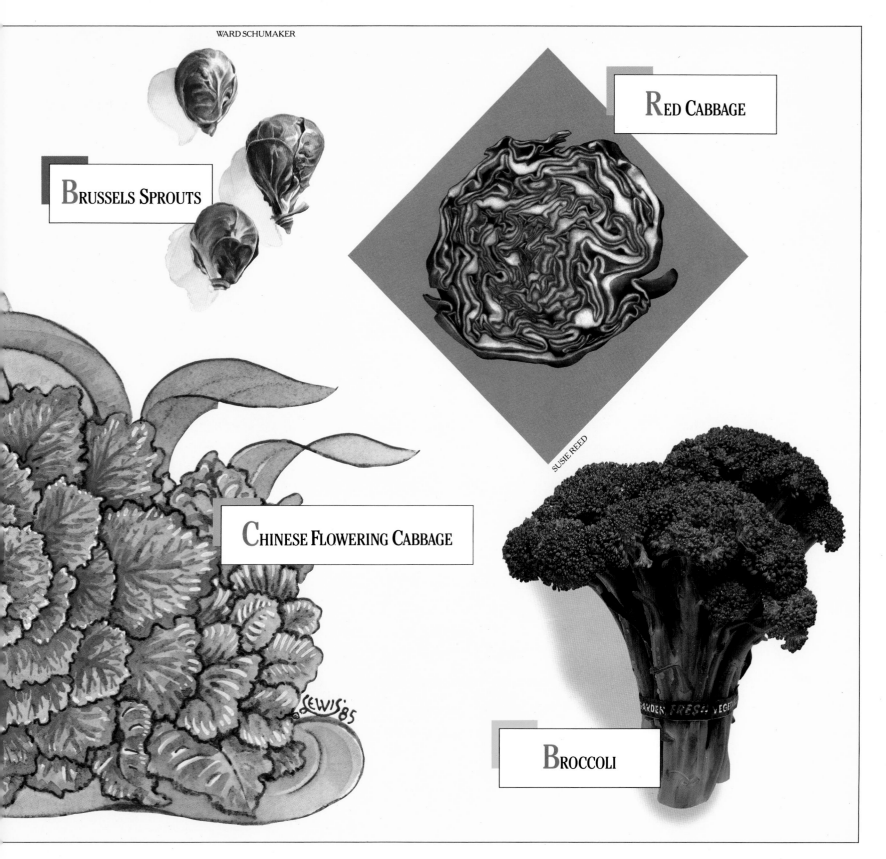

BRUSSELS SPROUTS

RED CABBAGE

SUSIE REED

CHINESE FLOWERING CABBAGE

LEWIS '85

BROCCOLI

Once available only at the whim of nature, mushrooms today can be cultivated as a commercial crop. New Asian varieties of fungi are coming on the market each year. Two of the most popular Asian mushrooms are shiitake, a pungent-flavored fungus that tastes like it grew wild in the forest, and enokitake, a delicate threadlike mushroom with a velvety texture.

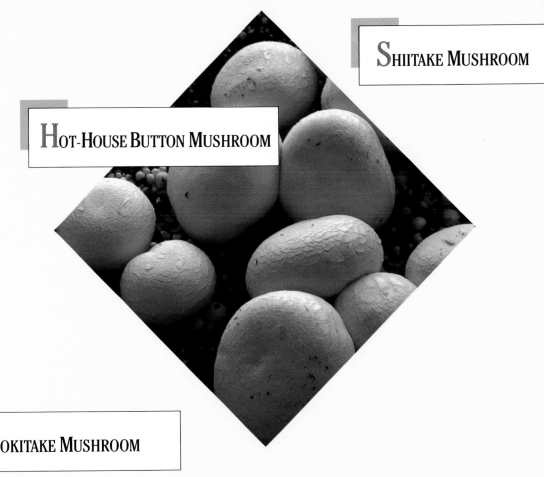

SHIITAKE MUSHROOM

HOT-HOUSE BUTTON MUSHROOM

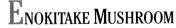
ENOKITAKE MUSHROOM

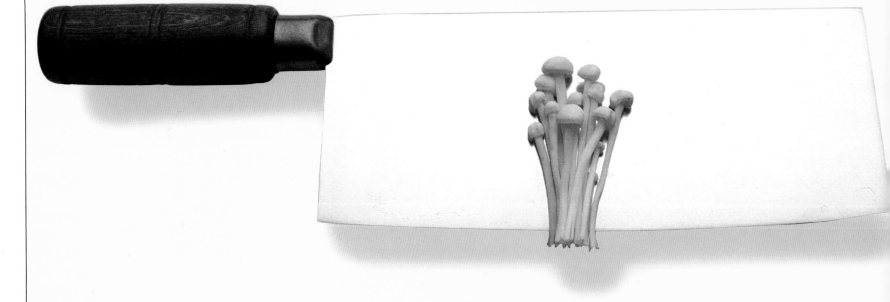

Many seeds are a great source of vitamins and, in the case of beans, of protein. Peas and beans are legumes whose pods split open along their seams when the seeds are ripe. Some legumes, such as kidney beans and peas, are harvested for their seeds alone. Others, such as

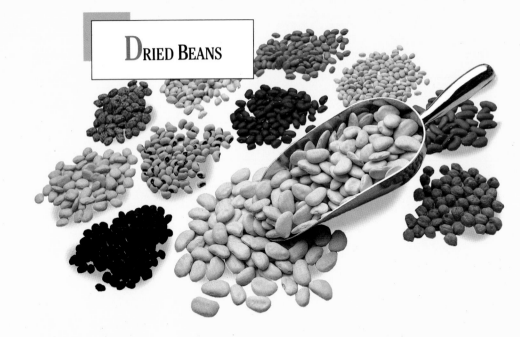

DRIED BEANS

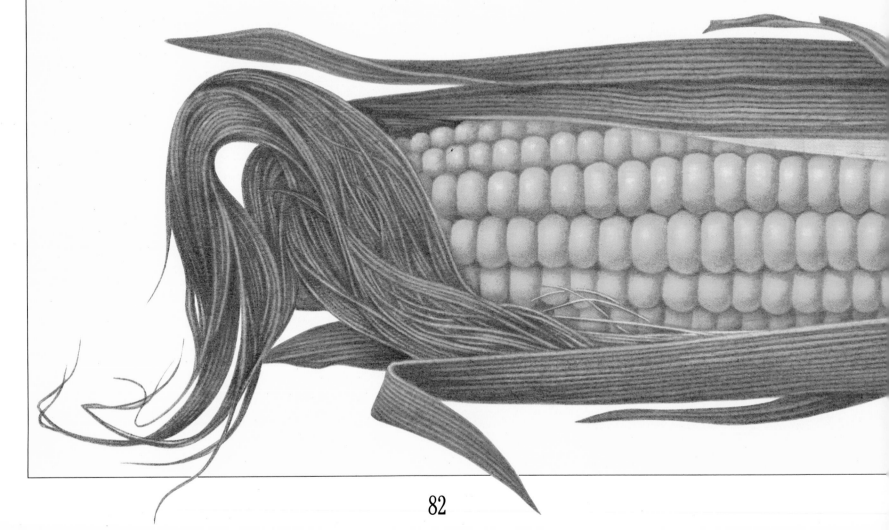

82

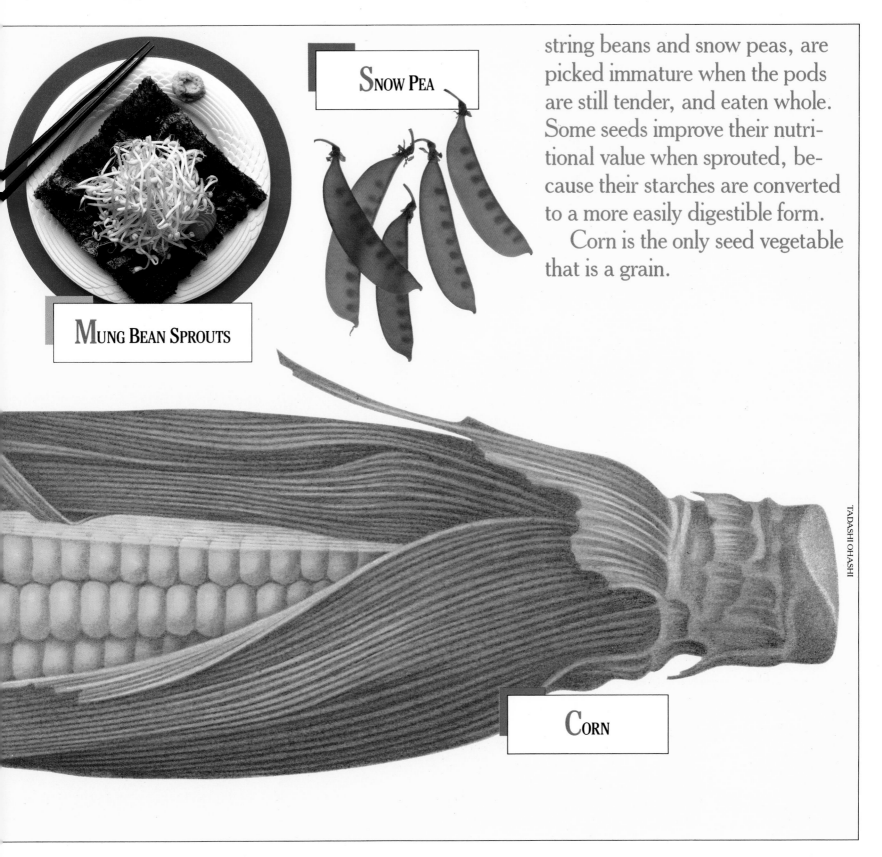

string beans and snow peas, are picked immature when the pods are still tender, and eaten whole. Some seeds improve their nutritional value when sprouted, because their starches are converted to a more easily digestible form.

Corn is the only seed vegetable that is a grain.

SNOW PEA

MUNG BEAN SPROUTS

CORN

TADASHI OHASHI

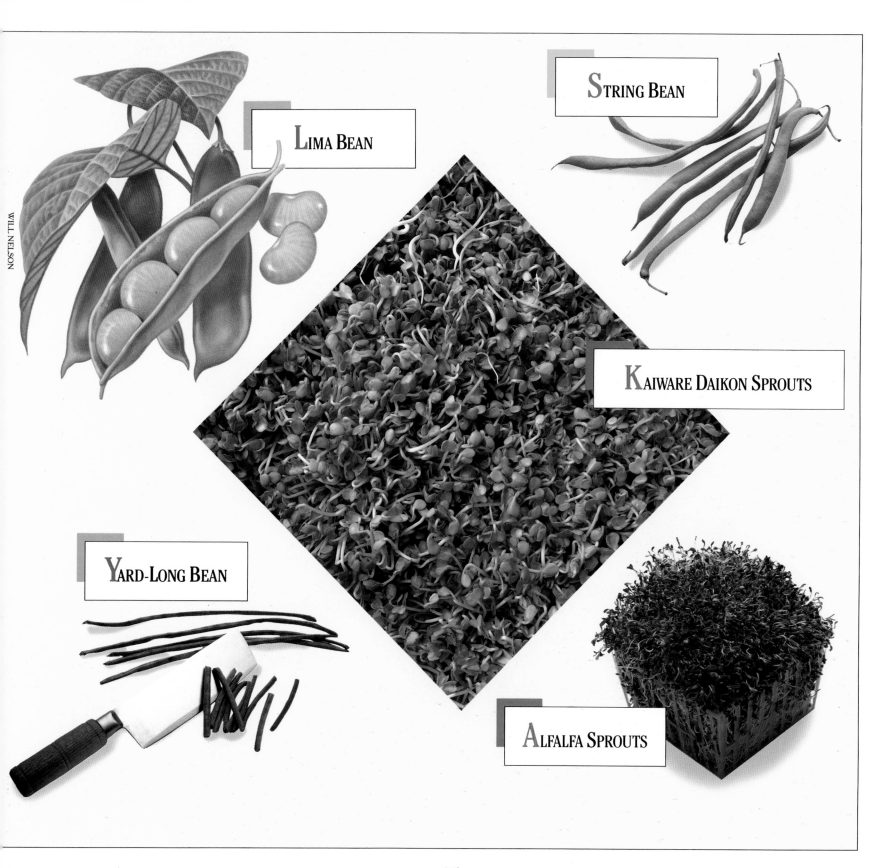

LIMA BEAN

STRING BEAN

KAIWARE DAIKON SPROUTS

YARD-LONG BEAN

ALFALFA SPROUTS

WILL NELSON

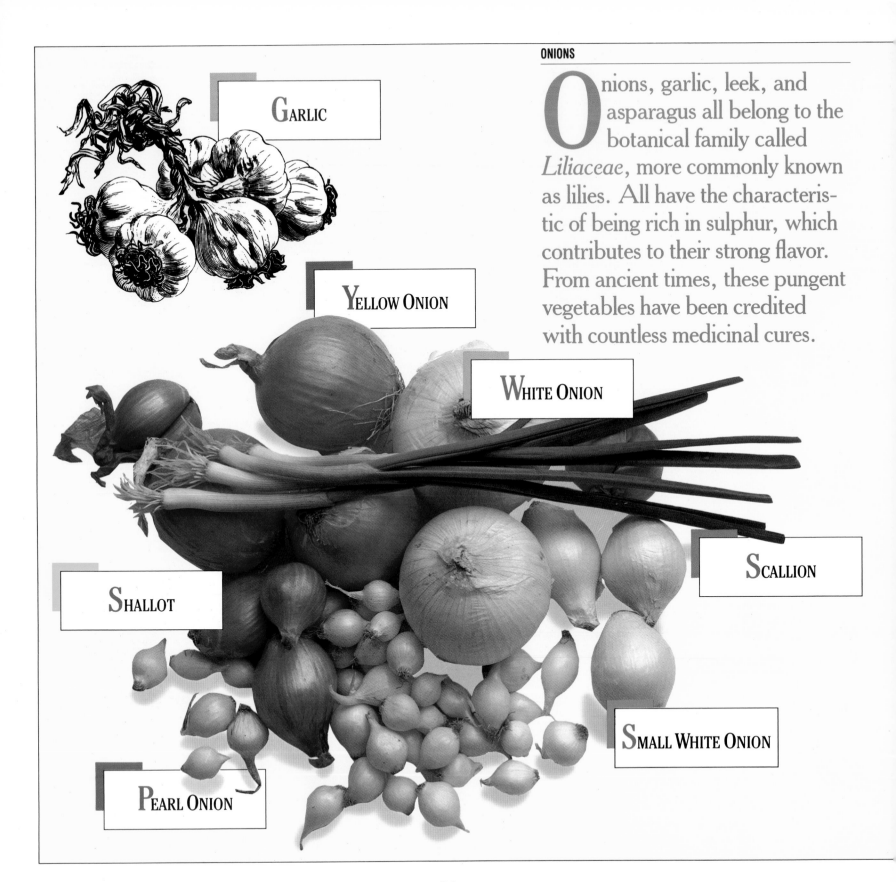

GARLIC

YELLOW ONION

WHITE ONION

SCALLION

SHALLOT

SMALL WHITE ONION

PEARL ONION

Onions, garlic, leek, and asparagus all belong to the botanical family called *Liliaceae*, more commonly known as lilies. All have the characteristic of being rich in sulphur, which contributes to their strong flavor. From ancient times, these pungent vegetables have been credited with countless medicinal cures.

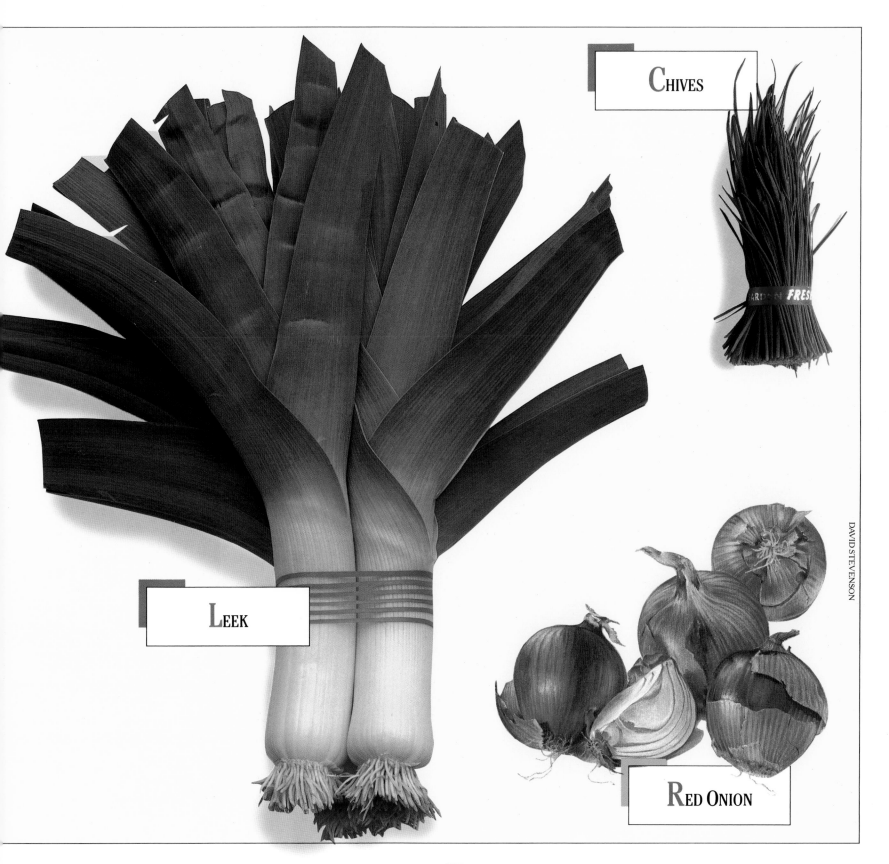

CHIVES

LEEK

RED ONION

DAVID STEVENSON

Peppers

Peppers are part of the genus *Capsicum*, which derives its name from the Latin term *capto*, meaning box, because the hollow fruit encloses the seeds. Hundreds of varieties of peppers exist today. Basically, they can be divided into two groups: sweet-mild and hot-spicy.

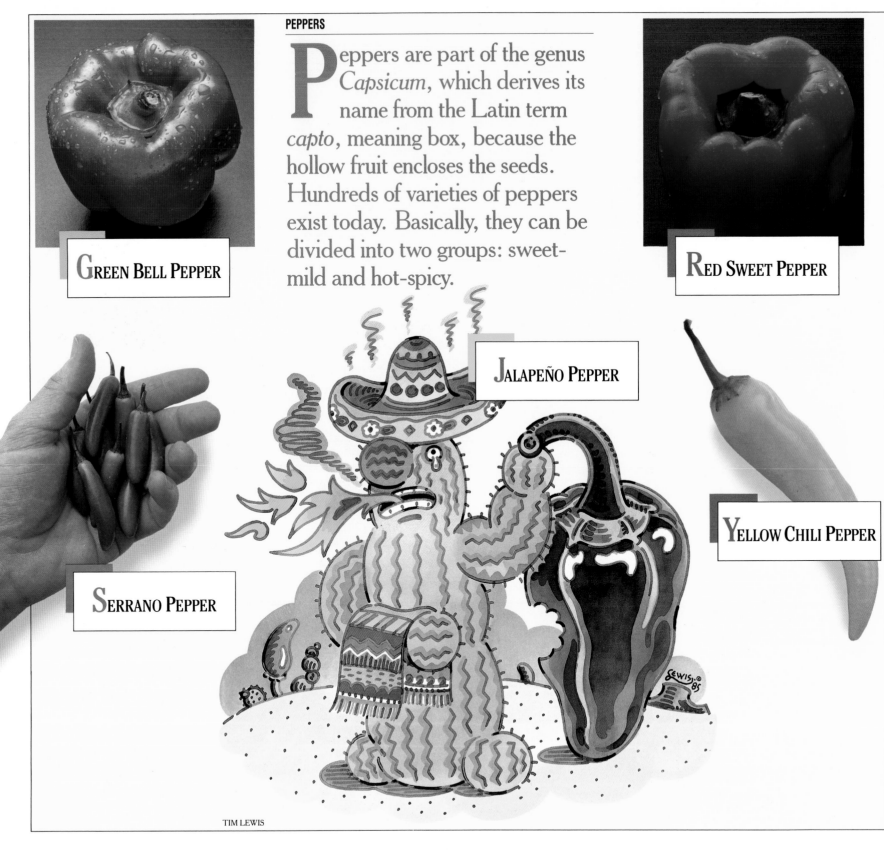

GREEN BELL PEPPER

RED SWEET PEPPER

JALAPEÑO PEPPER

YELLOW CHILI PEPPER

SERRANO PEPPER

TIM LEWIS

RED CHILI PEPPER

JOHN HYATT

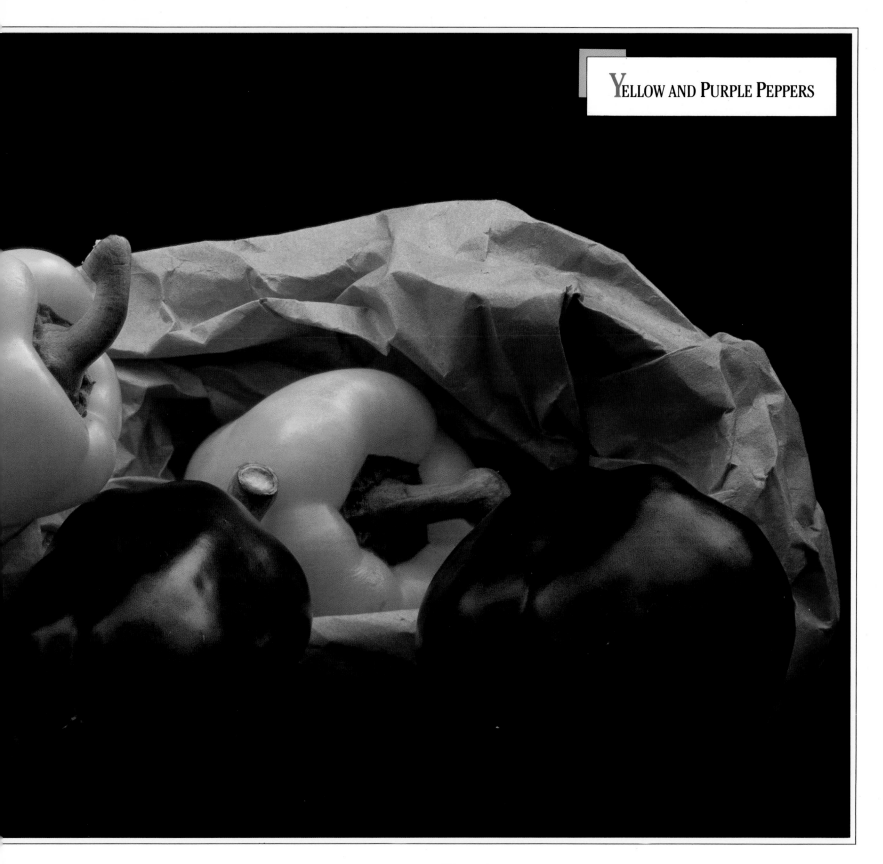

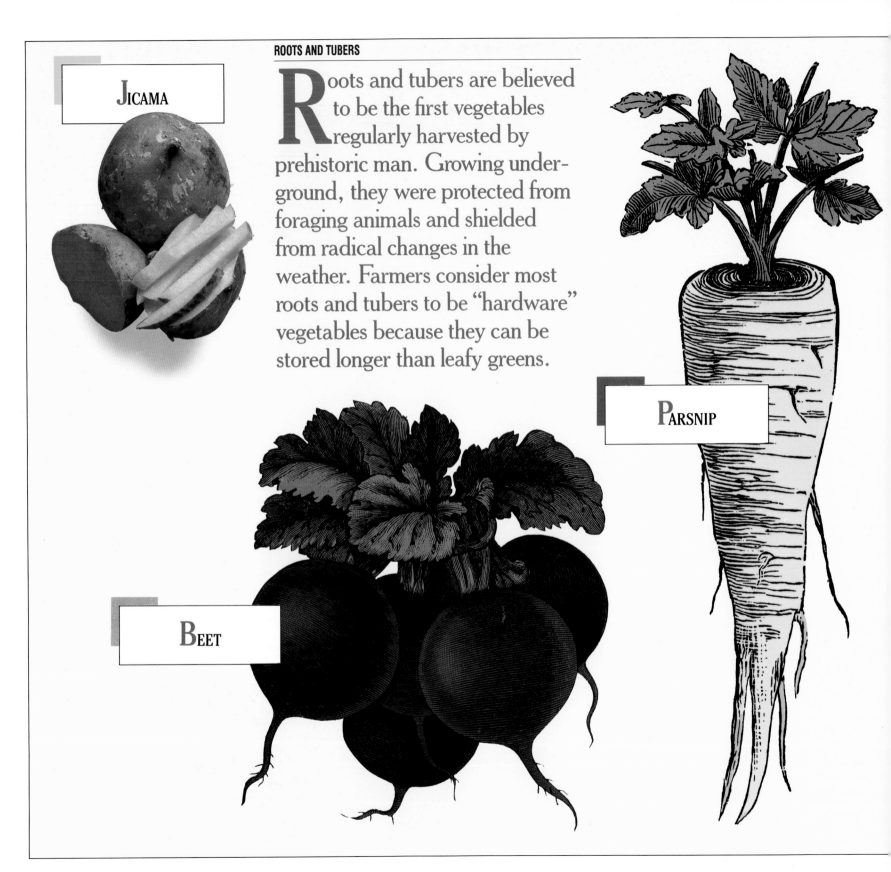

JICAMA

Roots and tubers are believed to be the first vegetables regularly harvested by prehistoric man. Growing underground, they were protected from foraging animals and shielded from radical changes in the weather. Farmers consider most roots and tubers to be "hardware" vegetables because they can be stored longer than leafy greens.

PARSNIP

BEET

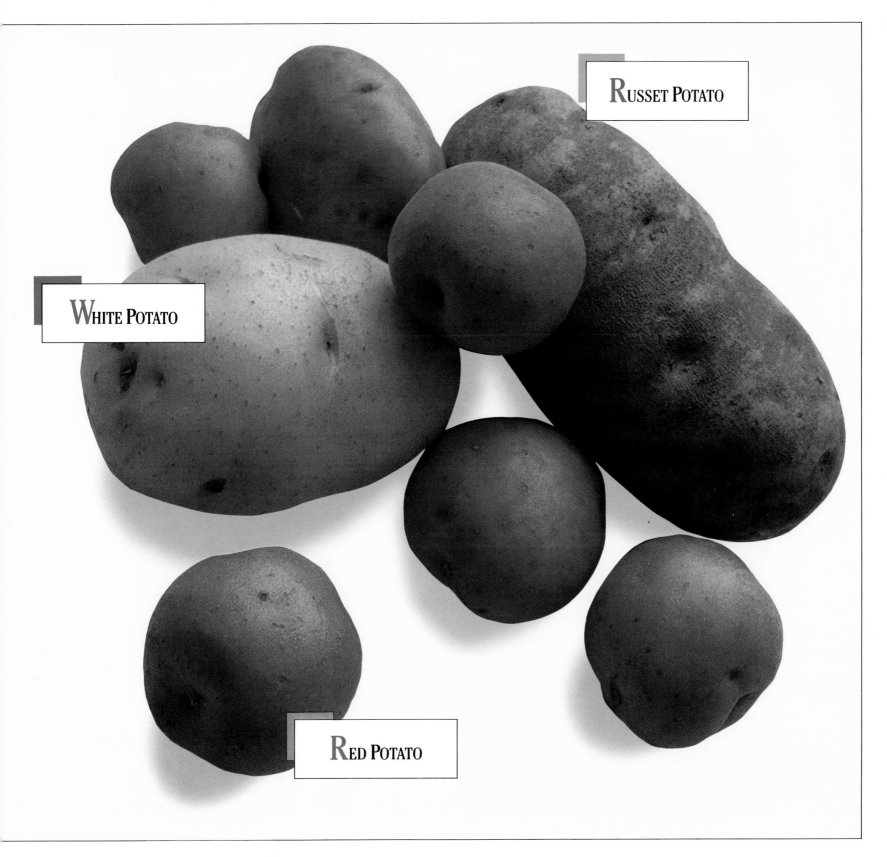

RUSSET POTATO

WHITE POTATO

RED POTATO

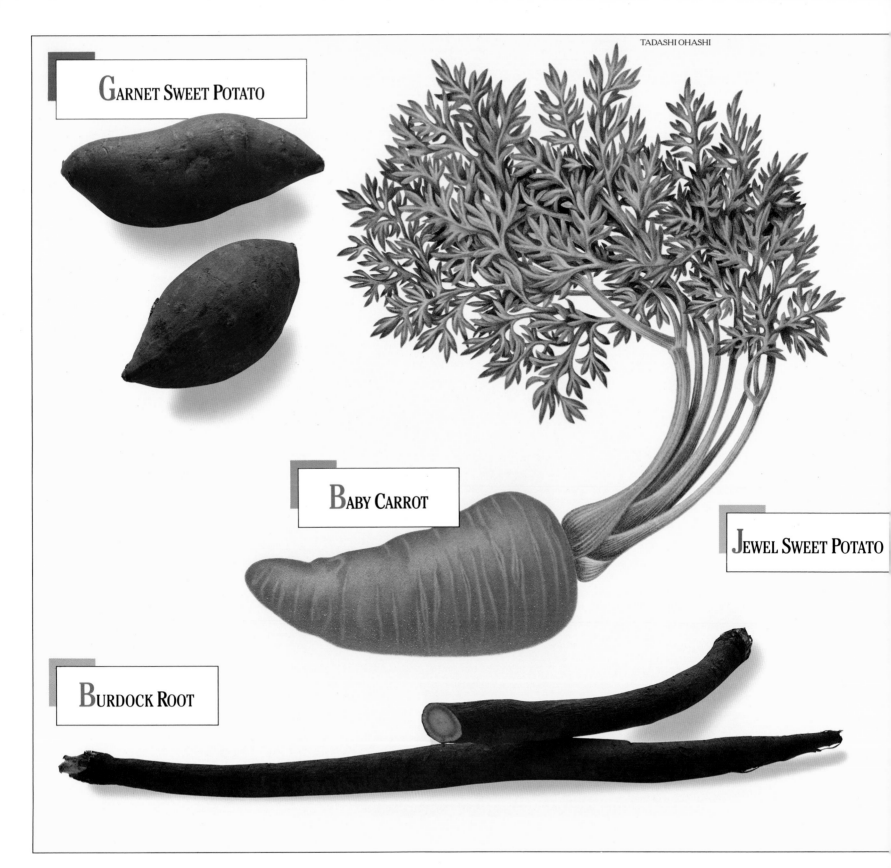

TADASHI OHASHI

GARNET SWEET POTATO

BABY CARROT

JEWEL SWEET POTATO

BURDOCK ROOT

White Turnip

Finnish Yellow Potato

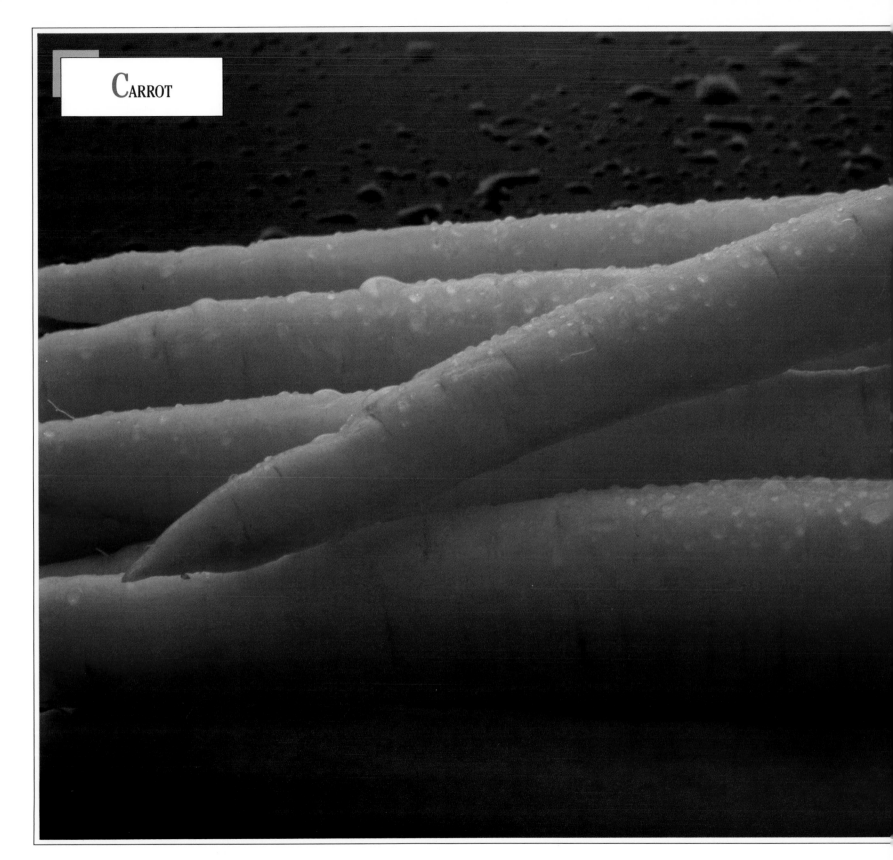

CARROT

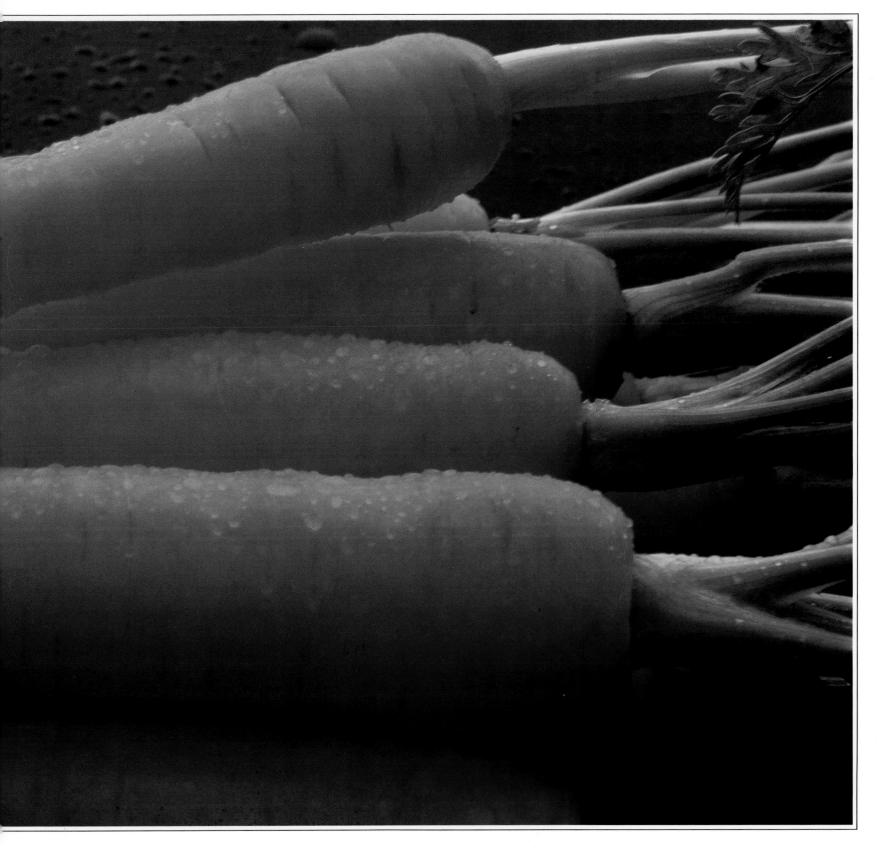

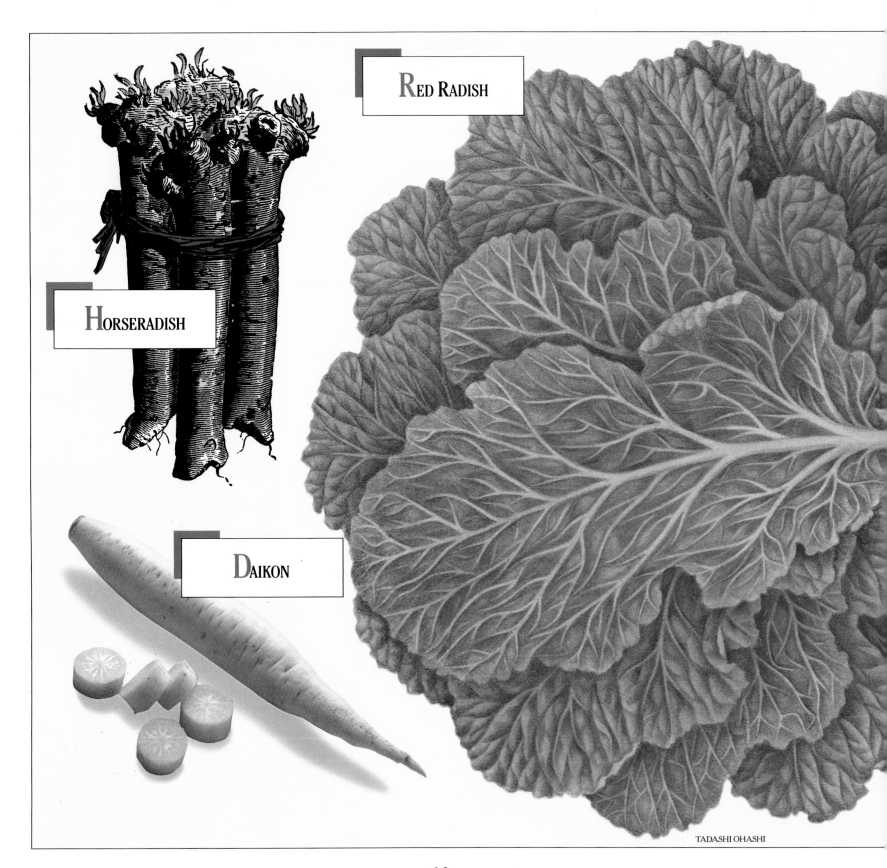

RED RADISH

HORSERADISH

DAIKON

TADASHI OHASHI

98

JERUSALEM ARTICHOKE

LOTUS ROOT

JERSEY SWEET POTATO

HANK OSUNA

The edible part of a squash is called a *pepo*, a fleshy gourd filled with seeds. Squashes are usually classified as belonging to either the summer or winter season. Summer squashes typically are small in size with tender edible rinds and seeds. Winter squashes are larger with tough outer shells and fibrous seeds.

ZUCCHINI SQUASH

TURBAN SQUASH

SPAGHETTI SQUASH

SQUASH BLOSSOM

COLLEEN QUINN

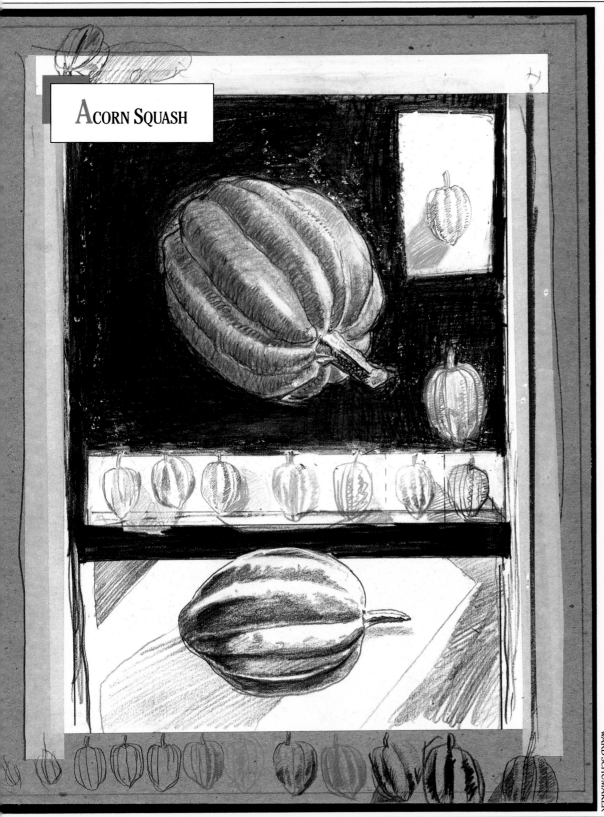

ACORN SQUASH

WARD SCHUMAKER

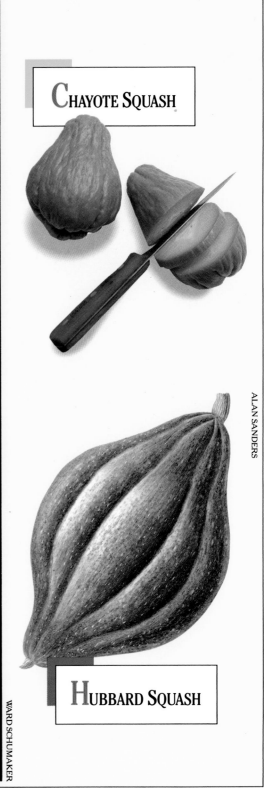

CHAYOTE SQUASH

ALAN SANDERS

HUBBARD SQUASH

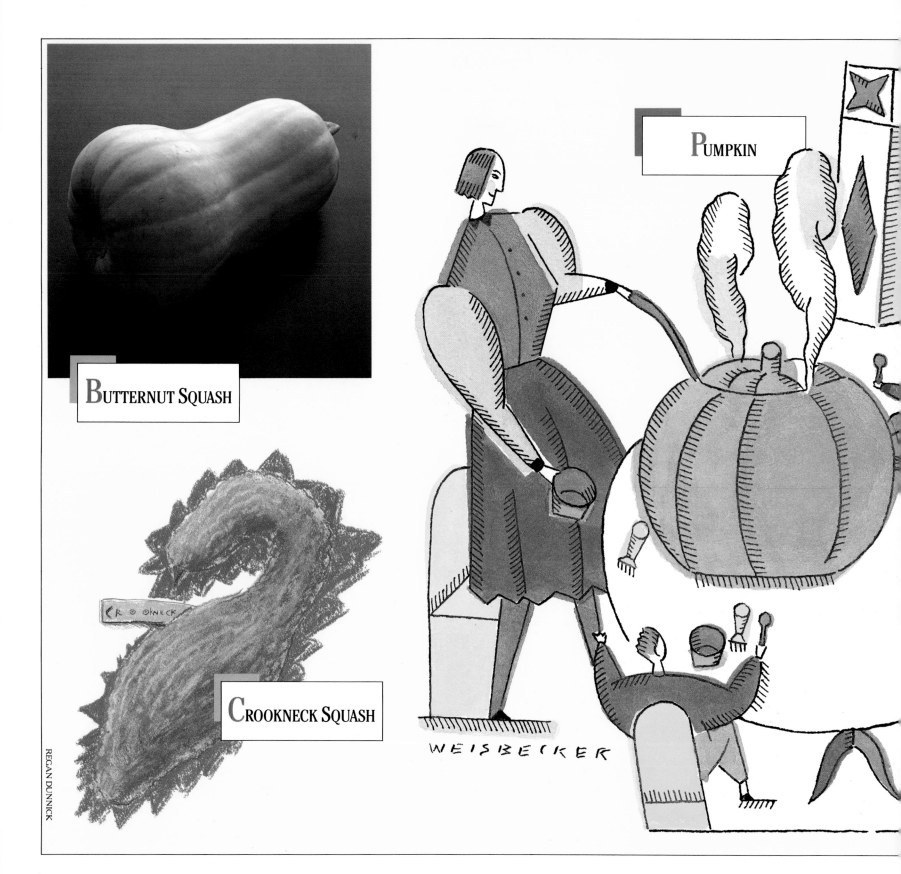

BUTTERNUT SQUASH

CROOKNECK SQUASH

PUMPKIN

WEISBECKER

REGAN DUNNICK

CALABAZA SQUASH

COCOZELLE SQUASH

SCALLOP SQUASH

PHILLIPE WEISBECKER

SARAH WALDRON

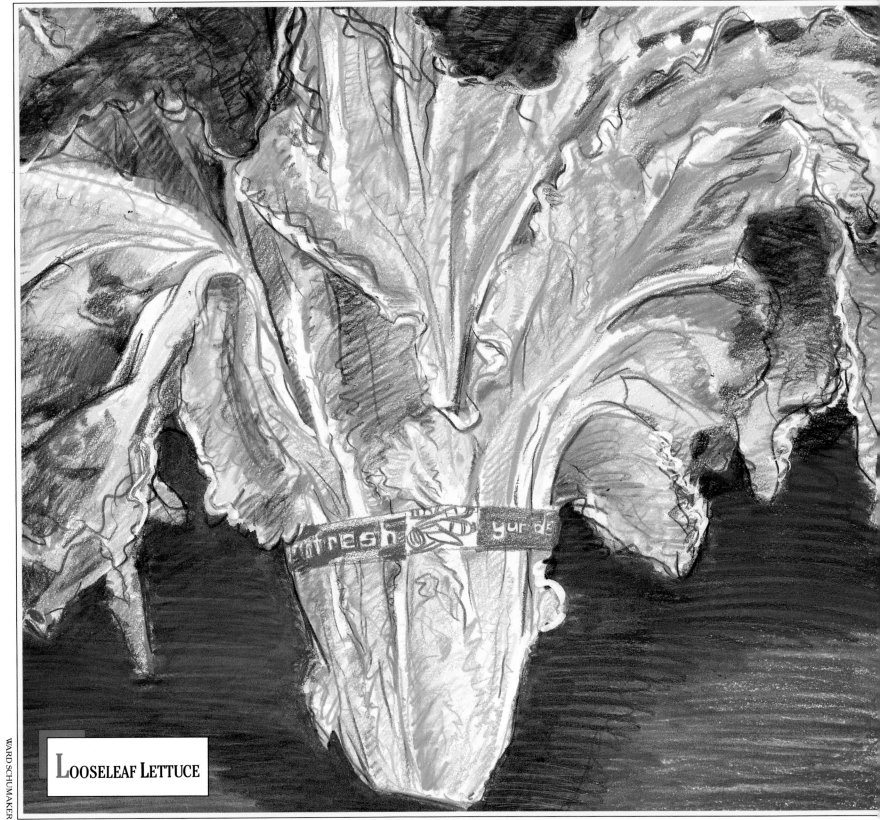

LOOSELEAF LETTUCE

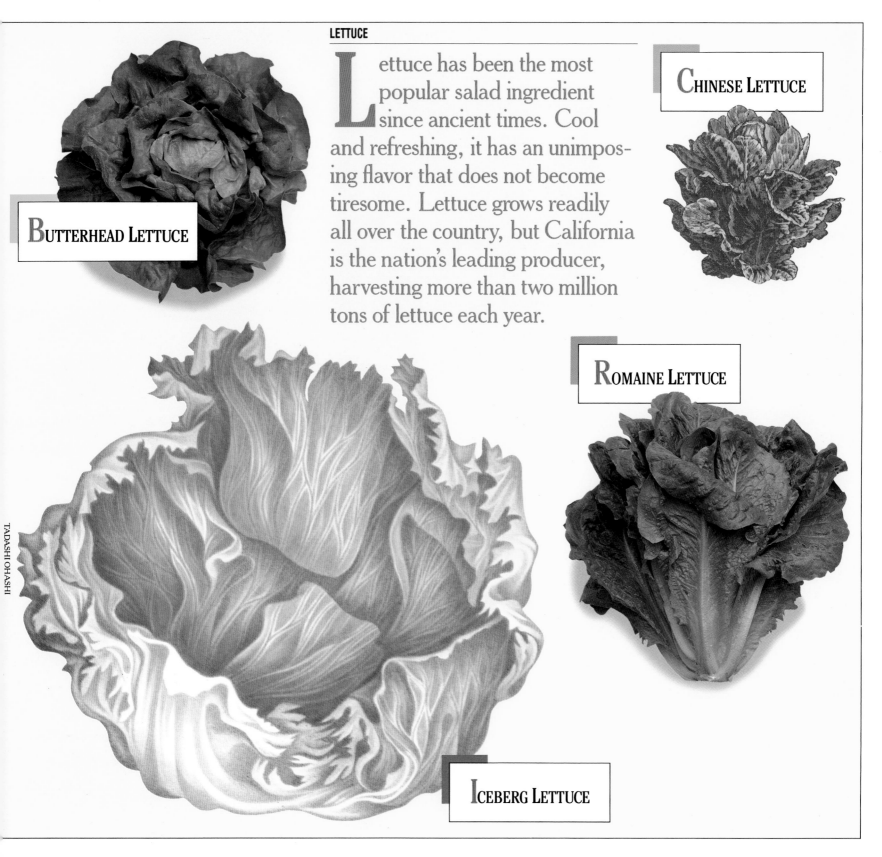

BUTTERHEAD LETTUCE

Lettuce has been the most popular salad ingredient since ancient times. Cool and refreshing, it has an unimposing flavor that does not become tiresome. Lettuce grows readily all over the country, but California is the nation's leading producer, harvesting more than two million tons of lettuce each year.

CHINESE LETTUCE

ROMAINE LETTUCE

ICEBERG LETTUCE

TADASHI OHASHI

105

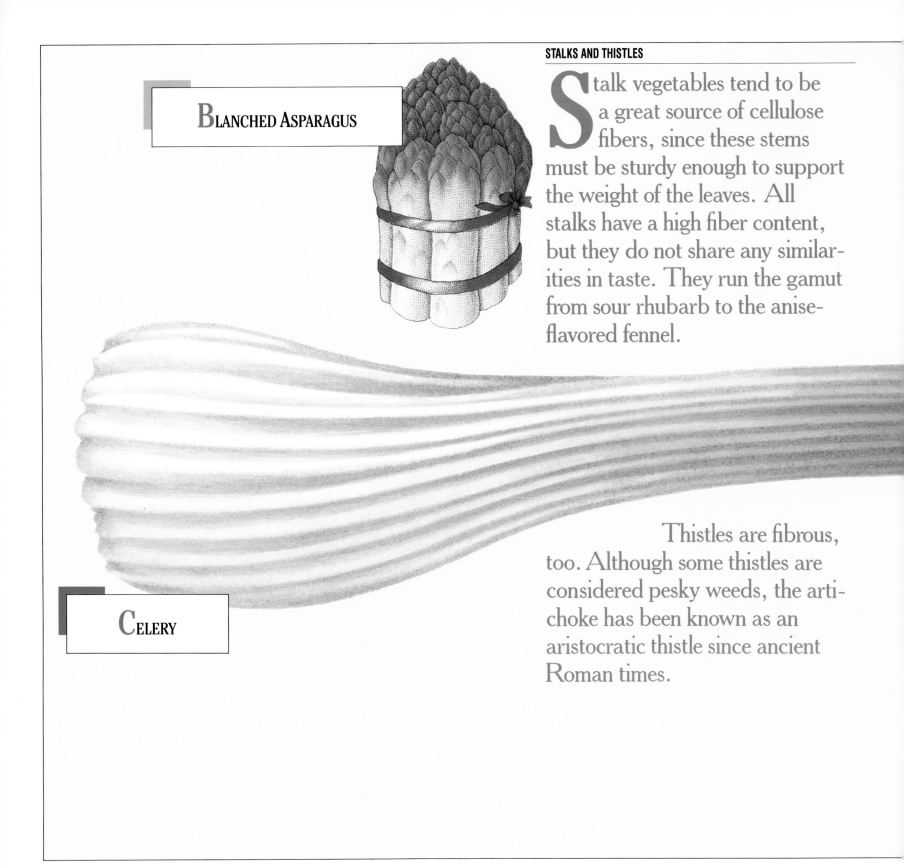

BLANCHED ASPARAGUS

S talk vegetables tend to be a great source of cellulose fibers, since these stems must be sturdy enough to support the weight of the leaves. All stalks have a high fiber content, but they do not share any similarities in taste. They run the gamut from sour rhubarb to the anise-flavored fennel.

Thistles are fibrous, too. Although some thistles are considered pesky weeds, the artichoke has been known as an aristocratic thistle since ancient Roman times.

CELERY

SWISS CHARD

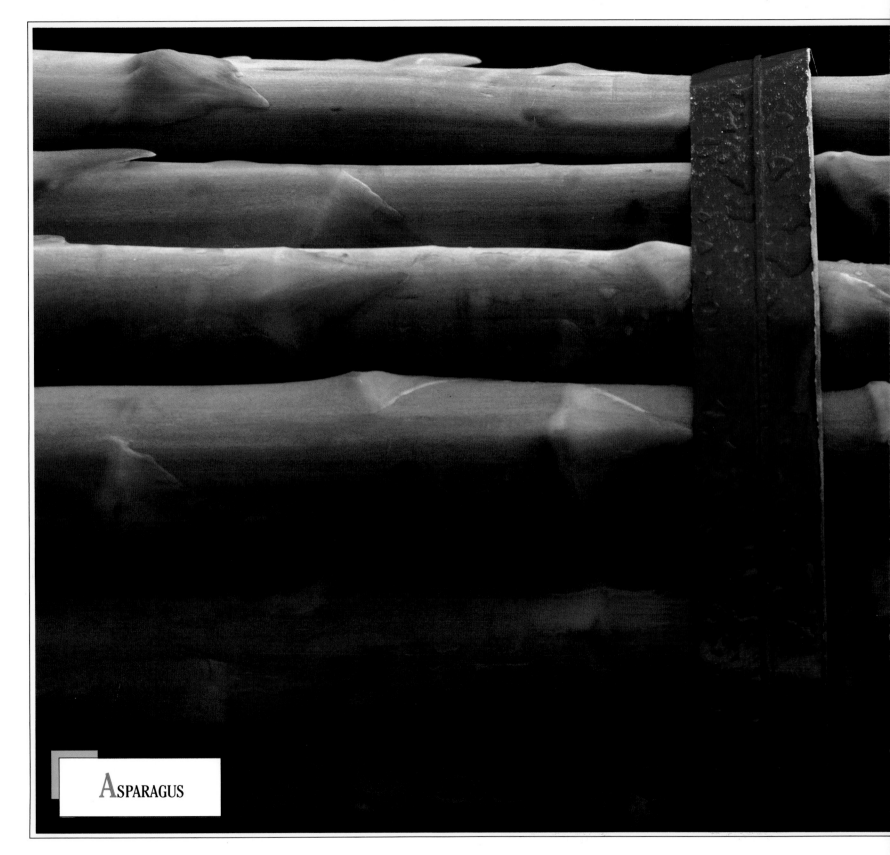

ASPARAGUS

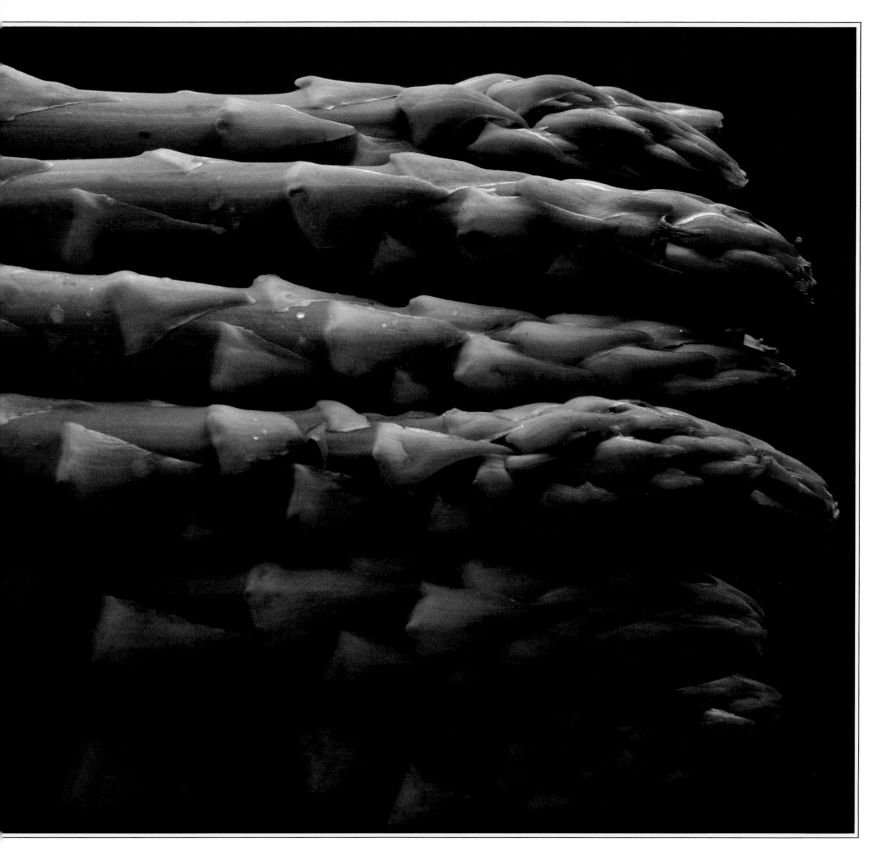

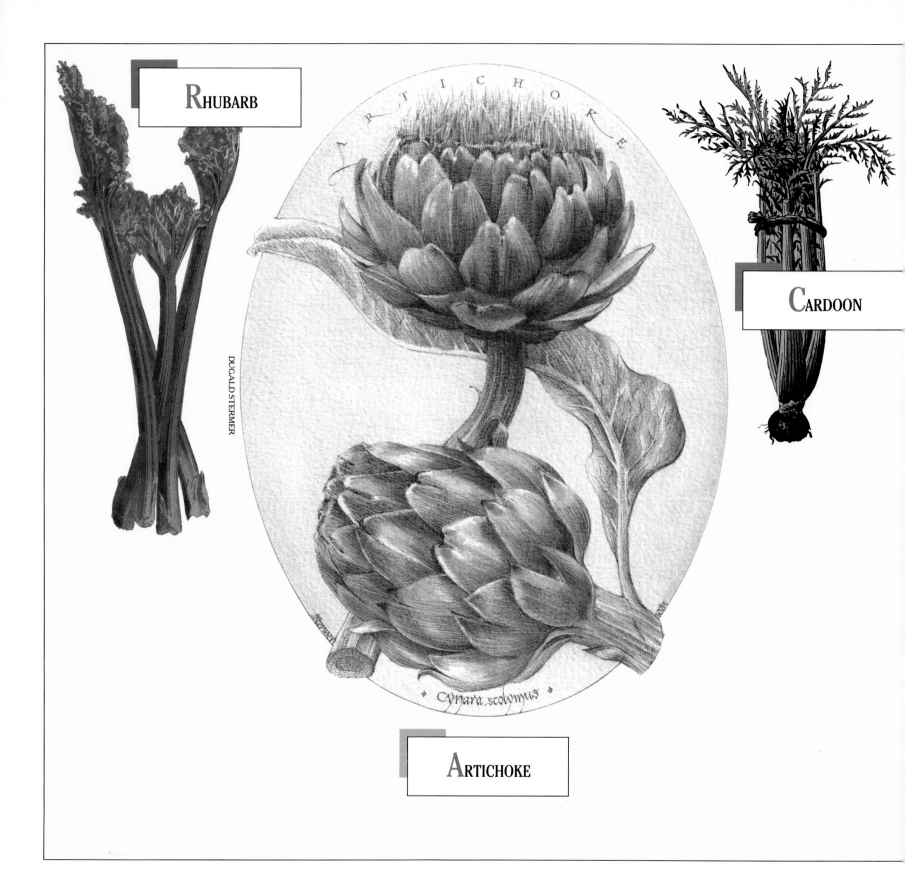

RHUBARB

DUGALD STERMER

ARTICHOKE

Cynara scolymus

CARDOON

FENNEL

Botanically, there are a number of fruits that are more often used as vegetables, including avocados, tomatoes, eggplants, and Asian melons. With the exception of avocados, which grow on trees, fruit vegetables mature on the vine and typically thrive in hot weather.

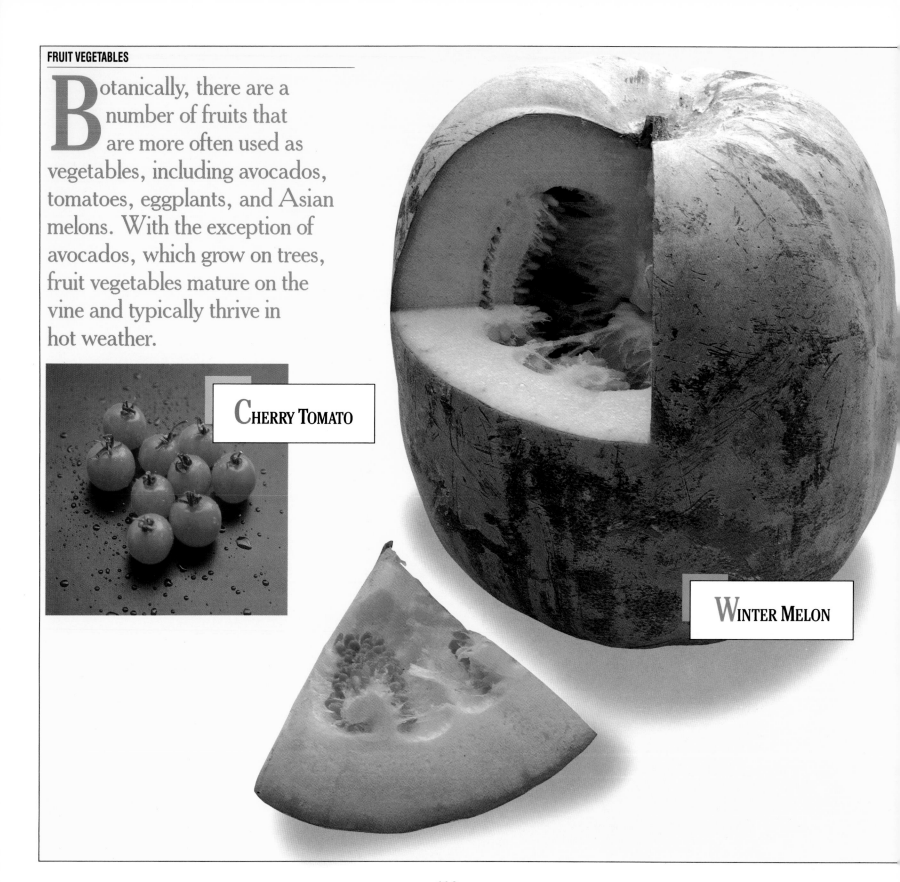

CHERRY TOMATO

WINTER MELON

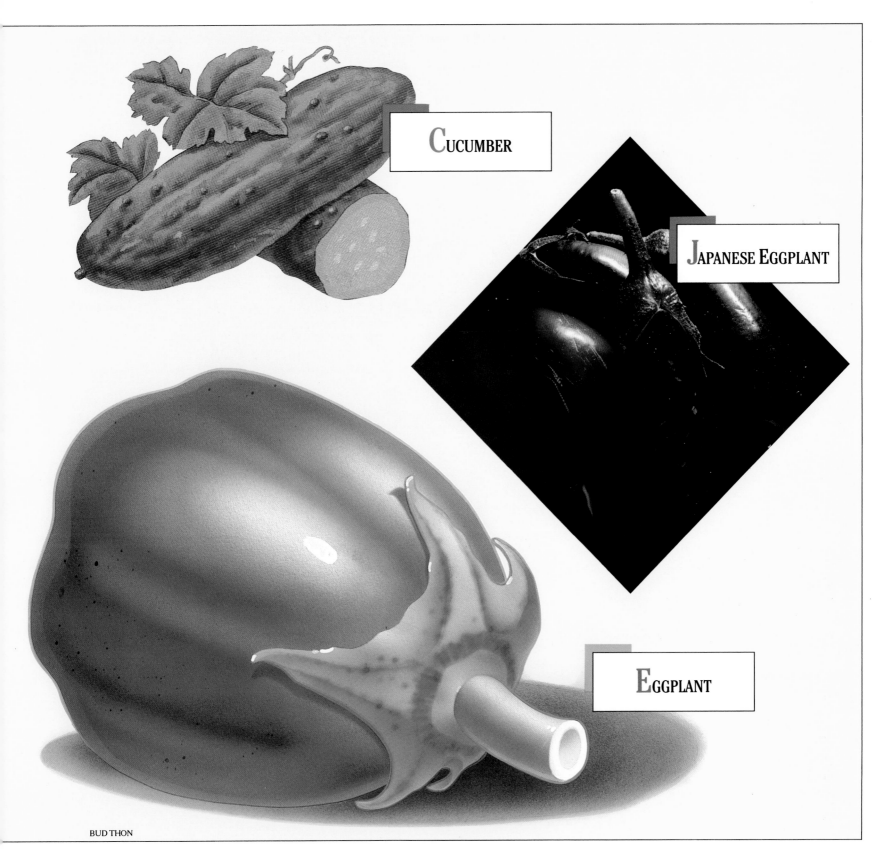

CUCUMBER

JAPANESE EGGPLANT

EGGPLANT

BUD THON

113

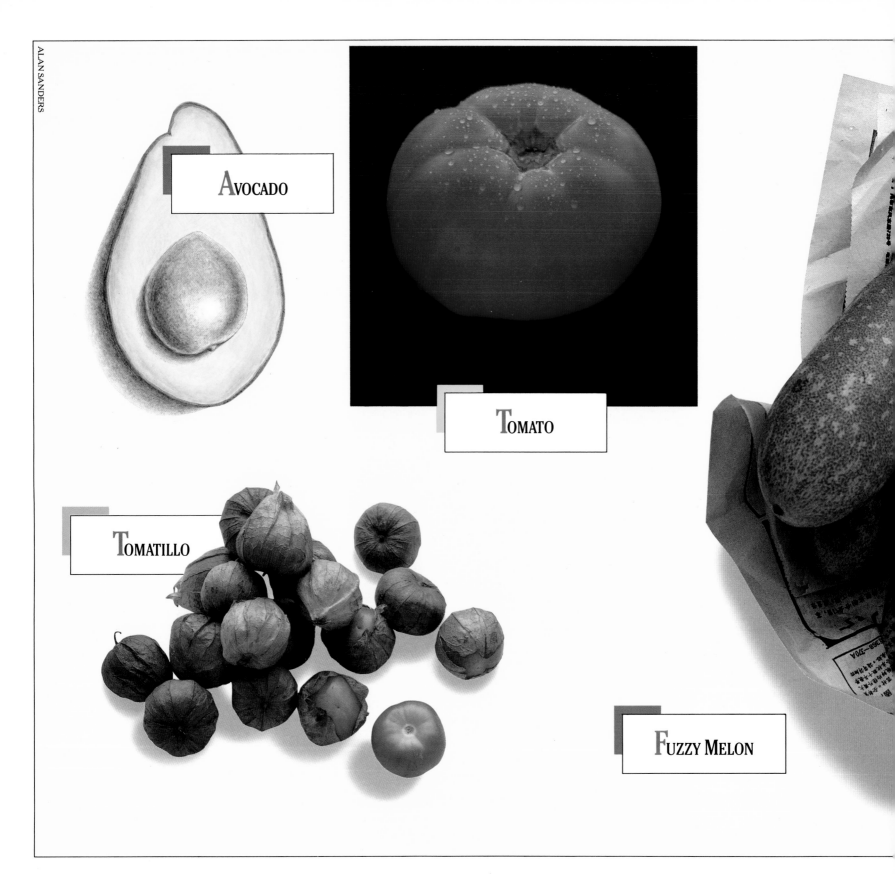

Avocado

Tomato

Tomatillo

Fuzzy Melon

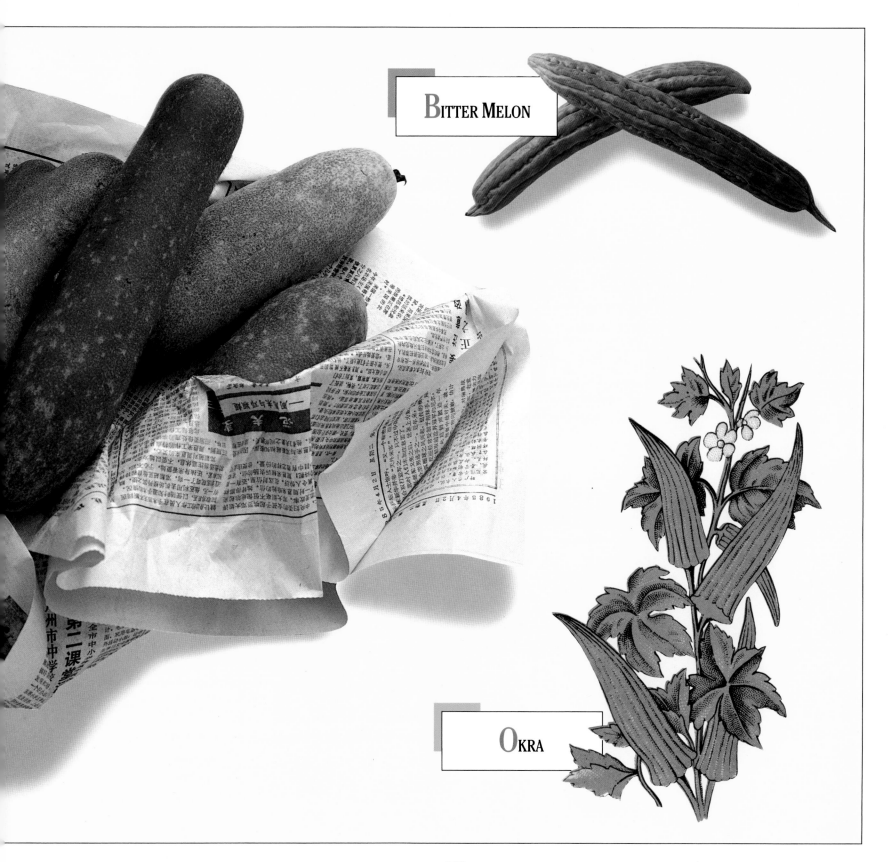

BITTER MELON

OKRA

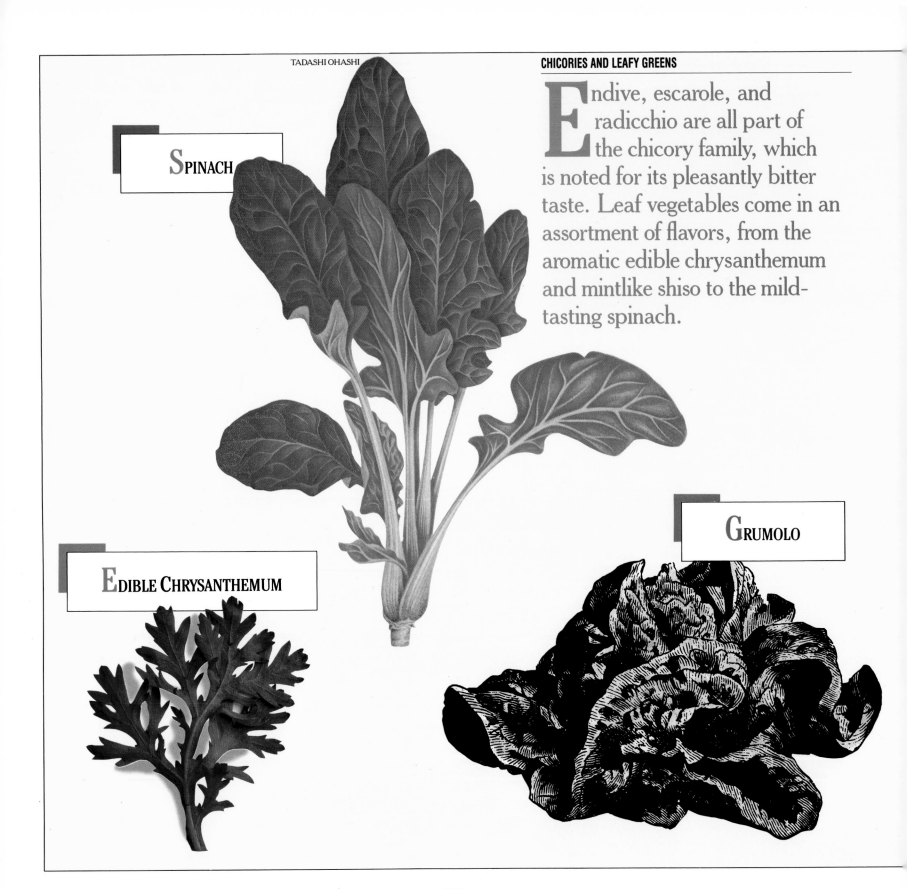

SPINACH

EDIBLE CHRYSANTHEMUM

GRUMOLO

Endive, escarole, and radicchio are all part of the chicory family, which is noted for its pleasantly bitter taste. Leaf vegetables come in an assortment of flavors, from the aromatic edible chrysanthemum and mintlike shiso to the mild-tasting spinach.

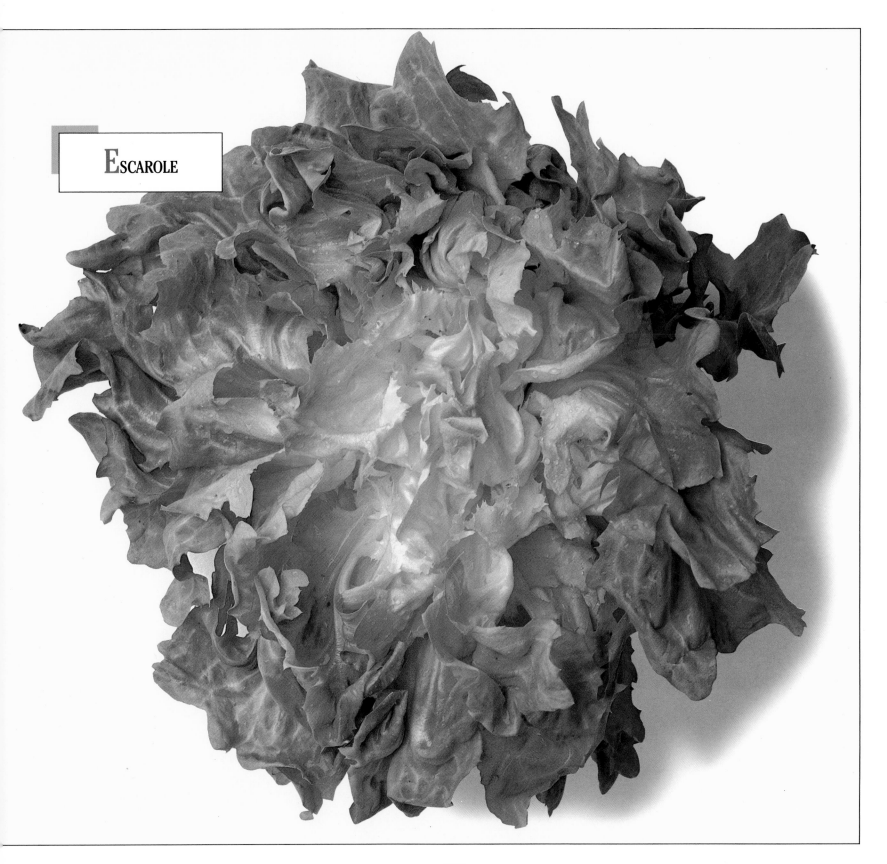

ESCAROLE

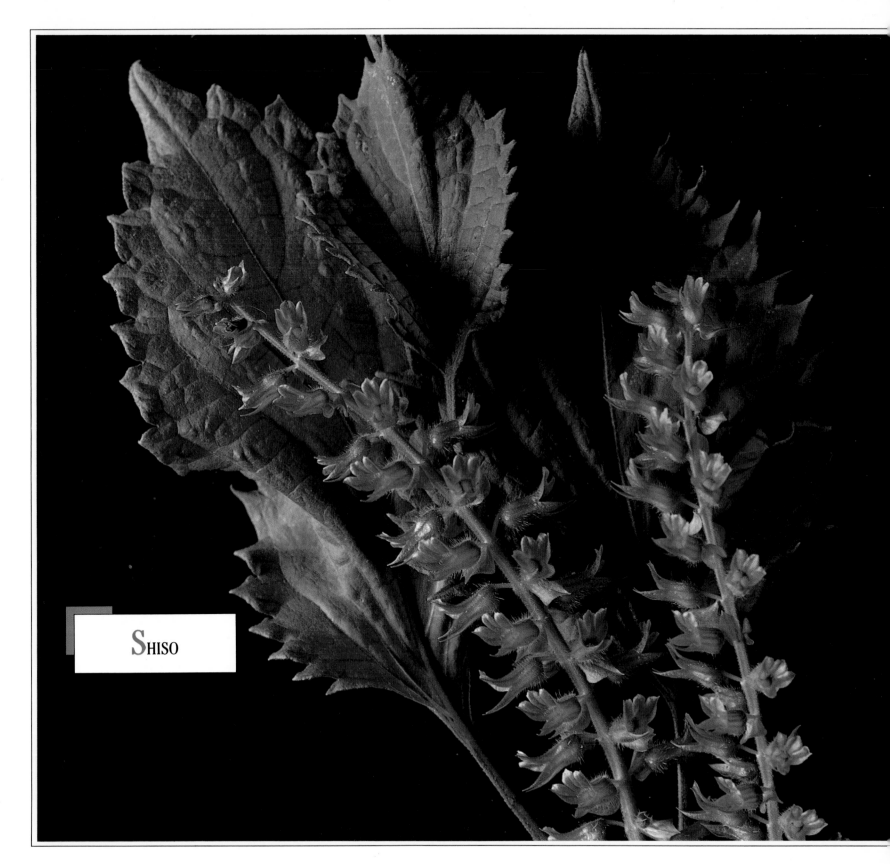

SHISO

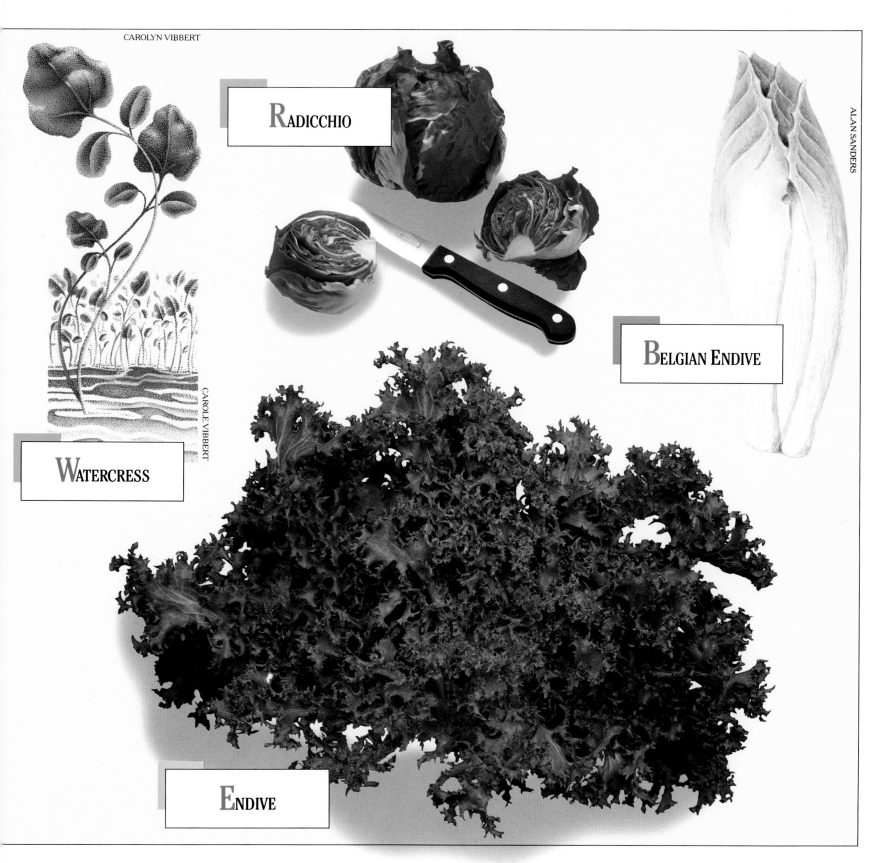

CAROLYN VIBBERT

ALAN SANDERS

CAROLE VIBBERT

RADICCHIO

BELGIAN **E**NDIVE

WATERCRESS

ENDIVE

119

VEGETABLE
RECIPES

SOUPS

The liquid nature of soup forces our attention on flavors, without the imposing distraction of textures. Soups allow us to discover the pungent essence of endive, the sweetness of carrots, and the starchy quality of peas.

ENDIVE SOUP

Serves 4-6

2 bunches endive or escarole, trimmed of hard rib sections
5 eggs
1 cup grated Romano or Parmesan cheese
⅛ teaspoon ground nutmeg
6 cups chicken stock
 salt and black pepper to taste

Steam the greens until wilted, and squeeze dry with hands. Cut into thin shreds and shape into walnut-sized balls. Beat the eggs, cheese, and nutmeg together. Bring the chicken stock to a boil. Season with salt and pepper to taste. Dip the balls into the egg batter and then drop them into the boiling chicken stock. When the egg has set, ladle stock and balls into bowls and serve immediately.

MUSTARD GREEN SOUP

Serves 4-6

6 cups chicken stock
⅓ pound lean pork, cut into thin, bite-sized strips and lightly sprinkled with salt
3 thin slices ginger root
1 pound mustard greens, chopped into 1-inch pieces*
2 teaspoons soy sauce (optional)
 salt to taste

Bring the stock to a boil, and add the pork and ginger root. Simmer for about 10 minutes. Add the mustard greens, cover, and simmer for 20 minutes. Season with soy sauce and salt to taste. Serve immediately.

Zucchini, chayote, or fuzzy melon may be substituted.

WATERCRESS CREAM SOUP

Serves 4-6

2 bunches watercress
3 cloves garlic, chopped
2 tablespoons butter
5 cups chicken stock
1 large potato, peeled and cubed
1½ cups heavy cream
 salt and black pepper to taste

Wash the watercress well, and discard the thicker stems. Save some sprigs for garnish, and chop the rest. In a saucepan, sauté the watercress and garlic in butter for 2 minutes. Add the chicken stock and potato, and boil until the potato is soft.

Purée until smooth in a blender or food processor, dividing the mixture into small batches so that it does not overflow the container. Transfer mixture to a saucepan placed over medium heat. Stir in cream, and reheat to serving temperature. Season with salt and pepper and serve at once.

WINTER MELON SOUP

Serves 6

1 medium whole winter melon*

½ tablespoon vegetable oil

½ pound pork, cut into thin, bite-sized strips and lightly sprinkled with salt

4 cups chicken stock

6 medium fresh shiitake mushrooms, quartered; or 6 dried shiitake mushrooms, soaked in 2 cups lukewarm water until soft, drained (press out excess water) and water reserved, and quartered

1 tablespoon soy sauce dash of MSG (optional)

6 fresh water chestnuts, peeled and sliced in ¼-inch-thick rounds**

½ pound shrimp, shelled and deveined

salt to taste

4 sheets dried laver (nori), lightly toasted over very low heat on stove until crisp

½ teaspoon Oriental-style sesame oil

1 green onion, finely chopped

Preheat the oven to 350° F. Cut off top one-third of winter melon and discard. Remove seeds and stringy inner portion and discard. Set melon upright in deep roasting pan.

Heat vegetable oil in saucepan and stir-fry pork until cooked. Add the chicken stock and reserved mushroom water and bring to a boil. Mix in the soy sauce and MSG, then add the mushrooms, water chestnuts, and shrimp.

Pour stock mixture into hollow of winter melon. Bake melon in the pre-heated oven for 1 hour, or until the white meat of melon becomes clear. Season with salt to taste.

Before serving, crumble in the dried laver, and add sesame oil and green onion.

Place melon on platter to serve. Ladle the broth into individual bowls, then scoop out some of the soft melon meat to add to each serving.

*Fuzzy melon, zucchini, or chayote cut into ⅜-inch-thick slices may be substituted for the winter melon. Continue to cook in a saucepan, and when the vegetable is tender, garnish with the dried laver, sesame oil, and green onion.

**Canned water chestnuts may be substituted.

SALADS

A salad is whatever you want to make it. Vegetables take on new personalities, depending on how they are combined, sliced, or seasoned. The only rules for a great salad are to start with fresh, ripe ingredients and a spirit of serendipity.

CABBAGE SLAW

Serves 6

1 small head red or green cabbage, shredded*

Dressing

1 2-ounce can anchovy fillets, drained

2 cloves garlic

½ cup olive oil

2 tablespoons red wine vinegar

1 tablespoon lemon juice salt and freshly ground black pepper to taste

Place the shredded cabbage in a large mixing bowl. In a blender or food processor, or a mortar with a pestle, blend together the anchovies and garlic into a paste. Add the olive oil and vinegar, and mix together well. Pour over the cabbage. Toss well. Sprinkle on the lemon juice, and salt and pepper. Toss again, and serve.

*Lettuce, escarole, or spinach may be substituted.

CHICKEN IN LETTUCE CUPS

Serves 4

1½ teaspoons dry sherry
½ teaspoon salt
¾ pound boned chicken breast meat, diced
5 tablespoons vegetable oil
¼ cup diced celery
¼ cup shelled green peas, boiled
1 fresh shiitake mushroom, diced; or 1 dried shiitake mushroom, soaked in ½ cup lukewarm water until soft, drained (press out excess water), and diced
¼ cup diced water chestnuts lightly toasted slivered almonds (optional)
1 head iceberg or romaine lettuce, separated into leaves to form cups
hoisin sauce (optional)*

Sauce
½ teaspoon salt
¾ teaspoon sugar
1 tablespoon dry sherry
1½ tablespoons oyster sauce*

Sprinkle the sherry and salt on the chicken, and let it set for about 5 minutes. Heat 3 tablespoons oil until very hot in a skillet or wok, add the chicken, and stir-fry until white. Do not overcook. Set aside. Heat 2 tablespoons oil, and quickly stir-fry the celery, peas, mushroom, and water chestnuts for about 1 minute or just enough time to heat through. Combine the sauce ingredients and add with chicken to the vegetables. Stir-fry for another 2 minutes. Transfer to a bowl, and sprinkle almonds on top.

Guests take a lettuce cup, spread it with a little hoisin sauce, add some of the chicken mixture, wrap it up, and then eat with the fingers.

Sold in bottles and cans in Oriental food stores and some large grocery chains.

DAIKON AND CARROT SALAD

Serves 4

1 medium daikon
1 carrot
1 teaspoon salt
toasted white sesame seeds for garnish (optional)

Sauce
3 tablespoons white vinegar
2½ tablespoons sugar
½ teaspoon salt
⅛ teaspoon MSG (optional)

Peel the daikon and cut into 2-inch lengths. Cut again lengthwise into ⅓-inch-thick slices, then cut each slice into very thin julienne strips. Peel the carrot and cut in the same way. Place daikon and carrot in a bowl, and sprinkle with salt. Knead the vegetables a little until limp. Place a heavy plate or other weight over them, and let stand for about 30 minutes.

Place the daikon and carrot in ice water for a few seconds, drain, and repeat. The vegetables should become crisp. Drain thoroughly.

In a small saucepan, combine the sauce ingredients and heat, stirring, just enough to dissolve the sugar and salt. Cool and combine with the vegetables. Garnish with the sesame seeds.

FENNEL SALAD

Serves 4-6

2 fennel bulbs, trimmed*

Dressing
1 cup olive oil
⅓ cup lemon juice
3 tablespoons red wine vinegar
1 clove garlic, finely minced
⅓ cup grated Parmesan cheese
2 tablespoons finely minced parsley
2 teaspoons dried oregano
¼ teaspoon salt
⅛ teaspoon freshly ground black pepper

Wash and clean the fennel bulbs in cool water, and cut into quarters or sixths. Arrange the fennel on a serving dish. Blend together the dressing ingredients, and pour into individual serving bowls. The fennel should be dipped in the sauce and eaten with fingers.

Variation: The fennel may be sliced and other vegetables added to make a tossed salad.

The feathery fennel tops may be minced and added to the dressing ingredients, or saved as an excellent seasoning for salads, boiled vegetables, or white meat or fish.

JICAMA AND PAPAYA SALAD

Serves 4-6

1 *bibb lettuce, washed and separated into leaves*
1 *medium jicama, peeled and cut into cubes*
2 *ripe papayas, peeled, seeded, and cut into cubes*
3 *limes*
chili powder or cayenne pepper
1/3 *cup grated Monterey jack cheese*

Arrange the lettuce leaves in a bowl, and fill with the jicama and papaya cubes. Squeeze on the lime juice or garnish with lime wedges. Lightly sprinkle with chili powder and cheese. Serve cold.

LATINO SALAD

Serves 4-6

1 *head romaine lettuce, torn in bite-sized pieces*
1 *bunch coriander, chopped*
1 *bunch radishes (discard leaves), thinly sliced*
1 *green bell pepper, deseeded and chopped*
2 *avocados, peeled, deseeded, and sliced*
2 *ripe tomatoes, sliced*
1/2 *pound shrimp, boiled, shelled, and deveined*
1/3 *cup olive oil*
2 *limes, cut in half and deseeded*
salt and black pepper to taste

Arrange the vegetables and shrimp in a large bowl, and drizzle with the olive oil. Squeeze on the lime juice, and add salt and pepper. Toss lightly.

LOTUS ROOT SALAD

Serves 4

5 *cups water*
2 *tablespoons white vinegar*
1 *lotus root, cut in half crosswise*
1/4 *pound shrimp, boiled, shelled, deveined, and sliced in half lengthwise*
2 *tablespoons minced fresh parsley*

Sauce
1/3 *cup white vinegar*
1/4 *cup sugar*
1/2 *teaspoon salt*
1/8 *teaspoon MSG (optional)*

Bring the water and vinegar to a boil and parboil the lotus root just long enough to heat through, about 5 minutes. Drain and place in cold water for 3 minutes, then peel and slice in rounds as thinly as possible.

In a small saucepan, mix together the sauce ingredients, and heat, stirring, just enough to dissolve the sugar and salt. Cool. Combine the lotus root, shrimp, parsley, and sauce, toss well, and serve.

SPAGHETTI SQUASH SALAD

Serves 4

1 *3-pound spaghetti squash, cut in half lengthwise*
1 *whole chicken breast, boiled, boned, skinned, and shredded*
1 *carrot, cut into thin julienne strips*
2 *green onions, cut into slivers*
1 *tablespoon minced coriander*
1/2 *teaspoon slivered ginger root*

Sauce
3 *tablespoons cider vinegar*
1/3 *cup vegetable oil*
1 *teaspoon Oriental-style sesame oil*
1/2 *teaspoon salt*
3/4 *teaspoon sugar*
1/8 *teaspoon black pepper*

Boil the squash, cut side down, in water for about 20 minutes. Drain, and with a fork lift the meat away from the shell so it forms noodlelike strands. Discard the shell, and cool the strands. Combine the strands with the chicken, carrot, onions, coriander, and ginger.

Mix together well all of the sauce ingredients. Pour over the salad. Toss lightly, and serve.

SIDE DISHES

The traditional role of vegetables in American cooking has been to act as a side dish, an accompaniment to the main course, which invariably has been some type of meat. With a little effort, a side dish can be a star on its own.

BABA GHANNOUJ (Eggplant Dip)

Middle Eastern **8**

Serves 8

1 large globe eggplant
1 tablespoon finely chopped onion*
2 tablespoons finely chopped parsley
2 tablespoons lemon juice
3 tablespoons olive oil
3 tablespoons toasted white sesame seeds, finely ground (optional)
 salt and black pepper to taste
 cayenne pepper for garnish (optional)
 sesame seed crackers or Armenian bread

Wash and roast the whole eggplant at 400° F. for about 40 minutes, or until soft.** Cool the eggplant slightly. Peel off the skin and discard. Squeeze out some of the liquid. Mash or blend the eggplant pulp with all other ingredients until mixture is smooth. Spoon onto a shallow dish and garnish with cayenne pepper. Serve cold or at room temperature with sesame seed crackers.

**1 to 2 cloves garlic, finely minced, may be substituted.*

***Eggplant may be roasted on a hot charcoal grill or in the broiler. This will take less time and will give this dip an interesting charred flavor.*

BEETS WITH SOUR CREAM

Russian **4**

Serves 4-6

2 pounds beets, washed and trimmed with 1-inch stems
2 tablespoons minced onion
⅔ cup sour cream
1¼ teaspoons prepared horseradish
⅜ teaspoon salt
⅛ teaspoon freshly ground black pepper
 snipped chives or chopped walnuts for garnish (optional)

Boil the beets in lightly salted water to cover until tender. Young beets will take 30 minutes to 1 hour; older beets will take 1 to 2 hours. Drain and place in cold water to cool. Peel and cut in ¼-inch-thick slices. Mix together the beets and onion, and place in a serving bowl. Combine the sour cream, horseradish, salt, and pepper, and pour over the vegetables. Garnish with chives.

CHINESE BROCCOLI WITH OYSTER SAUCE

Chinese **4**

Serves 4-6

1½ pounds Chinese broccoli (also called Chinese kale, or gai laan), washed and cut apart*
¼ cup vegetable oil
¼ teaspoon salt
1 clove garlic, minced
¼ cup oyster sauce**

Boil the broccoli in water to cover for 2 minutes, and drain well. Heat the oil very hot in a large skillet or wok, and add the salt and garlic. Stir-fry the garlic to a light golden brown. Add the broccoli and oyster sauce, and stir-fry quickly, just long enough to coat and heat through. Serve immediately.

**Chopped bok choy, nappa cabbage, or asparagus, or parboiled broccoli or cauliflower may be substituted. Do not overcook.*

***Sold in bottles in Asian specialty markets and many supermarkets.*

CHINESE OKRA FRIED IN BUTTER

Serves 4

1 pound Chinese okra*
 salt, black pepper, and
 flour
1 egg
1 tablespoon milk
 cracker crumbs
4 tablespoons butter

Wash and scrape off the brown edges of the okra. Cut the okra into lengthwise strips about ½ inch thick. Sprinkle with salt, pepper, and flour. Lightly beat the egg and milk together. Dip the okra strips into the egg mixture and roll them in the crumbs. Heat the butter in a skillet, and fry the okra until light golden brown and crisp on all sides, about 5 minutes. Serve immediately.

Common okra, zucchini, or eggplant may be substituted.

CHRYSANTHEMUM LEAVES WITH SESAME

Serves 4

1 bunch edible
 chrysanthemum leaves,
 about ½ pound*

Sauce
3 tablespoons toasted
 white sesame seeds,
 finely ground
1 teaspoon sugar
1½ tablespoons soy sauce
1 teaspoon Japanese rice
 wine (sake)

Bring a pot of lightly salted water to a boil, add the chrysanthemum leaves, and parboil until limp. Drain leaves and rinse immediately in cold water. Drain well and squeeze out the excess water. Cut the leaves into 1½-inch lengths. Combine the sauce ingredients, and add to the leaves. Toss lightly, and serve.

Spinach, beet tops, or nappa cabbage may be substituted.

CORN MEDLEY

Serves 4-6

3 cups corn kernels (about
 3 ears), or 1 20-ounce
 package frozen corn
 kernels
½ small onion, thinly sliced
1 small bell pepper (green,
 yellow, or red), diced
1 medium ripe tomato,
 diced
½ cup milk
¼ cup vegetable oil
½ teaspoon sugar
 (optional)
 salt and black pepper
 to taste

Combine all of the ingredients in a saucepan placed over medium heat. Cook for about 15 minutes, or until the corn is tender and the liquid has almost completely evaporated.

CURRIED PEAS

Serves 4

2 pounds fresh green peas,
 shelled, or 1 10-ounce
 package frozen peas,
 boiled and cooled
2 teaspoons minced onion
1½ tablespoons chopped
 water chestnuts
1½ tablespoons slivered
 blanched almonds,
 toasted
½ cup mayonnaise
½ teaspoon curry powder

Combine all of the ingredients, mix well, and serve.

FRENCH–FRIED PARSNIPS

Serves 4

 vegetable oil for deep
 frying
2 pounds parsnips, peeled
 and cut into strips
 grated Parmesan cheese

Heat the oil to about 375° F. in a deep frying pan. Fry the parsnip strips, as you would french fries, until a golden brown, about 3 minutes. Drain on paper towels, and sprinkle with cheese. Serve immediately.

FRIED CARDOONS

Serves 6

1 bunch cardoons
 (about 3 pounds)
1 lemon, cut into quarters
 vegetable oil for deep
 frying
 salt and black pepper
2 cups all-purpose flour
3 eggs, beaten

Discard the outer stalks and stringy parts of the cardoons, and clean tender center stalks like celery. Cut into 2-inch pieces, and soak pieces in cold water to cover with lemon quarters for about 30 minutes. Boil a large pot of water, and cook the cardoons and lemon for about 30 minutes, or until barely tender. The cooking time will depend on the age of the cardoons. Younger ones will take longer to cook. Discard the lemon, and drain and cool the cardoon pieces thoroughly.

Heat oil in a deep pan to 375° F. Lightly sprinkle the cardoon pieces with salt and pepper, and then dredge them in flour. Dip in egg, and drop into oil. (Fry a few pieces at a time; do not crowd the pan.) Fry to a golden brown. Remove the cardoon pieces with a slotted utensil and drain off the excess oil on paper towels. Serve hot or cold.

GREEN LIMA BEANS AND HAM

Serves 4-6

2 tablespoons butter
⅓ cup chopped onion
2 pounds fresh lima beans,
 shelled, or 1 10-ounce
 package frozen lima
 beans*
1 cup water or stock
¼ teaspoon sugar
¼ cup diced boiled ham

Melt the butter in a saucepan, and lightly sauté the onion. Then add the beans, water, and sugar. Cover and boil rapidly for about 10 minutes, stirring occasionally. Add the ham, and cook over low heat until the beans are tender and the liquid has mostly evaporated. Serve hot.

Peas may be substituted. They will require less cooking time.

GRILLED BELGIAN ENDIVE

Serves 4-6

8 medium Belgian
 endives, washed and cut
 in half lengthwise*
⅓ cup olive oil
1 clove garlic, minced
 salt and black pepper
1 lemon, cut into 8 wedges

Dry the endives thoroughly, being careful not to damage the leaves. Combine the olive oil and garlic, and with a brush baste the leaves. Sprinkle endives with salt and pepper, and then grill over hot charcoals (or in the broiler), roasting both sides. Garnish with lemon wedges, and serve hot.

Radicchio may be substituted.

HUTSPOT

Serves 6

3 medium carrots, peeled
 and chopped*
1 medium onion, chopped
¾ cup water
½ teaspoon salt
5 medium potatoes, peeled
 and cubed
2½ tablespoons butter
 salt and black pepper to
 taste

Boil the carrots and onion together in ¾ cup water (or less, if possible) and ½ teaspoon salt until tender. Drain and reserve the liquid; set the vegetables aside. Boil the potatoes in lightly salted water to cover until tender. Drain the potatoes.

Mash the potatoes with butter (or beat with an electric mixer). Add the carrots and onion, and continue to mash until well combined. Flecks of carrot should still be visible. If the mixture appears too dry, add a little of the reserved liquid for a better consistency. Season with salt and pepper. Serve this dish hot.

Rutabaga or kale may be substituted.

JERUSALEM ARTICHOKES AU GRATIN

Serves 4-6

1½ pounds Jerusalem artichokes, scrubbed and any dark blemishes removed

salt and black pepper to taste

⅓ cup freshly grated Parmesan cheese

2½ tablespoons butter

Preheat oven to 400° F. Boil the artichokes in lightly salted water to cover until barely done, about 10 to 15 minutes. Drain, peel, and slice. Arrange the artichokes in a baking dish, and add salt and pepper to taste. Sprinkle with cheese and dot with butter. Bake in the preheated oven until the artichokes are tender and the butter has melted, about 7 minutes. Serve hot.

KIMPIRA

Serves 4

3 to 4 burdock roots

1 carrot, peeled

1½ tablespoons Oriental-style sesame seed oil or vegetable oil

2 tablespoons sugar dash of MSG (optional)

⅛ teaspoon seven-spice seasoning mixture (shichimi togarashi) or cayenne pepper (optional)

¼ cup soy sauce

toasted white sesame seeds for garnish

Using a dull knife, scrape the brown outer layer from the burdock roots. Cut the burdock roots and carrot into matchsticklike strips (you should have about 4 cups of burdock root and ½ cup of carrot), and soak together in cold water to cover for about 20 minutes. Drain and remove excess water by wrapping briefly in a dish towel.

Heat oil in a skillet or wok and stir-fry the burdock root and carrot for about 5 to 8 minutes over medium-high heat. Add sugar, MSG, and seven-spice seasoning, and mix in well. Then add soy sauce, and stir-fry until liquid is absorbed. Sprinkle with sesame seeds before serving.

MARINATED BRUSSELS SPROUTS

Serves 4-6

1¼ pounds brussels sprouts, washed and trimmed

Seasoning

⅓ cup vegetable oil

¼ cup red wine vinegar

1 teaspoon Worcestershire sauce

½ teaspoon dry mustard

½ teaspoon salt

½ teaspoon sugar

¼ teaspoon dried oregano

¼ teaspoon dried thyme

⅛ teaspoon black pepper

bacon bits, cherry tomatoes, and/or minced parsley for garnish (optional)

Boil the brussels sprouts in lightly salted water to cover for about 6 minutes, or until tender. Drain well. Blend together the seasoning ingredients, and pour over the sprouts. Chill at least 3 hours.

For added color, garnish with bacon bits just before serving.

SAUTÉED CUCUMBERS AND MINT

Serves 4-6

3 medium cucumbers, peeled, deseeded, and sliced ¼ inch thick

¼ teaspoon sugar

2 tablespoons butter

¼ cup chopped fresh mint

salt and black pepper to taste

Bring a pot of lightly salted water to rapid boil, add the cucumbers, and boil for 30 seconds. Drain well, and sprinkle with sugar. Melt the butter in a skillet, and sauté the cucumbers and mint just long enough to heat through. Season with salt and pepper to taste.

SOUTHERN-STYLE GREENS

Serves 4

2 pounds collard, mustard, or turnip greens
3 strips bacon
¼ cup chopped onion
¾ cup hot water
¼ teaspoon salt
2 tablespoons white vinegar
⅛ teaspoon black pepper

Wash the greens well, removing tough stems and ribs, and shred leaves. Fry the bacon in a large pot over medium heat until crisp. Remove the bacon with a slotted utensil and drain on paper towels.

In the same pot, fry the onion in the bacon fat until golden brown, and then add the greens, water, and salt. Cover and simmer until tender, about 25 minutes. Drain and reserve the liquid ("pot likker"), and transfer the greens to a serving dish. Sprinkle with the vinegar and pepper. Crumble bacon over the top, and serve.

In the South, this dish is served with cornbread, for sopping up the "pot likker."

SWISS CHARD AND RICE

Serves 6-8

½ cup chopped onion
1 clove garlic, minced
4 tablespoons butter
1 bunch swiss chard (about 1 pound), shredded (use only the leafy green part)
1 cup raw long-grain white rice
3 cups hot chicken stock
 salt and black pepper to taste
 grated Romano or Parmesan cheese

Using a large skillet with a lid, sauté the onion and garlic in butter until light golden brown. Add the swiss chard and sauté until limp. Add the rice and evenly distribute with the swiss chard in the pan. Pour in the hot stock, and season with salt and pepper to taste. Cover and simmer for 20 minutes, or until the rice is cooked. Sprinkle with grated cheese, and serve immediately.

ZUCCHINI WITH DILL

Serves 4-6

1½ pounds zucchini, crookneck, or other summer squash, sliced
2 tablespoons butter
1 teaspoon dried dillweed
1½ tablespoons lemon juice
 salt and black pepper to taste

Bring a saucepan of water to a boil, add the squash, and cook until tender but still crisp. Drain squash well, and place in a serving bowl. Add all the other ingredients, toss, and serve immediately.

ENTRÉES

Most vegetables are cholesterol-free, low in calories, loaded with vitamins, and less expensive than meats. In combination with other vegetables, meats, or seafood, vegetables can make a hearty main dish.

AFRICAN STEW WITH OKRA

Serves 4

1 onion, chopped
1 green bell pepper, deseeded
2 cloves garlic
¼ cup chopped parsley
5 large ripe tomatoes, peeled
3 tablespoons vegetable oil
1½ pounds lamb or beef, cut into bite-sized pieces
1 pound okra, trimmed
salt and black pepper to taste

In a blender or food processor, purée the onion, green pepper, garlic, parsley, and tomatoes; set aside. Heat the oil in a saucepan, and brown the meat on all sides. Add the tomato mixture to the meat. If purée seems too thick, add a little water or stock. Cover and simmer until the meat is tender and done. Add the okra, and cook for 30 minutes. Season with salt and pepper.

ARTICHOKES AND PASTA

Serves 4

10 small artichokes, or 1 10-ounce package frozen artichoke hearts
1 lemon, cut in half (not necessary if using frozen artichokes)
3½ tablespoons olive oil
1 medium onion, chopped
2 cloves garlic, minced
2 ounces dried Italian mushrooms, soaked in 1 cup boiling water for 15 minutes, drained (reserve water), and chopped
1½ cups chopped parsley
½ cup dry white wine
1½ pounds ripe tomatoes* peeled and chopped
1 pound fresh linguine
salt to taste

The smaller the fresh artichokes the better. The ones that weigh an ounce or so are the best. Rinse thoroughly by holding the artichokes by their stems and swishing the leaves in water. Pull off the tough outer leaves and cut off the pointy leaf tips and the stems even with the base. (If using larger artichokes, scoop out and discard the fuzzy chokes.) Cut the artichokes into quarters and soak them in water with the lemon halves to prevent discoloration. The frozen artichokes need not be thawed.

In a large skillet or a saucepan, heat the olive oil and sauté the onion and garlic. Add the mushrooms and their soaking water, and stir briefly. Drain the artichokes, discarding the lemon, and add to the pan. (If using frozen artichokes, add at this point.) Cook the artichokes about 15 minutes, adding water if needed for moisture. Add the parsley, wine, and tomatoes, and simmer for about 20 minutes.

While the sauce finishes cooking, cook the linguine in boiling salted water until *al dente* (firm to the bite). Drain and place on a serving platter. Adjust sauce seasoning with salt, and pour over pasta. Serve at once.

*Canned peeled whole tomatoes may be substituted.

BEEF AND BOK CHOY

Serves 6

1 tablespoon soy sauce
½ tablespoon oyster sauce*
1 teaspoon whiskey
1 teaspoon sugar
1 pound beef (sirloin or flank steak), thinly sliced and lightly coated with 1 teaspoon cornstarch
3 tablespoons vegetable oil
1 pound bok choy, cut into 1¼-inch lengths**
1 clove garlic, minced
½ teaspoon minced ginger root
1 cup water
1 tablespoon cornstarch, mixed into a paste with 2 tablespoons water

Mix together the soy sauce, oyster sauce, whiskey, and sugar, and marinate the meat for about 10 minutes. Heat 1½ tablespoons oil very hot in a large skillet or wok, add the *bok choy*, and stir-fry quickly until leaves are coated with oil. Do not overcook. Remove the *bok choy*, and wipe the pan dry.

Heat to very hot another 1½ tablespoons oil, and lightly brown the garlic and ginger. Add the beef and brown. Remove the meat, keeping the liquid in the pan. Add the water, heat, and then add the cornstarch mixture. Heat until liquid thickens. Return the meat and *bok choy* to the pan, and stir-fry just long enough to heat through. Serve immediately.

*Sold in bottles in Asian specialty markets and many supermarkets.

**Asparagus, snow peas, green beans, or parboiled broccoli, Chinese broccoli (gai laan), or cauliflower may be used.

BITTER MELON WITH BLACK BEAN SAUCE

Serves 4

2 medium bitter melons*
½ tablespoon sugar
½ teaspoon salt
2½ teaspoons soy sauce
1 tablespoon sherry
½ pound beef, thinly
 sliced**
½ teaspoon cornstarch
2½ tablespoons fermented
 black beans (dow see)***
2 cloves garlic, minced
½ cup water or stock
1½ tablespoons vegetable
 or peanut oil
2 teaspoons cornstarch,
 mixed into a paste with
 2 tablespoons water

Cut the bitter melons in half lengthwise, and scoop out the spongy inner membrane and seeds. Slice the melons diagonally about ⅛ inch thick. Parboil for about 3 minutes, drain, and place in cold water. Drain again and squeeze out excess water. Set aside.

Mix together 1 teaspoon sugar, salt, soy sauce, and sherry, and marinate the beef for about 5 minutes. Sprinkle with ½ teaspoon cornstarch.

Wash the black beans until the water runs clear. The husks will float to the top and should be discarded. Drain well. Mash the beans together with the garlic and ½ teaspoon sugar. Add the water or stock.

Heat the oil until very hot in a large skillet or wok and stir-fry the meat until brown. Remove the beef, and set it aside. With the juice from the meat still in the pan, add the black bean mixture. Heat to a boil, and add the bitter melons. Stir-fry just long enough to coat with the sauce and heat through. Return the meat to the pan, and stir-fry to combine evenly with the bitter melons. Add the cornstarch paste to the ingredients. Continue to stir-fry until the sauce thickens, and serve immediately.

*Asparagus may be substituted.

**Pork spareribs, chopped in 1-inch lengths and boiled until tender, may be substituted.

***Fermented black beans are available in plastic bags in Chinese markets.

CHICKEN WITH MUSHROOMS AND SNOW PEAS

Serves 4

¾ pound boned chicken
 breast meat, cut into bite-
 sized pieces
½ tablespoon sherry
¼ teaspoon salt
⅛ teaspoon black pepper
1 egg white (optional)
2 teaspoons cornstarch
2 tablespoons vegetable oil
1 clove garlic, minced
1 4-ounce can button
 mushrooms with liquid
¼ cup water
½ teaspoon sugar
1 tablespoon soy sauce
⅓ pound snow peas,
 cleaned and tipped*
½ cup sliced celery
½ cup sliced water chestnuts
 salt and black pepper
 to taste
 toasted almonds,
 cashews, or walnuts for
 garnish (optional)

Sprinkle the chicken with the sherry, ¼ teaspoon salt, and ⅛ teaspoon pepper, and then coat with the egg white and cornstarch. Heat the oil very hot in a large skillet or wok, and stir-fry the garlic until a light brown. Add the chicken, and stir-fry for about 2 minutes. Add the mushrooms and their liquid, water, sugar, and soy sauce, and stir-fry just long enough to distribute evenly. Add the snow peas, celery, and water chestnuts, and stir-fry only to heat through. Adjust seasonings with salt and pepper. Garnish with the nuts, and serve immediately.

*Green beans or asparagus may be substituted.

EGG FOO YUNG

Serves 4-6

Egg Mixture

8 eggs, beaten
½ teaspoon salt
½ teaspoon cornstarch
1 cup crab meat, or raw or
 cooked shrimp, chopped
3 dried shiitake mushrooms,
 soaked in 1 cup lukewarm
 water until soft, drained
 (press out excess water),
 and cut into thin strips*
½ cup julienne-cut celery
¼ cup julienne-cut onion

¼ cup sliced water chestnuts
2 cups raw bean sprouts
 vegetable oil for frying
¼ cup minced green onion
 for garnish

Sauce

1 cup chicken or beef stock
½ teaspoon salt
1 teaspoon soy sauce
2 teaspoons cornstarch,
 mixed into a paste with
 2 tablespoons water

Gently combine all of the egg mixture ingredients. Heat about 2 tablespoons of oil in a skillet and ladle in about ¼ cup of the egg mixture to form a pancakelike round. Cook until brown on both sides, turning once; remove and keep warm. Repeat with remaining batter, adding more oil to pan as needed.

To make the sauce, heat the stock, and add the salt, soy sauce, and cornstarch paste. Continue to heat and stir until the mixture forms a thin gravy. Layer the "cakes," gravy, and green onions in a serving dish. Serve immediately.

The soaking water may be reserved and used in place of the stock.

EGGS WITH MAUHALO SAUCE

Serves 6

3 cloves garlic, minced
2 onions, sliced
3 tablespoons butter or
 vegetable oil
5 large ripe tomatoes,
 peeled and diced
1 green bell pepper,
 deseeded and cut into
 ¼-inch-wide strips
4 Anaheim peppers,
 deseeded and chopped

1 jalapeño pepper,
 deseeded and finely
 diced
¼ teaspoon ground
 cumin
⅛ teaspoon ground
 allspice
⅛ teaspoon ground clove
 salt and black pepper to
 taste
8 eggs*

In a saucepan, lightly sauté the garlic and onions in the butter. Add all of the other ingredients, except the salt and black pepper and the eggs, and simmer over medium-low heat for about 20 minutes. Season with salt and black pepper.

In a bowl, beat the eggs. Then add the eggs to the mauhalo sauce, stir, and cook over a medium-high heat until the eggs are cooked through. Serve immediately.**

Boiled shrimp may be substituted. The sauce is poured over the shrimp.

**This dish is frequently served with hot tortillas or French bread.*

LAMB AND TURNIP STEW

Serves 6

2 tablespoons vegetable oil
1 onion, chopped
3 cloves garlic, chopped
2 pounds lean lamb, cut
 into 2-inch chunks and
 dredged in flour
9 cups water
3 medium turnips, peeled
 and cubed*
5 ripe tomatoes, peeled
 and chopped
2 carrots, peeled and sliced
1 tablespoon dried oregano
2 teaspoons dried tarragon
2 bay leaves
 salt and black pepper to
 taste
½ cup chopped parsley

In a dutch oven, heat the oil and lightly brown the onion and garlic. Add the meat and brown all sides. Add the water, cover, and simmer for about 1½ hours. Skim the fat and froth off the surface, and add vegetables, oregano, tarragon, and bay leaves. Cover and cook for another 45 minutes. Season with salt and pepper, and stir in the parsley just before serving.

Rutabaga or kohlrabi may be substituted.

LEEK AND MUSHROOM QUICHE

Serves 4-6

Deep-Dish Pastry Shell
1 1/3 cups all-purpose flour

1/2 teaspoon salt

1/2 cup shortening

3 to 4 tablespoons cold
water

Sift together the flour and salt into a bowl. Cut in the shortening with a pastry blender until the particles are the size of small peas. Mix in the water, 1 tablespoon at a time, until the flour is moistened enough to hold together in a ball. On a lightly floured board, roll the dough out to fit a 10-inch deep-dish pie pan. Transfer the pastry round to the pie pan. Press gently against sides and bottom of pan, and crimp edges along rim.

Filling
1/2 pound sliced bacon, cut
into 3/8-inch-wide strips

1 1/2 cups chopped fresh
mushrooms

3 1/2 cups chopped leek,
boiled 3 minutes and
drained well*

4 eggs

1 1/4 cups heavy cream

1 teaspoon salt

1/8 teaspoon ground
nutmeg

1/2 tablespoon Tabasco
sauce

2 tablespoons lemon juice

1 1/2 cups shredded swiss
cheese

Preheat the oven to 350° F. Fry the bacon until almost crisp, and drain off the fat, leaving about 1 tablespoon. Sauté the mushrooms with the bacon. Then add the leek and sauté briefly. Lightly beat together the eggs, cream, salt, nutmeg, Tabasco sauce, and lemon juice. Mix in the cheese and the leek mixture. Pour into the pastry shell, and bake in the preheated oven for 40 minutes, or until the custard appears firm.

Spinach or asparagus may be substituted.

PORK WITH GREEN CHILI SAUCE

Serves 4

1 pound tomatillos,
dehusked

3 to 4 serrano peppers,
deseeded and chopped*

2 cloves garlic

2 teaspoons fresh coriander
leaves

1 medium onion, chopped

1/8 teaspoon sugar

1/2 cup water or stock

1 1/2 pounds pork butt, cut
into 2-inch chunks

3 tablespoons vegetable oil
salt and black pepper to
taste

Boil the tomatillos in lightly salted water to cover until soft, about 10 minutes. Drain. In a blender or food processor, purée the tomatillos, peppers, garlic, coriander, onion, sugar, and water. Season to taste with salt.

In a large skillet, brown the meat in oil and add the tomatillo sauce. It may be necessary to add a little more water if the sauce seems too dry. Cover and simmer for about 40 minutes, or until the meat is cooked through. Adjust the seasonings with salt and pepper.

Wash hands immediately after handling the peppers.

SPAGHETTI WITH BROCCOLI AND ANCHOVIES

Serves 4-6

2 pounds broccoli*

1/2 cup olive oil

4 cloves garlic, peeled

1 small dried red hot chili
pepper

1 1/2 pounds ripe tomatoes,
peeled and chopped**

4 ounces anchovy fillets,
drained and chopped
salt to taste

1/4 cup finely diced onion

1/3 cup seedless white
raisins, soaked in warm
water 15 minutes and
drained

1/4 cup pine nuts (optional)
freshly ground black
pepper to taste

1 1/2 pounds spaghetti

1 cup grated Romano or
Parmesan cheese

Peel the stalks of the broccoli and slice them; divide the tops into flowerets. In a deep pot, boil enough lightly salted water to cook the broccoli and then later the spaghetti. Parboil the broccoli 3 minutes. Scoop out with a slotted utensil to save the water. Set broccoli aside.

Heat ¼ cup oil in a skillet, and sauté 2 of the garlic cloves and the chili until golden. Remove and discard the garlic and chili and add the tomatoes and anchovies. Season with salt, and bring to a boil, cooking about 15 minutes. If the sauce seems too thin, continue to boil until desired consistency.

Heat the remaining ¼ cup oil in another pan, and sauté the onion and 2 remaining garlic cloves until golden. Remove and discard the garlic, and add the broccoli, raisins, and pine nuts. Season with salt and a good amount of black pepper, and then add to the tomato mixture. Mix gently not to break up the broccoli, and keep the sauce hot. This sauce should not be simmered or the broccoli will overcook.

Bring the broccoli cooking water to a boil, and cook the spaghetti until *al dente* (firm to the bite). Drain. Arrange the pasta, sauce, and cheese in layers in a serving dish so that they will be easier to toss together. Serve immediately.

Cauliflower may be substituted.

**Canned peeled whole tomatoes may be substituted.*

Serves 6

2	pounds spinach, boiled, drained, squeezed of excess liquid, and then finely chopped
1	cup grated Parmesan cheese
1	cup ricotta cheese
1	cup dry fine bread crumbs
4	eggs, well beaten
3	cloves garlic, minced

2½	teaspoons dried rosemary
	salt and black pepper to taste
	flour

Sauce

2	pounds lean ground beef
1	onion, chopped
2	cloves garlic, minced
1½	pounds ripe tomatoes, peeled and puréed*

2	ounces dried Italian mushrooms, soaked in 1 cup boiling water for 15 minutes, drained (reserve water), and chopped; or ½ pound fresh mushrooms, chopped
1	teaspoon dried mixed Italian herbs
	salt and black pepper to taste
	beef stock or water

Mix together well the spinach, cheeses, bread crumbs, eggs, and seasonings. If the mixture is too wet, add more cheese or bread crumbs. Flour hands, and form spinach mixture into 1½-inch balls. Bring a large pot of water to a boil, and add a few balls at a time. Do not add too many at once because they will clump together. When the balls float to the surface like dumplings, scoop them out and set them aside.

To make the sauce, brown the meat with the onion and garlic, and then add the tomatoes, mushrooms, and seasonings. Simmer at least 40 minutes. Add beef stock or water if mixture becomes too thick.

When the sauce is ready, add the boiled balls and let simmer for another 10 minutes. Serve hot.

Substitute a 1-pound can of solid-pack whole tomatoes, chopped, and 1 6-ounce can tomato sauce for the fresh tomatoes.

YARD–LONG BEANS A LA CREOLE

Serves 4-6

- 3 tablespoons olive oil
- 2 cloves garlic, minced
- 3 green onions, chopped
- 1 tablespoon minced parsley
- 2 large ripe tomatoes, peeled and chopped
- 1/8 teaspoon dried thyme
- 1/4 teaspoon dried oregano
- 1/2 tablespoon white wine
- 2 to 3 ounces pork, cut into bite-sized strips
- 1/2 cup shrimp, shelled, deveined, and chopped
- 1 pound yard-long beans or green beans, cut into 2-inch lengths
- salt and black pepper to taste

Heat the oil in a saucepan, and sauté the garlic until lightly golden. Add the onions, parsley, tomatoes, thyme, oregano, wine, and pork, and cover and simmer for about 15 minutes. Add the shrimp and beans, cover, and simmer for 10 minutes. Season with salt and pepper, and serve hot.

DESERTS

In the absence of exotic chocolates and imported foreign ingredients, American pioneer cooks learned to use the materials at hand. That usually was any vegetable that was growing in surplus in the garden.

CHAYOTE COMPOTE

Serves 4

- 3/4 cup sugar
- 1/2 cup cream sherry
- 1 1/2 cups water
- 2 chayotes, peeled, halved, and deseeded
- 1 tablespoon lime juice
- whipped cream or ice cream
- chopped nuts, chocolate chips, or mint for garnish

In a small saucepan, combine the sugar, sherry, and water and heat, stirring, just until the sugar dissolves. Place the chayote in a single layer in the liquid. Cover the pan and cook the chayote for about 25 minutes or until tender. Remove from heat and cool thoroughly.

When ready to serve, drain off the liquid and place chayote into individual serving bowls. Sprinkle chayote with lime juice and top with whipped cream. Garnish with nuts.

KABOCHA PIE

Serves 6-8

Deep-Dish Pastry Shell
- 1 1/3 cups all-purpose flour
- 1/2 teaspoon salt
- 1/2 cup shortening
- 3 to 4 tablespoons cold water

Sift together the flour and salt into a bowl. Cut in the shortening with a pastry blender until the particles are the size of small peas. Mix in the water, 1 tablespoon at a time, until the flour is moistened enough to hold together in a ball. On a lightly floured board, roll the dough out to fit a 10-inch deep-dish pie pan. Transfer the pastry round to the pie pan. Press gently against sides and bottom of pan, and crimp edges along rim.

Filling

1 kabocha pumpkin (about 2½ pounds)*
4 eggs
2 cups heavy cream
2 teaspoons ground cinnamon
½ teaspoon ground nutmeg
¼ cup granulated sugar
½ cup brown sugar
dash of salt
whipped cream for topping

Preheat the oven to 350° F. Cut off top one third of the kabocha pumpkin. Remove the seeds inside and discard. Place the top back onto the kabocha and set upright in a shallow pan. Bake in the oven for about 1 hour or until the inner pulp is soft. Remove from the oven.

Scoop the soft pulp from the shell, and discard shell. Purée the pulp in a blender or food processor until smooth. There should be about 2 to 2½ cups of pulp.

In a large bowl, blend together the eggs, cream, cinnamon, and nutmeg.

Then add the sugars and salt and stir thoroughly. Add the puréed kabocha and blend the mixture together.

Pour the mixture into the pastry shell. Bake in the preheated oven for 50 minutes to 1 hour, or until the custard is set.

Once the pie has cooled, top with whipped cream.

*Banana, hubbard, or acorn squash may be substituted.

RHUBARB SAUCE WITH ICE CREAM

Serves 6

1 pound rhubarb, trimmed and cut into 2-inch lengths
½ cup sugar
½ cup water
vanilla ice cream

Combine the rhubarb and sugar in a saucepan, and set it aside for about 1 hour. Add the water, bring to a boil, and cook gently for about 1 to 3 minutes, or until soft. Stir frequently and watch carefully, as rhubarb dissolves quickly and suddenly. Cool and serve over ice cream.

SWEET POTATO WALNUT BREAD

Serves 8

1 cup vegetable oil
¾ cup brown sugar
2 eggs
1 teaspoon vanilla extract
1½ cups all-purpose flour
1½ teaspoons baking soda
½ teaspoon salt
1 teaspoon ground cinnamon
1 teaspoon grated orange peel
1½ cups grated, peeled raw sweet potato (about 1 large potato)
1 cup chopped walnuts

Optional Orange Glaze
½ cup powdered sugar
1 teaspoon grated orange peel
1 tablespoon orange juice

Preheat the oven to 350° F., and butter and flour a 9×5×3-inch loaf pan. In a large bowl, mix the oil, brown sugar, eggs, and vanilla. Sift together the flour, soda, salt, and cinnamon, and combine with the sugar mixture. Stir in the orange peel, and then the sweet potato and walnuts. Pour into the loaf pan, and bake in the preheated oven for 55 to 60 minutes, or until the center springs back when gently pressed. Cool for 10 minutes before turning out on a wire rack, then cool completely.

If desired, mix together the glaze ingredients and drizzle on the cooled loaf.

Makes one loaf.

From the Sweet Potato Council of the United States, Inc.

RECIPE INDEX

ACKNOWLEDGMENTS

This book came about through the generous support of dozens of people who tested recipes and provided research materials, information, references, photographs, and two of the most valued human virtues, encouragement and patience. We'd like to thank and acknowledge them here.

Special thanks to:
Wendy Dietrich
Laurie Gordon
Takenobu Igarashi
Micky Karpas

Additional thanks to:
Mrs. Enrico Bellone, Guy Billout; Jim Heimann; Martine Madrigal; Mike O'Connell, Bon Appétit Foods; Hank Sandbach, Del Monte Corporation; Chris Saul; Debi Shimamoto, Igarashi Studio; John Sullivan, Ferry Morse Seed Company; Lee Ray Tarantino Wholesale Produce; Tommy Tracy; Robert Tracy; Valerie Turpen; Mark Westwind.

Text:
Joe Alvernaz, Carol Bowman-Williams of Frieda of California, Busse & Cummins, California Avocado Commission, California Artichoke Advisory Board, California Celery Research Advisory Board, California Dry Bean Advisory Board, California Fresh Market Tomato Advisory Board, California Potato Research Advisory Board, Paul Christy, Jenni Croghan, Merilyn Hand, Masato and Miho Hiramoto, Jim Hirasuna, Nancy (Matsue) Hirasuna, Iceberg Lettuce Research Program, Manuel J. Jimenez, Kitazawa Seed Company, Don Lenker, John Moore of Moore Marketing International, Shizuo Nakayama, Marvin Pettis, E. J. Ryder, Sakata Seed Company, San Francisco Public Library, Bill Sher of Tsang & Ma, Johnson and Itsie Shimizu, Toyo Shimizu, Mary Beth Smyth of the Alice Statler Library at City College of San Francisco, Sweet Potato Council of California, Hugh Tottino, Tulelake Horseradish Association, Ben and Sue Tsudama, Valerie Ventre, Nancy Walter, Ken Wong of *San Francisco Examiner.*

Recipes:
Lilia Alwatter, Lucy Barrera, Gary Bunn, Angelo Guerra, Ed and Kiyoko Hirasuna, Helen Hirasuna, Charisse and Evan Hong, Takako Ishizaki, Yuriko Kimura, Jane and Morris Kosakura, Kim Leventhal, Diva Lippi, Vic Lopez, Jean Micheli, Tricia Mitchell, Patsy Oda, Shirley Osobe, Amy Prahar, Margaret "Peggy" Proctor, Masuno Sasaki, Shirley Sasaki, Aline Sinai, Diane Takeshita, Lloyd Thibeaux, George Yamasaki, Jr.

Visual Resources:
Cover Illustration, David Stevenson; Page 9, Dugald Stermer; Page 10–11, California Historical Society, San Francisco; Page 11 inset, The Bettmann Archive, New York; Page 12, The Bettmann Archive, New York; Page 13, Labels courtesy of Laurie Gordon; Page 16, California State Library, Sacramento; Page 17, Oakland Museum History Department, Photographic Collection; Page 18–19, California Historical Society/Los Angeles Area Chamber of Commerce Collection of Historical Photographs; Page 19 inset, Courtesy of Mrs. Enrico Bellone; Page 20–21, Oakland Museum History Department, Photographic Collection; Page 22–23, Labels courtesy of Laurie Gordon; Page 24, Ferry Morse Seed Company; Page 25, Oakland Museum History Department, Photographic

Collection; Page 28, Underwood Photo Archives Collection, San Francisco; Page 29, Underwood Photo Archives Collection, San Francisco; Page 30–31, Oakland Museum History Department, Photographic Collection; Page 33, U.S. Department of Agriculture, Photo by Forsythe; Page 75, Daniel Pelavin; Page 78–79, Tim Lewis; Page 79, Ward Schumaker, Susie Reed; Page 81, John Mattos; Page 82–83, Tadashi Ohashi; Page 85, Will Nelson; Page 87, David Stevenson; Page 88, Tim Lewis; Page 89, John Hyatt; Page 94, Tadashi Ohashi; Page 95, David Stevenson, Carolyn Vibbert; Page 98–99, Tadashi Ohashi; Page 99, Hank Osuna; Page 100, Colleen Quinn; Page 101, Ward Schumaker, Alan Sanders; Page 102, Regan Dunnick, Phillipe Weisbecker; Page 103, Sarah Waldron; Page 104, Ward Schumaker; Page 105, Tadashi Ohashi; Page 106–07, Tadashi Ohashi; Page 110, Dugald Stermer; Page 111, David Stevenson; Page 113, Bud Thon; Page 114, Alan Sanders; Page 116, Tadashi Ohashi; Page 119, Carolyn Vibbert, Alan Sanders.

ABBREVIATED BIBLIOGRAPHY

Aresty, Esther B. *The Delectable Past*. Simon and Schuster, 1964.

California Agriculture— 1983. Produced by Department of Food and Agriculture.

California Farmer Magazine.

Carcione, Joe and Lucas, Bob. *The Greengrocer*. Chronicle Books, 1972.

Chang, K.C. edited by. *Food in Chinese Culture*. Yale University Press, 1977.

Church, Charles Frederick. *Food Values of Portions Commonly Used*. J. B. Lippincott, 1970.

Cole, Allan B. edited by. *Scientist with Perry in Japan: The Journal of Dr. James Morrow*. University of North Carolina Press, 1947.

Culpeper, Nicolas. *Culpeper's Complete Herbal*. Reprinted by Foulsham Company, undated.

Dahlen, Martha and Phillips, Karen. *A Popular Guide to Chinese Vegetables*. Crown Publishers, Inc., 1983.

Davidson, Alan and Jane translated by. *Dumas on Food*. Folio Society, 1978.

Ellwanger, George H. *The Pleasures of the Table, an account of gastronomy from ancient days to present times*. Doubleday Page and Company, 1969.

Fisher, M.F.K. translated and annotated by. *Brillat-Savarin's The Physiology of Taste*. Alfred A. Knopf, 1972.

Fite, Gilbert Courtland. *The Farmers' Frontier: 1865–1900*. Holt, Rinehart and Winston, 1966.

Friedlander, Barbara. *The Vegetable Fruit & Nut Book*. Grosset & Dunlap, 1974.

Grieve, Mrs. M. *A Modern Herbal*. Dover Press, 1971.

Grigson, Jane. *Food with the Famous*. Atheneum, 1980.

Grigson, Jane. *Jane Grigson's Vegetable Book*. Atheneum, 1979.

Haughton, Claire Shaver. *Green Immigrants: The Plants That Transformed America*. Harcourt Brace Jovanovich, 1978.

Hays, Wilma and R. Vernon. *Foods the Indians Gave Us*. Ives Washburn Inc., 1973.

Jacobs, Jay. *A History of Gastronomy*. Newsweek Books, 1975.

Kirschmann, John D. director. *Nutrition Almanac*. McGraw-Hill Book Company, 1979.

Leighton, Ann. *Early American Gardens, "For Meate or Medicine."* Houghton Mifflin Co., 1970.

Lin, Hsiang Ju and Lin, Tsuifeng. *Chinese Gastronomy*. Pyramid Publications, 1972.

London, Sheryl. *Eggplant and Squash*. Atheneum, 1976.

Marcus, George and Nancy. *Forbidden fruits and Forgotten vegetables, A guide to cooking with ethnic, exotic and neglected produce*. St. Martin's Press, 1982.

Mendelsohn, Oscar A. *A Salute to Onions*. Hawthorn Books, Inc., 1966.

Munroe, Esther. *Sprouts*. Stephen Greene Press, 1974.

Newsome, J. edited by. *Pliny's Natural History; a selection form Philemon Holland's translation*. Clarendon Press, 1964.

Pullar, Philippa. *Consuming Passions*. Little, Brown, 1970.

Tannahill, Reay. *Food in History*. Stein and Day, 1973.

We Japanese. Yamagata Press, 1950.

Wickson, E. J. *Rural California*. The Macmillan Company, 1923.

Yamaguchi, Mas. *World Vegetables: Principles, Production and Nutritive Values*. AVI Publishing Company, 1983.

PRODUCTION NOTES

Design:
Kit Hinrichs

Design Associates:
D.J. Hyde, Lenore Bartz
Production Manager:
Tanya Stringham
Project Coordinators:
Diana Dreyer, Laurie Goddard

Jonson Pedersen Hinrichs & Shakery Production Staff:
Ken Andreotta, Victor Arre, Beverly Catli, Marsha Girardi, Doug Murakami, Alan Sanders, Gwyn Smith, Kern Toy, Valerie Turpen.

Typography:
Cheltenham Oldstyle, Cheltenham Bold Extra Condensed, Cheltenham Oldstyle Italic, ITC Cheltenham Light Condensed, ITC Cheltenham Book Condensed, Helvetica Light Condensed, Helvetica Bold Extra Condensed, Aurora.

Set By:
On Line Typography, San Francisco

Printing:
Toppan Printing Company, Tokyo, Japan

Vegetables is a collaboration of four San Francisco Bay Area talents:

Delphine Hirasuna is recognized as an outstanding corporate journalist. As corporate publications manager for Potlatch Corporation, she won dozens of awards for the company's annual report, magazine, and other publications. She is the recipient of five Clarion awards from Women in Communications and more than a dozen local and international awards from the International Association of Business Communicators. Delphine co-authored the cookbook, *Flavors of Japan*, and writes weekly feature columns for the two largest Japanese-American daily newspapers, *Rafu Shimpo* and *Hokubei Mainichi*. In addition, her essays have been published in textbook anthologies. Recently Delphine established her own consulting firm, providing editorial services to corporations.

Kit Hinrichs is a principal in the graphic design firm Jonson Pedersen Hinrichs & Shakery, which has offices in San Francisco, New York, and Connecticut. Recognized as "one of the important American graphic designers in the past 25 years"

Clockwise from Center: Tom Tracy, Kit Hinrichs, Delphine Hirasuna, Diane J. Hirasuna

by *Idea Magazine*, Kit serves as design consultant to many multinational corporations, for whom he has won well over one hundred design awards. Kit has taught at the School of Visual Arts in New York City and at the

Academy of Art in San Francisco, and has been a guest lecturer at the Stanford Design Conference and at universities around the nation. His work has been exhibited internationally and is included in the permanent collection of the Museum of Modern Art in New York City. He is also on the board of directors of the American Institute of Graphic Arts.

Tom Tracy is a consistent recipient of national and international photography awards. His exquisite photographs have appeared in dozens of consumer magazines, including *Life*, *Time*, *Newsweek*, *Fortune*, *Money*, and *U.S. News and*

World Report, and in corporate publications worldwide. Although Tom works primarily for corporate and industrial clients, photographing annual reports and other corporate publications, he has a number of books to his credit, including *Photographing Nature* by Time-Life Books; *The Sierra*, *The Great Divide*, and *The Northwest Coast* for the Wilderness Series, and *Cold Pasta* recently released by Chronicle Books.

Diane J. Hirasuna is a woman of eclectic talents. Along with her sister, Diane wrote the cookbook, *Flavors of Japan*, which was nominated for the national French's Tastemakers' Award. She has served as a food consultant to restaurants in California, has given a number of Japanese cooking demonstrations before local organizations, and is a member of the Institute of Food Technologists. Diane has been a workers' compensation counselor for northern California hospitals. Most recently she has been employed as tour manager for Kosakura Tours & Travel, leading groups on vacation tours of Asia.